CATALOGUE OF THE BLAKE COLLECTION IN THE FITZWILLIAM MUSEUM CAMBRIDGE

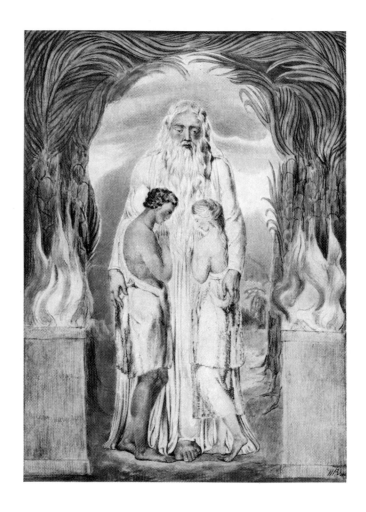

The Angel of the Divine Presence clothing
Adam and Eve with coats of skins (25)

WILLIAM BLAKE

CATALOGUE OF THE COLLECTION
IN THE
FITZWILLIAM MUSEUM
CAMBRIDGE

EDITED BY

DAVID BINDMAN

PUBLISHED FOR THE SYNDICS OF THE FITZWILLIAM MUSEUM
BY W. HEFFER AND SONS LTD, CAMBRIDGE
1970

© Fitzwilliam Museum, 1970

Published for the Fitzwilliam Museum by
W. Heffer and Sons Ltd,
20 Trinity Street
Cambridge, England

ISBN 0 85270 053 9

Text and plates printed in Great Britain at the
University Printing House, Cambridge
(Brooke Crutchley, University Printer)

CONTENTS

FOREWORD

About 1953, Sir Geoffrey Keynes compiled, as a labour of love, a manuscript catalogue of the works of William Blake in the Fitzwilliam Museum. This manuscript was subsequently used in the Department of Drawings, and annotated and added to by many hands, notably those of Mr Carlos van Hasselt, Mr J. W. Goodison, Mr Malcolm Cormack and Mr Martin Butlin. In 1969, generous contributions from the Paul Mellon Foundation for British Art (towards the cost of printing) and from Mr Kerrison Preston (towards editorial costs) made the preparation of the manuscript for press, and its subsequent publication, a practical proposition. The Museum was fortunate in securing the services of Mr David Bindman to edit the by-now complex manuscript. In effect, Mr Bindman, besides co-ordinating the original material, bringing it up to date and revising it where necessary, has entirely recast it so that, it is hoped, it will serve both as a normal catalogue for reference, and as an introduction and guide to Blake's work. The latter aim seems justifiable in view of the richness, variety and extent of the Museum's holdings of the work. The catalogue is arranged mainly chronologically, and divided into sections, each devoted to a specific period of Blake's career and provided with an introductory commentary. A separate section is devoted to the Museum's remarkable representation of portraits of Blake. Thanks are due to Mr E. C. Chamberlain and Miss P. M. Giles for help with entries for prints and books.

In the course of Mr Bindman's work, Sir Geoffrey Keynes made known his intention to bequeath the major part of his great collection of Blake material, including many original works, to the Fitzwilliam Museum, so increasing immeasurably our already large debt to him. He has most generously agreed that the items that will ultimately come (while they remain of course in his keeping during his lifetime) might be listed in the Museum catalogue, and they have therefore been included as an Appendix, the entries for them being taken from Sir Geoffrey Keynes's in his catalogue of his collection, *Bibliotheca Bibliographica* (1964).

DAVID PIPER

EDITOR'S ACKNOWLEDGEMENTS

My principal debt is to Mr Malcolm Cormack, Keeper of Paintings at the Fitzwilliam Museum, who has made countless suggestions that have been absorbed into the text, and has been closely involved in all stages of bringing the work to press. Mr Martin Butlin has kindly looked through the text and has also made many suggestions.

I should also like to thank the following who have answered my enquiries: Sir Geoffrey Keynes, Mr Stephen Rees Jones, Mr John Brealey, Professor G. E. Bentley, Jr., Dr John Barron, Lady Tennant and Mr Herbert Blount. Miss Jane Low typed the manuscript and helped in various ways.

DAVID BINDMAN

THE HISTORY OF
THE FITZWILLIAM BLAKE
COLLECTION

The Fitzwilliam already owned a copy of Blake's engravings for Young's *Night Thoughts* in 1818, during the artist's lifetime, and in 1872 a fine copy of the Illuminated Book, *The Marriage of Heaven and Hell*, was bequeathed to the Museum. Since then the Fitzwilliam collection has steadily acquired important items by gift and purchase, but many of the greatest treasures come from two comparatively recent donations. In 1935 T. H. Riches, who had married one of John Linnell's granddaughters, bequeathed his own fine Blake collection to the Museum, and in 1949 the trustees of the W. Graham Robertson collection presented six important paintings and watercolours that had been in the Butts collection. These two bequests, therefore, brought to the Museum a substantial part of the collections of Blake's two greatest patrons, John Linnell and Thomas Butts.

T. H. Riches inherited a small part of John Linnell's Blake collection through his wife, but he added to it greatly at the John Linnell sale in 1918, when he bought the drawings for the *Book of Job* and the twelve designs for *Paradise Regained*, and in later years he was able to reunite the greater part of Linnell's collection of Illuminated Books. W. Graham Robertson was the most famous Blake collector of his day, and the nucleus of his collection came from his purchase of the residue of the Butts collection, from a member of the family, in 1905.

In 1900 the Director, M. R. James, was responsible for the enlightened purchase of the early watercolours of *The Story of Joseph*, and the Fairfax Murray gift of 1912 brought, amongst other important Blake items, the *Island in the Moon* manuscript.

The Fitzwilliam collection is remarkably comprehensive, and is not limited to any section of Blake's work. Thus Blake can be studied in all his complexity, not only as a painter or watercolourist, but as a persistent experimenter with the techniques of printing.

REFERENCES USED IN THE CATALOGUE

All references to the writings of Blake have been made to the Nonesuch edition of *The Complete Writings of William Blake*, edited by Sir Geoffrey Keynes, 1957, reprinted by Oxford University Press, 1966 and 1969, with a number of additions and corrections. All references to previous editions of the *Complete Writings* by Sir Geoffrey Keynes and others have, therefore, been omitted.

Full reference has been made only to the first edition of Gilchrist's *Life of Blake*, 1863, unless there is additional information in the 1880 and 1907 editions. If any item in the catalogue is illustrated in the present volume, then reference is only made to colour reproductions from other sources.

Measurements are given in inches, followed by centimetres in brackets. Height precedes width.

EXHIBITIONS

All exhibitions took place in London unless otherwise stated. The following,
in chronological order, are given in abbreviated form

1785 Royal Academy

1809 Blake's Exhibition: Broad Street

1857 *Art Treasures*, Manchester

1862 *International Exhibition*, South Kensington

1865 *37th Exhibition*, Royal Hibernian Academy, Dublin

1876 *The Works of William Blake*, Burlington Fine Arts Club

1891 *Summer Exhibition*, New Gallery

1893 *Works by Old Masters . . . including a collection of Water-colour Drawings, &c., by William Blake . . .*, Royal Academy (Winter Exhibition)

1904 *Works by William Blake*, Carfax & Co.; January

1905 *Books, Engravings, Water-colours and sketches by William Blake*, Grolier Club, New York; January–February

1906 *Spring Exhibition*, Whitechapel Gallery
Frescoes, Prints and Drawings by William Blake, Carfax & Co.; June–July

1910 *Loan Exhibition*, Fitzwilliam Museum, Cambridge

1911 *Century of Art* (International Society of Sculptors, Painters and Gravers), Grafton Gallery

1913–14 *Works by William Blake*, National Gallery of British Art (Tate Gallery); October–December. Whitworth Institute, Manchester; February–March. Art Museum, Nottingham Castle; April
Works by William Blake and David Scott, National Gallery of Scotland, Edinburgh; May–July

1916 *Herbert Horne collection of Drawings . . .*, Burlington Fine Arts Club

1923 Agnew

1927 *Blake Centenary Exhibition*, Burlington Fine Arts Club
XCV. Ausstellung, Meisterwerke englischer Malerei aus drei Jahrhunderten (Vereinigung bildender Künstler Wiener Sezession), Vienna

1929 *English Painting (eighteenth and nineteenth centuries)*, Musée Moderne, Brussels; October–December

1930 *Jubilee Exhibition*, Corporation Art Gallery, Cartwright Memorial Hall, Bradford

1934 *British Art c.1000–1860*, Royal Academy; January–March

The Graham Robertson Collection, Whitechapel Art Gallery; April–May

1935–6 *Desenul și gravura engleză (secolele XVIII–XX)*, Muzeul Toma Stelian, Bucharest

1936 *Two Centuries of English Art*, Stedelijk Museum, Amsterdam; July–October

1937 *Water-colours by Turner, works by William Blake*, Bibliothèque Nationale, Paris; January–February. Albertina, Vienna; March–April

1939 *English Painting, eighteenth and nineteenth centuries* (British Council), Louvre, Paris

1947 *English Romantic Art* (Arts Council), Leeds; May–June. Hull; June–July. Harrogate; July–August. Derby; August–September. Cardiff; September–October. Bristol; October–November

1947 *William Blake* (British Council), Galerie René Drouin, Paris; March–April. Musée Royal des Beaux-Arts, Antwerp; May–June. Kunsthaus, Zurich; June–July. Tate Gallery; August–September

1949 *Original Works by William Blake from the* *Graham Robertson Collection*, College of Art, Bournemouth; April. Art Gallery, Southampton; April–May. Art Gallery, Brighton; May–June

1949–50 *British Painting from Hogarth to Turner* (British Council), Kunsthalle, Hamburg; October–November. Kunsthernes Hus, Oslo; December–January. National museum, Stockholm; January–February. Statens Museum for Kunst, Copenhagen; March–April

William Blake, Lady Lever Art Gallery, Port Sunlight; July–September

1951 *The Tempera Painting of William Blake*, Arts Council Gallery, June–July

1951–2 *The First Hundred Years of the Royal Academy, 1769–1868*, Royal Academy

1956–7 *British Portraits*, Royal Academy

1959 *Treasures of Cambridge*, Goldsmiths' Hall; March–April

1961 *Shakespeare in Art*, Nottingham

1964 *Shakespeare in Art* (Arts Council)

1969 *British Neo-Classicism*, Ickworth

William Blake, Whitworth Art Gallery, Manchester

William Blake, National Library of Scotland, Edinburgh

BIBLIOGRAPHY

William Blake, *A Descriptive Catalogue of Blake's Exhibition* 1809

J. T. Smith, *Nollekens and his Times* (2nd edition 1829, and reprinted 1920, ed. W. Whitten) 1828

Alexander Gilchrist, *Life of William Blake* 1863
new and enlarged edition 1880

A. T. Story, *The Life of John Linnell* 1892
William Blake, his Life, Character and Genius 1893

E. J. Ellis and W. B. Yeats, *Works of William Blake, Poetic, Symbolic and Critical* 1893

Catalogo dei libri posseduti da Charles Fairfax Murray 1899

W. M. Rossetti, *Rossetti Papers* 1903

John Sampson, *The Poetical Works of William Blake* 1905

A. G. B. Russell, *The Letters of William Blake* 1906

E. J. Ellis, *The Real Blake* 1907

Alexander Gilchrist, *Life of William Blake*, ed.
W. Graham Robertson — 1907

Arthur Symons, *William Blake* — 1907

A. G. B. Russell, *The Engravings of William Blake* — 1912

'The Graham Robertson Collection', *Burlington Magazine*, XXXVII, p. 27 ff. — 1920

Sir Geoffrey Keynes, *A Bibliography of William Blake* — 1921

Laurence Binyon, *The Drawings and Engravings of William Blake* — 1922

The Followers of William Blake — 1925

Sir Geoffrey Keynes (ed.), *The Writings of William Blake* — 1925

Darrell Figgis, *The Paintings of William Blake* — 1925

Sir Geoffrey Keynes, *Milton's Poems in English* — 1926

Pencil Drawings by William Blake — 1927

Mona Wilson, *Life of William Blake* (revised 1948) — 1927

Thomas Wright, *The Life of William Blake* — 1929

Laurence Binyon and Sir Geoffrey Keynes, *Illustrations to the Book of Job by William Blake* — 1935

Sir Anthony Blunt, 'Blake's "Ancient of Days"', *Journal of the Warburg Institute*, II, p. 53–63 — 1938–9

E. Marsh, *A Number of People* — 1939

Sir Anthony Blunt, 'Blake's Pictorial Imagination', *Journal of the Warburg and Courtauld Institutes*, VI, p. 190–212 — 1943

Sir Geoffrey Keynes, *Blake Studies* — 1949

Kerrison Preston, *Notes on Blake's Large Painting in Tempera, 'The Spiritual Condition of Man'* (privately printed) — 1949

(ed.), *The Blake Collection of W. Graham Robertson, Described by the Collector* — 1952

Sir Geoffrey Keynes and Edwin Wolf II, *William Blake's Illuminated Books: A Census* — 1953

Joseph Wicksteed, *William Blake's 'Jerusalem'* — 1953

David V. Erdman, *Blake: Prophet against Empire* — 1954

Sir Geoffrey Keynes (ed.), *The Letters of William Blake* — 1956

Pencil Drawings by William Blake, second series — 1956

Engravings by William Blake: the Separate Plates — 1956

Complete Writings of William Blake — 1957

William Blake's Illustrations to the Bible — 1957

V. de Sola Pinto, *The Divine Vision* — 1957

Martin Butlin, *The Works of William Blake in the Tate Gallery* — 1957

'Bicentenary of William Blake', *Burlington Magazine*, C, p. 40–4 — 1958

Sir Geoffrey Keynes, 'William Blake and John Linnell', *Times Literary Supplement*, 13 June — 1958

Sir Anthony Blunt, *The Art of William Blake* — 1959

S. Foster Damon (ed.), *Blair's Grave: A Prophetic Book* — 1963

G. E. Bentley, Jr., *A Blake Bibliography* — 1964

Sir Geoffrey Keynes, *William Blake: Poet, Printer, Prophet* — 1964

S. Foster Damon, *Blake Dictionary* — 1965

D. V. Erdman (ed.), *The Poetry and Prose of William Blake* — 1965

Martin Butlin, *William Blake* (Tate Gallery) — 1966

S. Foster Damon (ed.), *Blake's Job* — 1966

G. E. Bentley, Jr., *Tiriel* — 1967

R. Lister, *William Blake* — 1968

David Bindman, 'William Blake as a Painter', *Encyclopaedia Britannica* — 1968

Kathleen Raine, *Blake and Tradition* — 1968

Sir Geoffrey Keynes, *Letters of William Blake* — 1968

A. H. Rosenfeld (ed.), *William Blake: Essays for S. Foster Damon* — 1969

Martin Butlin, *The Blake–Varley Sketchbook* — 1969

G. E. Bentley, Jr., *Blake Records* — 1969

4

The Fitzwilliam is fortunate in possessing two of the most important works of Blake's early period: the *Story of Joseph* watercolours and the original manuscript of the satire known as *An Island in the Moon*. The *Story of Joseph* watercolours were exhibited at the Royal Academy in 1785, and they show the influence of James Barry and other British Neoclassical artists in their monumental forms[1] and classical references, while the watercolour of *Queen Katherine's Dream* shows something of the decorative strain in his earlier work that flowers in the *Songs of Innocence* and *The Book of Thel*. *An Island in the Moon* is the longest piece of writing to have survived from the period between the publication of the *Poetical Sketches* in 1783 and the manuscript of *Tiriel* (British Museum) of *c.* 1788–9. *Tiriel* is represented in the collection by one of twelve pen and wash illustrations that were dispersed in 1863.

NOTE

1 See Blunt, 1959, p. 11.

I THE STORY OF JOSEPH—three designs

Not signed or dated, *c.* 1784–5.

Indian ink and watercolour over pencil; faded and paper damaged in some areas.

A. JOSEPH'S BRETHREN BOWING DOWN BEFORE HIM

 Genesis clii. 6–8 *Plate 1*

 $15\frac{7}{8} \times 22\frac{1}{8}$ ($40 \cdot 3 \times 56 \cdot 2$)

B. JOSEPH ORDERING SIMEON TO BE BOUND

 Genesis xlii. 24 *Plate 2*

 $15\frac{15}{16} \times 22\frac{1}{16}$ ($40 \cdot 5 \times 56$)

C. JOSEPH MAKING HIMSELF KNOWN TO HIS

 BRETHREN *Plate 3*

 Genesis xlv. 1–3

 $15\frac{15}{16} \times 22\frac{1}{16}$ ($40 \cdot 5 \times 56 \cdot 1$)

 Purchased 1900. 456A–C.

Coll.: First owner or owners not known;[1] Walter E. Tiffin, his sale Sotheby's, 29 February–9 March 1860 (9th day) (1826), bt. by Palser for J. H. Chance;[2] Lord Coleridge by 1862; Anne, Lady Coleridge, Christie's, 12 December 1898 (62, 63 and 64); bt. by Dunthorne (for 11 gns.); purchased from them (for £55).

Exh.: R.A., 1785 (A: 455, B: 462, C: 449); London, 1862 (965); B.F.A.C., 1876 (A: 9, B: 54, C: 37); Tate, 1913 (A only: 6); R.A., 1951–2 (A: 522, B: 517, C: 526)

Lit.: Gilchrist, 1863, I, p. 56, II, p. 202, cat. nos. 7, 8 and 9; also 1880 and 1907 editions; Erdman, 1954, p. 90, n. 19; Keynes, *Bible*, 1957, p. 6; Blunt, 1959, p. 11, n. 27; Damon, 1965, p. 224, *Joseph*; Bentley, 1967, p. 14.

Mr S. Foster Damon sees the theme of the three paintings as the Forgiveness of Sin, and Joseph as a symbol of the Sacrifice of the Innocent.[3] Bentley sees parallels between the Story of Joseph drawings and the theme of Tiriel.[4] The immediate source for the

designs is probably to be found in Blake's engraving after Raphael's *Joseph and his Brethren* from the Loggie, for the *Protestant's Family Bible*, 1780–2. The gestures of the figure of Joseph in all three water-colours seem to be derived from classical prototypes, although it is not clear whether they were known to Blake through engravings after the Antique or after Italian paintings of the Renaissance or later. The figure of Joseph in C, with outstretched arms, seems to go back to a Niobe figure that reappears frequently in fourteenth-century Italian painting as a lamenting Magdalen in an Entombment, while Joseph's gesture of lifting his cloak to veil his face in A may be derived from a common gesture in Graeco-Roman art also associated with veiling the face.[5] The rather empty grandeur of the figures in these watercolours (particu-larly if compared with the slender forms of *Queen Katherine's Dream*, cat. no. 2) suggests that Blake was deliberately attempting a more elevated style, presumably under the influence of James Barry's wall-paintings at the Adelphi which Blake was known to have admired.

A double-sided sheet at Windsor Castle of (recto) *Joseph discovering himself* and (verso) *Benjamin accepted as a hostage* is preparatory to the Fitzwilliam watercolours,[6] and a watercolour sketch of *Joseph ordering Simeon to be bound* is in the collection of Mrs Arthur Moberly.

NOTES

1 According to Gilchrist, writing about 1860: 'The three *Joseph* drawings turned up within the last ten years in their original close rose-wood frames (a far from advantageous setting), at a broker's in Wardour Street, who had purchased them at a furniture-sale in the neighbourhood' (Gilchrist, 1863, I, p. 57).

2 J. H. Chance was John Linnell's nephew. See letter from Chance to John Linnell, 12 March 1860, in the possession of Miss Joan Linnell Ivimy. Photocopy kindly given by Sir Geoffrey Keynes.

3 Damon, 1965, p. 223–4, *Joseph*.

4 Bentley, 1967, p. 14–15.

5 I am indebted to Dr John Barron for his advice on classical prototypes.

6 Pen and grey wash, $13\frac{1}{4} \times 17\frac{7}{8}$ (33·5 × 45·5), inv. no. 13599; see A. P. Oppe, *The English Drawings at Windsor Castle*, 1950, p. 27, no. 65, figs. 7 and 8; also reproduced in Keynes, *Bible*, 1957, pl. 32a and b.

2 QUEEN KATHERINE'S DREAM *Plate 4*

Inscr. 'W B' (b.r.), but probably not by the artist. Not dated, *c.* 1783–90.

Pen, Indian ink, grey wash and watercolour over some pencil; $8 \times 6\frac{3}{8}$ (20·3 × 16·1)

Purchased 1935. 1771.

Coll.: Samuel Prince;[1] his sale Sotheby's, 11–14 December 1865 (1st day) (276); bt. Halstead (for £4); Rev. Stopford A. Brooke;[2] his sale, Sotheby's, 12 December 1935 (621), bt. by Maggs; purchased from them (for £120).

Exh.: B.F.A.C., 1876 (29); Whitechapel, 1906 (95); Carfax, 1906 (52); Tate, 1913 (47).

Lit.: Gilchrist, 1863, II, p. 238, cat. no. 226; also 1880 and 1907 eds; Butlin, *Burl. Mag.* C, 1958, p. 42; W. M. Merchant, *Shakespeare and the Artist*, 1959, p. 85.

Reprod.: W. M. Merchant, *Shakespeare and the Artist*, 1959, plate 33.

Although the subject is the same as cat. no. 27 it is much earlier in date. It certainly belongs to the 1780s, and probably to the second half of the decade. It is less

monumental than the *Oberon, Titania and Puck with fairies dancing* (Tate Gallery) which Butlin sees as close in date to the Fitzwilliam *Story of Joseph* series exhibited at the Royal Academy in 1785,[3] and it has something in common with the decorative style of *Songs of Innocence* and the *Book of Thel* of 1789. The subject is taken from Shakespeare's *Henry VIII*, act 4, scene 2.[4]

NOTES

1 The early provenance is problematic. A watercolour of *Queen Katherine's Dream* appeared as lot 137 in the Butts sale, Foster's, 29 June 1853, described as 'very fine', and was bought by H. G. Bohn for £2 17s 6d, but it cannot be positively identified as cat. no. 2, and it is unlikely that Butts would have owned such an early drawing.

 Gilchrist, 1863, II, p. 238, cat. 226, describes a watercolour belonging to Mr Chance, London Street, Fitzroy Square (London) that may possibly be identified with cat. no. 2, as follows: 'A Recumbent Figure, hovered over by Angels. Delicate in glow of colour: the composition very characteristic and spiritual.' J. H. Chance was John Linnell's nephew (see entry for cat. no. 1).

2 Exhibited as his property at B.F.A.C. exhibition, 1876.

3 Butlin, 1957, p. 34, no. 3, plate 2.

4 'THE VISION. Enter, solemnly tripping one after another, six personages clad in white robes, wearing on their heads garlands of bays, and golden vizards on their faces; branches of bays or palm in their hands. They first congee unto her, then dance; and, at certain changes, the first two hold a spare garland over her head; at which the other four make reverent courtesies: then the two that held the garland deliver the same to the other next two, who observe the same order in their changes, and holding the garland over her head: which done, they deliver the same garland to the last two, who likewise observe the same order: at which—as it were by inspiration—she makes in her sleep signs of rejoicing, and holdeth up her hands to heaven: and so in their dancing they vanish, carrying the garland with them.'

3 HAR AND HEVA BATHING: MNETHA LOOKING ON *Plate 5*

No signature or date, c. 1785–9.

Point of the brush, Indian ink, grey wash; $7\frac{1}{4} \times 10\frac{3}{4}$ ($18 \cdot 1 \times 27 \cdot 3$)

Bequeathed by Sir Edward Howard Marsh, K.C.V.O., C.B., C.M.G., through the National Art-Collections Fund, 1953. PD.13—1953.

Coll.: Possibly from the collection of Frederick Tatham (d. 1878); Joseph Hogarth; his sale, Southgate and Barrett's, 8 June 1854 (643),[1] bt. by Morley (probably for E. Bicknell); Bicknell sale, Christie's, 1 May 1863 (381), bt. by Herbert P. Horne (d. 1916) (for 9s); acquired by Edward Marsh (through Carfax Gallery) in 1904.[2]

Exh.: Carfax, 1904 (28); Whitechapel, 1906 (69); Grafton, 1911 (196); N.G.B.A., 1913 (60); Manchester, 1914 (65); Nottingham, 1914 (50); Edinburgh, 1914 (80); B.F.A.C., 1916 (82); B.F.A.C., 1927 (53); Vienna, 1927 (212); Bradford, 1930 (346); R.A., 1934 (1155); Comm. Cat., 1934 (700); Bucharest, 1935–6 (26); Paris, 1937 (3); Vienna, 1937 (3); Paris, 1947 (35); Antwerp, 1947 (35); Zürich, 1947 (35); Tate, 1947 (35); Hamburg, 1949 (2); Oslo, 1949 (2); Stockholm, 1950 (2); Copenhagen, 1950 (2).

Lit.: Gilchrist, 1863, II, p. 254, cat. no. 156E; also 1880 and 1907 editions; Keynes, *Bibliography*, 1921, p. 24, repr.; *Writings*, 1957, p. 99–110; Blunt, 1943, pp. 194, 203; Bentley, 1967, pp. 20, 21, 23, 24, 28, 33; Butlin, *Burl. Mag.*, c. 1958, p. 40–4; K. Raine, *Huntington Library Quarterly*, XXI, November 1957, p. 19–20; Raine, 1968, p. 52–3.

The subject is one of twelve drawings[3] illustrating the

symbolic poem *Tiriel* normally dated 1788–9.[4] It shows Har and Heva sitting naked in a shallow stream, while Mnetha lies on the bank watching them. The drawing does not correspond exactly to any passage in the text of *Tiriel*, but Bentley suggests that it may refer to lines 59–60, p. 3: 'They were as the shadow of Har and as the years forgotten. / Playing with flowers and running after birds they spent the day.'[5]

For an amusing comment by Edward Marsh on the elongated figure of Mnetha, see his autobiography, *A Number of People*.[6]

Mr Malcolm Cormack has suggested a derivation of the figure of Mnetha from figures by Pellegrino Tibaldi in Bologna.[7] The figures of Har and Heva may be derived from James Barry's *Jupiter and Juno on Mount Ida* (Sheffield Art Gallery).[8]

NOTES

1 Joseph Hogarth's sale, 7–30 June 1854, lot 643: 'Twelve elaborate subjects designed to illustrate a work, the subject unknown . . .' Set sold for £3.

2 Marsh acquired the whole of the Horne collection of English water-colours for £2,400. See C. Hassall, *Edward Marsh*, 1959, p. 112.

3 The other *Tiriel* drawings are distributed as follows (following Bentley's numbering): 1. Gwen, Lady Melchett coll., London; 2. Fitzwilliam; 3. Untraced since 1863; 4. British Museum Print Room; 5. Untraced since 1863; 6. Gwen, Lady Melchett coll., London; 7. Victoria and Albert Museum; 8. Sir Geoffrey Keynes coll.; 9. Untraced; 10. Mrs Louise Y. Kain, Louisville, Kentucky; 11. Sir Geoffrey Keynes; 12. T. Edward Hanley, Bradford, Pa.

4 Dated 1789 by Blunt (Blunt, 1959, p. 11, n. 29) and to the same year, but with reservations, by Bentley (*op. cit.*).

5 Bentley, 1967, p. 33.

6 P. 353: 'When visitors have had their fill of reverent gazing, I sometimes relax the tension by quoting *Alice*: "All persons more than a mile high to leave the Court." "I'm not a mile high," said Alice indignantly. "You are," said the King. "Nearly two miles high," added the Queen.'

7 See, for example, G. Briganti, *Il Manierismo e Pellegrino Tibaldi*, 1945, figs. 144–5, and for the influence of Tibaldi on Blake see Blunt, 1938, p. 53 ff., and Blunt, 1959, p. 35.

8 Reprod. *Romantic Art in Britain*, Philadelphia, cat. 1968, p. 117. See Butlin's review of the exhibition in *Master Drawings*, 1968, p. 279.

4 AN ISLAND IN THE MOON *Plates 6 & 7*

c. 1784–5

Holograph MS in Blake's early hand. A quire of 16 leaves, lacking two, or perhaps four, leaves from the centre. Size of leaf: $12\frac{1}{4} \times 7\frac{1}{4}$ (31 × 18·5). Watermark resembles 'Churchill 216'; countermark resembles 'Churchill 213'.[1] Bound in red morocco.

The MS begins at the head of the first leaf, recto, and ends at line 19 of the ninth leaf, recto; seven leaves at the end are blank except for the last leaf, verso, which is covered with rough pen-and-ink sketches by Blake of horses' heads, two groups of a lion and a lamb lying down together, heads of the lamb, and human profiles, with trials of signatures and the beginning of one in reverse, scattered letters and the word 'Numeration' written in full. Four fly-leaves have been added at the beginning and two at the end; on the third and fourth of these are mounted a letter from A. H. Palmer, and a sheet of woodcuts for Thornton's *Pastorals of Virgil* signed by Blake (see cat. no. 36(1)).

Given by Charles Fairfax Murray (d. 1919) in 1905.

Coll.: Early ownership not known; Fairfax Murray by 1893.

Lit.: *The Light Blue*, II, 1867, p. 146–51; Ellis and Yeats, 1893, I, p. 186 ff.; Sampson, 1905, p. 50–2; Ellis, 1907, p. 66–85; Keynes, *Bibliography*, 1921, p. 21–3, cat. no. 2; *Writings*, 1957, pp. 44–63, 884; Blunt, 1959,

p. 47; Erdman, 1954, p. 83–104; Martha W. England, 'The Satiric Blake: apprenticeship at the Haymarket?', pt. I, p. 440–64, *Bulletin of the New York Public Library*, September 1969.

Reprod.: Ellis, 1907, two pages in facsimile (reduced), between p. 80 and p. 81.

The title is taken from the first sentence of the MS, none having been supplied by Blake. The subject is a satire in the form of a burlesque novel, introducing various contemporary figures, including the author, under facetious pseudonyms. First drafts of several of the *Songs of Innocence* are found among the passages in verse.

David Erdman dates the *Island in the Moon* to the latter part of 1784 on the basis of a reference to 'Balloon hats', which were apparently only in fashion for a few months at the time of Lunardi's balloon ascent in London in September 1784.[2] There is also a reference to 'Robinsons', which may have been a reference to 'Perdita' Robinson, the actress, whose fashionable career came to an end at the close of 1784. Keynes suggests 1784–5 as the most likely date.[3]

The early history of the manuscript is unknown,[4] but Keynes has argued that a manuscript mentioned by Mrs Gilchrist in a letter of 1863 to W. M. Rossetti as in her possession, is the *Island in the Moon*.[5] Mrs Gilchrist describes it as 'a long thing which I really believe even Mr Swinburne will pronounce pure rubbish'. W. M. Rossetti commenting on the letter describes the manuscript as follows:

'The "long thing" by Blake, which Mrs Gilchrist regarded as "pure rubbish", was a prose narrative of a domestic, and also fantastic, sort, clearly intended by its author to count as humouristic or funny, and somewhat in the Shandean vein. I read this performance, and heartily confirmed Mrs Gilchrist in the conviction of its being rubbish; yet I was startled to learn soon afterwards that, on receiving my letter, she had burned the MS. The thing was stupid, but it was Blake's, and a curiosity.'[6]

It is possible that Mrs Gilchrist had only destroyed the missing leaves in the middle. Bentley feels that there is not enough evidence to allow the *Island in the Moon* to be identified with Mrs Gilchrist's manuscript, but W. M. Rossetti's description seems reasonably conclusive. The first unequivocal mention of the manuscript was in 1893,[7] when it was already in the possession of C. Fairfax Murray.

A full and accurate text, with deletions, can be found in the 1957 edition of Keynes, *Writings*, while the most detailed interpretation of the work and its references to Blake's contemporaries, can be found in David Erdman, *Blake: Prophet against Empire*, 1954, p. 83–104.

An early drawing in the Lessing J. Rosenwald collection, Jenkintown, Pa., of seven figures seated in a semicircle, in contemporary dress, may be connected with the *Island in the Moon*.[8]

NOTES

1 See W. A. Churchill, *Watermarks in paper in the XVII and XVIII Centuries*, 1935.

2 See Erdman, 1954, p. 87–8. Also Erdman, 1965, p. 766 (December 1784 or slightly later).

3 See Keynes, *Writings*, 1957, p. 884.

4 *The Lawgiver's song* from the *Island in the Moon* is quoted in *The Light Blue*, a Cambridge magazine, for 1867. Three articles on Blake in the same magazine are signed 'P.M.', and the author shows familiarity with watercolours owned by John Linnell.

5 W. M. Rossetti, 1903, p. 42.

6 W. M. Rossetti, 1903, p. 41–2.

7 Ellis and Yeats, 1893, I, p. 186–7.

8 Pen and grey wash, over pencil underdrawing, approx. 28 × 35 cm.

The period from Blake's original 'stereotype' of 1788 until the publication of his engraved edition of Young's *Night Thoughts* in 1797 was one of continued experiment with the problems of printing.[1] The Fitzwilliam collection of Illuminated Books is by no means complete, but it contains a number of printings of extremely high quality. The early printings of the Illuminated Books, in which each page has the text and design integrated on one copper-plate, are usually only lightly added to in pen and watercolour, while the later printings of the Illuminated Books are notable for a greater intervention by Blake in strengthening the outlines in pen, and in elaboration of colour. *The Book of Thel*, for example, is an early printing, probably before 1794, and it is tinted delicately in transparent washes.[2] The two versions of *The Marriage of Heaven and Hell* (designed *c.* 1790–3) were printed between 1815 and 1821 (cat. no. 9), and after 1825 (cat. no. 10) respectively, and they are richly painted with watercolours and heightened with gold, while the lettering in the case of cat. no. 9 has been strengthened with pen and brought out in watercolour.

The two versions of the *Songs of Innocence and of Experience* were both printed some years after they were designed, cat. no. 5 between 1802 and 1808, and cat. no. 6 between 1815 and 1826, but they vary greatly from each other in the arrangement of the plates and in the colours used. In the letter to George Cumberland of 12 April 1827 (cat. no. 42) Blake reveals that in his last years he did not keep a stock of Illuminated Books, but printed them on demand: 'You are desirous I know to dispose of some of my Works & to make them Pleasin(g). I am obliged to you & to all who do so. But having none remaining of all that I had printed I cannot Print more Except at a great loss, for at the time I printed those things I had a whole House to range in; now I am shut up in a Corner therefore am forced to ask a Price for them that I scarce expect to get from a Stranger.' The remarkably fine copies of *America* and *Europe*, printed and illuminated for John Linnell, can be contrasted with the posthumous printings of the same works by Frederick Tatham, who acquired Blake's copper plates as Mrs Blake's executor. The quality of these late printings is harsh and unpleasant.[3]

The large colour prints, some of which are dated 1795, are represented by a version of *The Lazar House*, which has been heavily strengthened in all details in pen and body colour and varies considerably from the better-known version in the Tate Gallery.

Blake's continuing use of conventional engraving methods in this period of experiment is illustrated by the two fine prints of *Job* and *Ezekiel*, which came by descent to Mr E. M. Forster who presented them to the Fitzwilliam, and by a copy of Young's *Night Thoughts*, the product of an unsuccessful attempt to launch Blake as a popular designer.

NOTES

1 For a detailed discussion of Blake's experiments in printing see Keynes, *Poet, Printer, Prophet*, 1964, and an article by Ruthven Todd on 'The Techniques of William Blake's Illuminated Printing', *Print Collector's Quarterly*, XXIX, November 1948, p. 25–36. For a description of the monotype process see Butlin, 1957, p. 38–9 and in *Essays for Foster Damon*, 1969.

2 For an analysis of all surviving copies of Blake's illuminated books see Keynes and Wolf, *Census*, 1953.

3 A great number of books have been written discussing the

Illuminated Books in the light of their prophetic content, so it would be impossible to list more than a tiny proportion. For a detailed bibliography of writings about Blake see Bentley, 1964.

The first scholarly analysis of the Illuminated Books, S. Foster Damon's *William Blake, His Philosophy and Symbols*, 1924, is still an indispensable introduction, while David Erdman's *Blake: Prophet against Empire*, 1954, gives an invaluable background to the circumstances of their composition. *The Poetry and Prose of William Blake*, ed. by David Erdman, 1965, contains a commentary on all the Illuminated Books by Harold Bloom. The Blake Trust, through the Trianon Press, has produced excellent facsimiles of the more important Illuminated Books.

5 SONGS OF INNOCENCE AND OF EXPERIENCE

Designed 1789–94.

Relief etchings, finished in pen and watercolour, on paper with watermarks 'I TAYLOR 1794' and, in one leaf, 'J WHATMAN 1808'. Size of leaf $11\frac{13}{16} \times 8\frac{1}{2}$ (30 × 21·5). Plate size about $4\frac{1}{2} \times 2\frac{1}{4}$ (11·5 × 7). 54 plates on 54 leaves. Printed in grey-green, and elaborately painted in watercolour, with outlines strengthened in pen by Blake himself. Framing lines in Indian ink around each plate. General title-page inscribed by Blake 'Title-Page'. Plate numbers added by Blake himself. Bound in white vellum, one fly-leaf with watermark dated 1824.

Bequeathed by T. H. Riches in 1935, received 1950. P.124—1950.

Coll.: John Linnell (d. 1882), who bought it from Blake in 1819 (for £1 19s 6d);[1] his son, William Linnell (d. 1906);[2] his daughter, Mrs T. H. Riches (d. 1950).

Lit.: Gilchrist, 1863, I, pp. 68–75, 119–26; II, pp. 25–70, 261–2; also in 1880 and 1907 editions; Keynes, *Bibliography*, 1921, pp. 114–18, 122, copy K; Keynes, *Census*, 1953, pp. 50–5, 62, copy R.

This copy belongs to a group of four copies executed, according to Keynes and Wolf, in the years 1802–8. The arrangement of the plates is different from that in other copies of the same period.[3]

NOTES

1 The receipt reads as follows: 'August 27, 1819 / Receiv'd One Pound Nineteen & Sixpence of Mr. Linnell / for Songs of Innocence & Experience. / One Copy / William Blake / 1/19/6'. The receipt was formerly in the collection of John Linnell and is now in the library of Yale University, U.S.A. (see Keynes, *Letters*, 1968, pp. 142, 205, no. 118).

2 See note on fly-leaf reading 'Given to William Linnell / by John Linnell Senʳ April 28 1863'.

3 The plates in this copy have been correlated against a MS index in Blake's hand (see Keynes, *Letters*, 1968, p. 140–1, no. 113) and are in the following order: 1–4, 8, 5–7, 10, 11, 19, 20, 26, 27, 12, 15, 16, 21, 18, 22, 23, 50, 13, 14, 17, 9, 45, 24, 25, 28–31, 38, 40, 35–7, 53, 32, 43, 33, 42, 34, 46, 47, 39, 51, 54, 49, 41, 44, 52, 48.

6 SONGS OF INNOCENCE AND OF EXPERIENCE

Designed 1789–94.

Relief etchings, finished in pen and watercolour, on paper varying in size from $7\frac{1}{4} \times 6\frac{1}{4}$ (18·4 × 15·8) to $5\frac{1}{4} \times 4\frac{1}{4}$ (13·3 × 10·3); plate size, approx. $4\frac{1}{2} \times 2\frac{1}{4}$ (11·5 × 7). 54 plates on 54 leaves (foliated by Blake 1–54). Printed in orange-red, and elaborately painted in watercolour, with outlines strengthened in pen by Blake himself. Each plate has framing line in orange-red. The leaves are now mounted on larger leaves and bound in red cloth.

Bequeathed by T. H. Riches in 1935, received 1950. P.125—1950.

Coll.: Mrs Eliza Aders,[1] who bought it from Blake in 1826;[2] bought by John Linnell (d. 1882); his son, James Thomas Linnell (d. 1905);[3] Linnell sale, Christie's, 15 March 1918 (215); bt. by Messrs. Carfax for T. H. Riches (for £735); Mrs T. H. Riches (d. 1950).

Exh.: B.F.A.C., 1927 (78).

Lit.: Keynes, *Bibliography*, 1921, pp. 114–18, 125, copy R; Keynes, *Census*, 1953, pp. 50–5, 66, copy AA.

One of a group of eight copies, according to Keynes and Wolf, dating from the years 1815–26.[4]

NOTES

1 Mrs Aders, the daughter of Raphael Smith the mezzotint engraver, was married to Charles Aders, a Hamburg merchant who owned a fine collection of paintings by early Northern masters. They lived at Euston Square and there entertained many artists and literary men.

2 A receipt from the collection of John Linnell and now in the library of Yale University reads as follows: 'Recieved [*sic*] 29 July 1826 of Mrs Aders by the hands of / Mr Linnell the Sum of Five Pounds Five Shillings for the Songs of Innocence. / William Blake/ £5/5/0'. (See Keynes, *Letters*, 1968, pp. 158, 211, no. 139 as £2.5.0.) This copy was probably bought by John Linnell from Mrs Aders for six guineas shortly after 8 August 1835 (see Bentley, *Records*, 1969, p. 583, n. 1).

3 A note on the fly-leaf reads: 'Given to James Thos Linnell Senr April 28 1863'.

4 The plates in this copy have been correlated against a MS index in Blake's hand (see Keynes, *Letters*, 1968, p. 140–1) and are in the following order:
1–4, 8, 5–7, 10, 11, 19, 20, 26, 27, 12, 15, 16, 21, 18, 22, 23, 13, 14, 17, 9, 24, 25, 28–31, 38, 40, 35–7, 53, 32, 43, 33, 42, 34, 46, 47, 39, 51, 54, 49, 41, 48, 52, 44, 50, 45.

7 ELECTROTYPES OF PLATES OF SONGS OF INNOCENCE AND OF EXPERIENCE

Electrotypes of 16 copper-plates, comprising seven from *Songs of Innocence*: title-page, The Echoing Green, The Lamb, A Cradle Song, The Divine Image, Nurse's Song, On Another's Sorrow; and nine from *Songs of Experience*: title-page, Holy Thursday, The Little Girl Lost (2), My Pretty Rose Tree, London, The Human Abstract, Infant Sorrow, The School Boy.

Deposited by Sir Geoffrey Keynes, 1942. A duplicate set made from those in the possession of Messrs Clay and Son of Bungay.

Lit.: Keynes, *Blake Studies*, 1949, p. 107–9.

8 THE BOOK OF THEL

Designed in 1789.

Relief etchings, printed in blue, finished in watercolour, on paper; some lines strengthened in pen. No watermark. Size of leaf $11\frac{13}{16} \times 9\frac{1}{4}$ ($30 \times 23 \cdot 5$); plate size approx. $6\frac{1}{8} \times 4\frac{1}{4}$ ($15 \cdot 5 \times 10 \cdot 7$), except plate 1, which measures $2\frac{3}{8} \times 4$ ($6 \times 10 \cdot 1$). 8 plates on 8 leaves. Bound in modern dark green morocco; gilt.

Given by Charles Fairfax Murray in 1912.

Coll.: Earlier history not known.[1] First mentioned in Fairfax Murray's collection in 1899.

Lit.: Gilchrist, 1863, I, p. 76–8; II, pp. 71–5, 261; also 1880 and 1907 editions; *Catalogo*, 1899, p. 16 (no. 141); Keynes, *Bibliography*, 1921, pp. 103–4, 105, copy E; Keynes and Wolf, 1953, p. 23, copy G.

Reprod.: In colour microfilm by Micro Methods Ltd.

Blake or his wife coloured at least 12 copies in the years 1789–94 of which this is one; two others were done in 1815 or soon after.

NOTE

1 Prof. G. E. Bentley, Jr., has suggested that the present copy might in fact be Keynes and Wolf copy P, which was sold anonymously at Sotheby's, 2 July 1895, lot 502 (£14) to Ellis and offered in Ellis and Elvey Catalogues 81 and 82 (?1895) for £31 10s.

9 THE MARRIAGE OF HEAVEN AND HELL, AND A SONG OF LIBERTY

Designed c. 1790–3.

Relief etchings, finished in pen and watercolour. No watermark. Size of leaf $8 \times 5\frac{1}{4}$ (20·3 × 13·2); plate size variable between $6\frac{1}{2} \times 4$ and $5\frac{1}{4} \times 4$ (16·5 × 10·2 and 13·3 × 10·2). 27 plates on 15 leaves. Printed mainly in red, and richly painted with watercolours, heightened with gold; parts of the text illuminated with bright tints. Plate numbers added by Blake in red. In contemporary binding of vellum; gilt.

Bequeathed by T. H. Riches in 1935, received 1950. P.123—1950.

Coll.: John Linnell (d. 1882), who bought it from Blake in 1821 (for 2 gns.);[1] the Linnell Trustees; John Linnell sale, 15 March 1918 (195); bt. by Messrs. Carfax for T. H. Riches (for 720 gns.); Mrs T. H. Riches (d. 1950).

Exh.: N.G.B.A., 1913 (90); Manchester, 1914 (146); Nottingham, 1914 (116); Edinburgh, 1914 (Case A 6, p. 22); B.F.A.C., 1927 (74); Edinburgh, 1969 (35).

Lit.: Gilchrist, 1863, I, p. 78–89; II, p. 261; also 1880 and 1907 editions; Keynes, *Bibliography*, 1921, pp. 107–10, 112, copy I; Keynes and Wolf, 1953, p. 38–9, copy H.

This copy was probably produced between 1815 and 1821.[2]

NOTES

1 The receipt, reading 'Receivd April 30: 1821 of Mr Linnell the Sum of Two Guineas for Heaven & Hell / Willm Blake / £2.2.0', was formerly in the coll. of John Linnell and is now in the library of Yale University, U.S.A. (Keynes, *Letters*, 1968, pp. 143, 205–6, no. 121).

2 The plates in this copy, following Keynes and Wolf, are arranged in the following order: 1–11, 15, 14, 12–13, 16–27.

10 THE MARRIAGE OF HEAVEN AND HELL, AND A SONG OF LIBERTY

Designed c. 1790–3.

Relief etchings, finished in pen and watercolour, on paper with watermark 'J WHATMAN 1825'; size of leaf $12 \times 9\frac{1}{8}$ (30·5 × 23·2 cm); plate size varies between $6\frac{1}{2} \times 4$ and $5\frac{1}{4} \times 4$ (16·5 × 10·2 and 13·3 × 10·2). 27 plates on 27 leaves. Printed in brick-red, and richly painted with watercolours, heightened with gold. Each plate surrounded by a single painted line. Plate numbers added by Blake in red. The leaves mounted on guards in half-leather binding.

Bequeathed by the Rev. Richard Edward Kerrich in 1872.[1]

Coll.: Possibly T. G. Wainewright;[2] Rev. R. E. Kerrich by 1856.

Lit.: *Century Guild Hobby Horse*, II, 1887, p. 135–57; Keynes, *Bibliography*, 1921, pp. 107–10, 112, copy H; Keynes and Wolf, *Census*, 1953, pp. 33–6, 39, copy I.[3]

Reprod.: In facsimile, with a note by Max Plowman. J. M. Dent, 1927.

This copy, executed not before 1825, is the last known copy produced by Blake.

NOTES

1 With his signature on the fly-leaf: 'Richard Edward Kerrich / August 31" 1856'.

2 Wainewright asked Linnell for a coloured copy of the *Songs of Innocence* and *The Marriage of Heaven and Hell* in 1827 and this could be the present version (Bentley, *Records*, p. 339). Thomas Griffiths Wainewright (1794–1852) was an acquaintance and admirer of Blake. He was a painter and literary journalist but achieved his greatest notoriety as a poisoner. He was deported to Australia in 1837 for forgery.

3 Arranged in the same order as the previous copy (cat. no. 9). See also cat. no. 9 for further bibliography.

11 THE MARRIAGE OF HEAVEN AND HELL

(A fragment)

Designed *c.* 1790–3

Relief etchings. Paper without watermark; size of leaf $9\frac{1}{2} \times 5\frac{5}{8}$ ($24 \times 14 \cdot 2$); plate size variable between $6\frac{1}{2} \times 4$ and $5\frac{1}{4} \times 4$ ($16 \cdot 5 \times 10 \cdot 2$ and $13 \cdot 3 \times 10 \cdot 2$). 4 plates (nos. 21–4) on 2 leaves. Printed in black, uncoloured. Bound in black morocco by Rivière.

Given by Charles Fairfax Murray (d. 1919) in 1912.

Coll.: Henry Crabb Robinson; given to E. W. Field; who gave it to Sir Frederick Burton (1816–1900); bequeathed by him to C. F. Murray.[1]

Exh.: Edinburgh, 1969 (36).

Lit.: Keynes, *Bibliography*, 1921, pp. 107–10, 112, copy K; Keynes and Wolf, *Census*, 1953, pp. 33–6, 39, copy K (for further bibliography see cat. no. 9).

Probably trial proofs. The design is omitted from pl. 24.

NOTE

1 These leaves were found loose by C. F. Murray in the cover of *Songs of Innocence and of Experience*, bequeathed to him by Sir Frederick Burton in 1900. This copy is now in the Lessing J. Rosenwald collection, Library of Congress, Washington, D.C. (See Keynes and Wolf, 1953, p. 65–6, copy Z.)

12 VISIONS OF THE DAUGHTERS OF ALBION

Designed 1793.

Relief etchings, finished in pen and watercolour, on paper with watermark 'RUSE & TURNERS 1815'; size of leaf $11\frac{1}{16} \times 9$ ($28 \times 22 \cdot 8$); size of plate approx. $8\frac{3}{4} \times 6\frac{3}{4}$ ($22 \cdot 2 \times 17 \cdot 1$). 11 plates on 11 leaves. Printed in red-brown; elaborately painted with watercolours. Each plate with a framing line painted in red-brown. Plate numbers 1–11 added by Blake (plates 2, 3, 5, 7 of text are numbered on the plates in the earlier copies). Bound in modern straight-grained maroon morocco gilt.

Bequeathed by T. H. Riches in 1935, received 1950. P.126—1950.

Coll.: Formerly bound with *The Book of Thel*[1] and *The Marriage of Heaven and Hell*;[2] sold at Sotheby's, 17 February 1890 (301); bt. by Robson (for £120); it was then divided up, and the *Visions of the Daughters of Albion* was sold to Alexander Mackay (for £60); Mrs A. Mackay's sale, Christie's, 26 April 1921 (5); bt. by T. H. Riches (for £260); Mrs T. H. Riches (d. 1950).

Exh.: B.F.A.C., 1927 (79).

Lit.: Gilchrist, I, p. 104–9; II, p. 261; also 1880 and 1907 editions; Keynes, *Bibliography*, 1921, pp. 129–30, 132, copy N; Keynes and Wolf, *Census*, 1953, copy P.

Blake is known to have completed seventeen copies, of which twelve were done with simple colouring probably in the years 1793–5 or soon after; three copies were done with more elaborate colouring in 1815 or soon after, of which this is one.

NOTES

1 See Keynes and Wolf, *Census*, 1953, p. 24, copy N. This copy is now in the collection of John J. Emery, Cincinnati.

2 See Keynes and Wolf, *Census*, 1953, p. 38, copy G; this copy is now in Harvard College Library.

13 AMERICA, A PROPHECY

Designed in 1793.

Relief etchings, finished in pen and watercolour, on paper with watermarks 'J WHATMAN 1818' and '(ditto) 1820'. Size of leaf $12 \times 9\frac{5}{16}$ ($30 \cdot 4 \times 23 \cdot 6$); size of plate approx. $9\frac{1}{2} \times 6\frac{3}{4}$ ($24 \cdot 1 \times 17 \cdot 1$). 18 plates on 18 leaves. Printed in orange-red. Richly painted with watercolours, heightened with gold. Each plate with a framing line in red. Plate numbers 1–18 added by Blake in black.[1] Bound in vellum with *Europe, a Prophecy* (cat. no. 15).

Bequeathed by T. H. Riches in 1935, received 1950. P.127–1950.

Coll.: John Linnell (d. 1882);[2] the Linnell Trustees; John Linnell sale, 15 March 1918 (172); bt. by Messrs Carfax for T. H. Riches (for 750 gns.); Mrs T. H. Riches (d. 1950).

Exh.: Tate, 1913 (96); Manchester, 1914 (145); Nottingham, 1914 (122); Edinburgh, 1914 (Case A 3, p. 22); B.F.A.C., 1927 (81); Edinburgh, 1969 (47).

Lit.: Gilchrist, 1863, I, p. 109–13; II, p. 262; also 1880 and 1907 editions; Keynes, *Bibliography*, 1921, pp. 133–6, 138, copy N; Keynes and Wolf, 1953, pp. 40–3, 47, copy O.

Reprod.: Colour microfilm by Micro Methods Ltd. Bentley, *Records*, 1969, pl. LI (pl. 10 only).

The first copies of *America* were executed by Blake in 1794 and others were done at intervals as needed. The present copy is probably the last one, begun in 1821.

NOTES

1 Plate 1 without *Preludium*, plate 2 with added lines, the serpent on plate 11 with one tail.

2 Linnell entered payment of £1 in his general account book under 8 August 1821 'On acct of a Book of Europe & America not finished'. This almost certainly refers to the Fitzwilliam copies, and Professor Bentley suggests that later unexplained payments from Linnell to Blake may account for their colouring (see letter in Museum file, 20 December 1967). Keynes has suggested that a receipt of 1 March 1822 for £3 'on Accot.' refers to the purchase of the present volume.

14 AMERICA, A PROPHECY

Designed in 1793.

Printed on paper with watermark 'J WHATMAN 1832' from plates in relief etching. Size of leaf $11\frac{1}{16} \times 8\frac{3}{16}$ ($28 \times 22 \cdot 3$); size of plate approx. $9\frac{1}{2} \times 6\frac{3}{4}$ ($24 \cdot 1 \times 17 \cdot 1$). 18 plates on 18 leaves. Printed in red-brown, uncoloured. Bound in contemporary red morocco elaborately tooled in gold, together with *Europe, a Prophecy* (cat. no. 16).

Given by Charles Fairfax Murray in 1912.

Coll.: Samuel Boddington (with his bookplate); acquired by C. Fairfax Murray before 1899.

Lit.: *Catalogo*, 1899, p. 16, no. 142; Keynes, *Bibliography*, 1921, pp. 133–6, 138, copy P; Keynes and Wolf, 1953, pp. 40–3, 47, copy P.

The plates were in existence after Blake's death in 1827, and this copy was printed, probably by Frederick Tatham, in 1832 or soon after. Frontispiece follows title-page. Note 1 to previous catalogue entry applies also to this copy.

15 EUROPE, A PROPHECY

Designed 1794.

Relief etchings, finished in pen and watercolour, on paper, with watermarks 'J WHATMAN 1818', '(ditto) 1819', and '(ditto) 1820'. Size of leaf $12 \times 9\frac{5}{16}$ ($30\cdot4 \times 23\cdot6$); plate size approx. $9\frac{1}{2} \times 6\frac{3}{4}$ ($24\cdot1 \times 17\cdot1$); 18 plates on 18 leaves. Printed in orange-red; elaborately painted with watercolours, heightened with gold. Plate numbers 1–18 added by Blake in black.[1] Bound in vellum together with *America, a Prophecy* (cat. no. 13).

Bequeathed by T. H. Riches in 1935, received 1950. P.127—1950.

Coll.: See *America, a Prophecy* (cat. no. 13).

Exh.: See *America, a Prophecy* (cat. no. 13).

Lit.: Gilchrist, 1863, I, p. 127–30; II, p. 262; also 1880 and 1907 editions; Keynes, *Bibliography*, 1921, pp. 139–41, 143, copy I; Keynes and Wolf, 1953, p. 83, copy K.

Reprod.: Colour microfilm by Micro Methods Ltd.

Blake was at work on *Europe* after completing *America*, the title-pages of both being dated 1794. Copies were executed at intervals afterwards as needed. This is one of two known copies containing plate (iii), the other being in the Harvard College Library.

NOTE

1 Arrangement in this copy, following Keynes and Wolf: (i), (ii), (iii), 1, 2, 7, 6, 3–5, 8–15.

16 EUROPE, A PROPHECY

Designed 1794.

On paper with watermark 'J WHATMAN 1832'; size of leaf $11\frac{1}{16} \times 8\frac{13}{16}$ ($28 \times 22\cdot3$); size of plate approx. $9\frac{1}{2} \times 6\frac{3}{4}$ ($24\cdot1 \times 17\cdot1$); 17 plates on 17 leaves.[1] Printed in red-brown, uncoloured. Bound in contemporary red morocco, elaborately tooled in gold, together with *America, a Prophecy* (cat. no. 14).

Given by Charles Fairfax Murray in 1912.

Coll.: For history see *America, a Prophecy* (cat. no. 14).

Lit.: *Catalogo*, 1899, p. 16, no. 142; Keynes, *Bibliography*, 1921, pp. 139–41, 144, copy K; Keynes and Wolf, 1953, pp. 77–80, 83, copy M; for further bibliography see *Europe* (cat. no. 15).

The plates were in existence after Blake's death in 1827, and this copy was printed, probably by Frederick Tatham, in 1832 or soon after.

NOTE

1 This copy lacks plate (iii).

17 THE LAZAR HOUSE *or* HOUSE OF DEATH *Plate 8*

No signature or date, *c.* 1795.

Colour-printed monotype,[1] finished in black chalk, body colour, watercolour, point of the brush, Indian ink and heightened with white. Size of leaf $18\frac{7}{8} \times 23\frac{3}{4}$ ($47\cdot9 \times 60\cdot3$).

Bequeathed by T. H. Riches in 1935. 1769.

Coll.: William Linnell (d. 1906);[2] T. H. Riches.

Exh.: B.F.A.C., 1876 (19).

Lit.: Gilchrist, 1863, II, p. 202, cat. no. 17; also 1880

and 1907 editions; Butlin, 1957, p. 44. Butlin in *Essays for Foster Damon*, 1969.

One of a series of 12 designs,[3] which Blake described as being of 'Historical and Poetical' subjects.[4] They are printed in a monotype technique, and normally three[5] impressions of each design were run off, each being finished off by hand according to the density of the printing. This means that there are considerable differences between impressions, as can be seen from a comparison with the impression of the same subject in the Tate Gallery.

The subject is taken from Milton, *Paradise Lost*, Book XI, 477–93. Others in the series are of mainly Biblical and Shakespearian subjects, and it is not clear whether or not they are united by a general theme related to the prophetic books of the same period.[6]

Two of the other examples of this design are dated 1795, so it can be assumed to date from that year.

NOTES

1 For an account of the technique used, see Butlin, 1957, p. 38–9, and Butlin in *Essays for Foster Damon*, 1969, which also includes a complete list of owners of the colour prints.

2 Inscribed on the back of the frame: 'This drawing by Wm Blake does not belong to the series / of Mr. J. Linnell Se. but was bought by me of / a dealer in London / William Linnell.' This may be a version that belonged originally to a set owned by Joseph Hogarth part of which was offered through George Richmond to Ruskin about 1843 (see Ruskin, *Works*, library edition, 1909, XXXVI, p. 32) and sold in Hogarth sale, 7–30 June 1854, 5th evening, 2724, as 'The Plague, in colours'; bt. Olwen, £1.

3 Butlin, 1957, p. 38–45, and also Butlin's correction of a number of designs in *Burl. Mag.* C, 1965, p. 86.

4 Letter to Dawson Turner, 9 June 1818. Keynes, *Letters*, 1968, p. 139, no. 112.

5 Two other impressions of the *Lazar House* are known: 1. British Museum (inv. no. 1885–5–9–1616), signed and dated: 'W.B. inv.

1795'. 2. Tate Gallery (inv. no. 5192). Butlin, 1957, no. 20, pl. 9. Gilchrist describes the Tate Gallery impression, then belonging to the Butts collection, but also mentions that 'Mr. Harvey, of Cockspur street, has a duplicate of this great work, paler in tint', now in the British Museum.

6 The other designs in the series are: *God creating Adam; God judging Adam; Satan exulting over Eve; Naomi entreating Ruth and Orpah to return to the land of Moab; Lamech and his two wives; Nebuchadnezzar; the Good and Evil angels struggling for possession of a child; Pity, from Macbeth; Hecate; Newton; Christ appearing to the Apostles after the Resurrection.*

18 JOB

Designed 1793.

Line engraving. Engraved surface $13\frac{3}{4} \times 19\frac{5}{16}$ (34.8×49). Printed in black on paper, approx. $19\frac{1}{2} \times 26\frac{1}{2}$ (49×67).

Given by E. M. Forster, King's College, Cambridge, in 1953. P.3—1953.

Coll.: Dr John Jebb (d. 1833), Bishop of Limerick, who bought it[1] from Mrs Blake after William Blake's death in 1827; bequeathed by Dr Jebb in 1833 to his chaplain, the Rev. Charles Forster (d. 1871); E. M. L. Forster (d. 1880), his son; Miss Laura M. Forster (d. 1924), his sister; given by her to her nephew, E. Morgan Forster.

Lit.: Keynes, *Separate Engravings*, 1956, p. 10–12, cat. no. III, pl. 7.

Second state of two. Of the first state only one example is known (coll. Sir Geoffrey Keynes); of the second state two further examples exist, one in the Print Room of the British Museum, the other in the collection of Sir Geoffrey Keynes.

NOTE

1 See Story, 1892, I, p. 243–4 and Bentley, *Records*, 1969, p. 379 (2 March 1830).

19 EZEKIEL

Designed 1794.

Line engraving. Engraved surface $13\frac{7}{8} \times 18\frac{7}{8}$ ($35\cdot3 \times 48$); printed in black on paper approx. $19\frac{1}{2} \times 26\frac{1}{2}$ (49×67).

Given by E. M. Forster, King's College, Cambridge, in 1953. P.4—1953.

Coll.: See cat. entry for *Job* engraving (cat. no. 18).

Lit.: Keynes, *Separate Engravings*, 1956, p. 23, cat. no. VIII, pl. 15.

Only state. Only two other impressions are known; one in the British Museum and the other in the collection of Sir Geoffrey Keynes.

20 YOUNG'S 'NIGHT THOUGHTS'

The Complaint, and The Consolation; or, Night Thoughts, by Edward Young. London ... 1797.

17×13 (43×33) approx.; uncut. 56 separate leaves, no signatures. 43 engravings designed and executed by Blake.

Given by the Rev. James Fleetwood (d.1821), Jesus College, Cambridge, in 1818.

Lit.: Gilchrist, 1863, I, p. 139–44; also 1880 and 1907 editions; Keynes, *Bibliography*, 1921, p. 200–2, cat. no. 70; Bentley, 1964, p. 167–70, no. 422; M. D. Paley in *Essays for Foster Damon*, 1969.

THE PATRONAGE OF THOMAS BUTTS AND THE
FELPHAM PERIOD—1799–1808

In 1799 Blake received an important commission for a series of small paintings of Biblical subjects from Thomas Butts, a government clerk. According to a letter dated 26 August 1799, Blake had an 'order for Fifty small Pictures at one Guinea each.'[1] It is probable, therefore, that the first series for Butts, painted in a kind of tempera, was intended to comprise fifty subjects, but rather fewer than that number survive today or are known from records, so the series was either left incomplete or a number of them have perished through defective technique.[2] Blake was working on the tempera series in 1799 and 1800, and in the latter year he commenced another series of Biblical paintings, this time in watercolour, for Butts. This series seems to have comprised a hundred watercolours, and Blake was engaged on them at least until 1806.

Sir Anthony Blunt has suggested that 'Blake planned these groups as continuous series developing a personal religious idea',[3] but the watercolours frequently seem to fall into small groups concerned with a single theme. *The Soldiers casting lots for Christ's Garments* of 1800 seems to belong in style to a group of watercolours on the subject of the Crucifixion, and *The Angel of the Divine Presence clothing Adam and Eve with coats of Skins* of 1803 may form a pair with *The Angel of the Divine Presence Bringing Eve to Adam* in the Metropolitan Museum, New York.

Butts also bought works from Blake outside the Biblical series, including sets of Miltonic illustrations and the watercolour of *Queen Katherine's Dream* which is derived from a 'visionary' passage in Shakespeare's *Henry VIII*.

The years 1800–3 when he was living at the cottage in Felpham, Sussex, near William Hayley, the poet, are represented by a copy of *Hayley's Ballads* with illustrations by Blake; and the following years, when he tried to re-establish himself in London, are represented by copies of Blair's *Grave*—the first edition of 1808 and the second of 1813—the production of which caused him the humiliation of having his designs engraved by another artist. A posthumous copy of the Illuminated Book *Jerusalem* is included in this section, because the title-page is dated 1804, but it was certainly worked on by Blake for many years after this date, possibly as late as 1820.

NOTES

1 Keynes, *Letters*, 1968, p. 32, no. 7.

2 Blake's purpose in experimenting with 'fresco', as he called it, was to avoid what he felt were the 'blotting and blurring' and darkening properties of oil paint. He hoped to bring to a more permanent medium the precise outline of his own pen and watercolour technique, thus achieving the clarity and freshness of Italian quattrocento panel painting, which he believed to have been painted in 'fresco'. J. T. Smith has left a vivid account of Blake's method of painting in 'fresco': 'Blake's modes of preparing his ground, and laying them over his panels for painting, mixing his colours, and manner of working, were those which he considered to have been practised by the earliest fresco painters, whose productions still remain, in numerous instances, vivid and permanently fresh. His ground was a mixture of whiting and carpenter's glue, which he passed over several times in thin

coatings: his colours he ground himself, and also united them with the same sort of glue, but in a much weaker state. He would, in the course of painting a picture, pass a very thin transparent wash of glue-water over the whole of the parts he had worked upon, and then proceed with his finishing.

'This process I have tried, and find, by using my mixtures warm, that I can produce the same texture as possessed in Blake's pictures of the Last Judgment, and others of his productions, particularly in Varley's curious picture of the personified Flea.' (Smith, 1829, p. 487.)

The ground of whiting and carpenter's glue was unusual at the time but perfectly sound in practice, although there was difficulty when it was applied to copper as in the *Judgment of Solomon*. The medium was inevitably delicate because of Blake's practice, described above, of passing glue-water over the parts he had completed. This made the surface of the painting extremely sensitive to atmospheric conditions, and the variation in condition of surviving paintings from the Butts series reflects their treatment by later owners.

It is noteworthy, however, that some of Blake's later paintings in 'fresco' still are in good condition, for example *Body of Abel found by Adam and Eve*, *Satan smiting Job with Sore Boils* (both in the Tate Gallery), and *Ugolino and his children* (coll. Sir Geoffrey Keynes) all dating from 1824-7. Blake seems to have changed his technique completely, applying the watercolour directly to a pure white ground, putting a glue-mixture on top of it as a protective surface.

3 Blunt, 1959, p. 104. See also Appendix B, which lists the surviving tempera and watercolour paintings from the Butts series.

21 THE JUDGMENT OF SOLOMON *Plate 9*

Not signed or dated, but 1799 or 1800.

Tempera on copper; $10\frac{1}{2} \times 15$ (26·7 × 38·1).

Given by the executors of W. Graham Robertson, through the National Art-Collections Fund, 1949. PD.28—1949.

Coll.: Painted for Thomas Butts (d. 1846); Thomas Butts, Jnr. (d. 1862); and grandson, Captain F. J. Butts (d. 1905); bought from the widow of Captain Butts through the Carfax Gallery by W. Graham Robertson (d. 1948), April 1906; Robertson sale, Christie's, 22 July 1949 (16); bt. in by his executors (for £399).

Exh.: Tate, 1947 (51); Bournemouth, 1949 (3); Southampton, 1949 (3); Brighton, 1949 (3).

Lit.: Gilchrist, 1863, II, p. 225, no. 128; Preston, 1952, p. 99, no. 30; Keynes, *Bible*, 1957, no. 62, plate 62; Blunt, 1959, p. 104.

Much damaged through loss of paint and surface wear; the face of the man at the extreme left is renewed, as is Solomon's left cheek, but restoration of the other heads is confined to occasional strengthening, particularly in the outlines, which also occurs elsewhere, notably in the hands. Restored in 1906, when the missing areas were repainted, in part from the small painting of the same subject in cat. no. 33. Loose paint was secured in 1965.

The subject is taken from I Kings iii. 25, 26.

This painting belongs to the series of Biblical subjects commissioned by Thomas Butts in 1799 which was probably intended to comprise a total of fifty tempera paintings.[1] Some of them are dated either 1799 or 1800, and most of the surviving examples are in poor condition owing to the impermanence of Blake's technical methods.

NOTE

1 See general introduction to this section.

22 THE SOLDIERS CASTING LOTS FOR CHRIST'S GARMENTS *Plate 10*

Signed and dated 'WB inv 1800' (b.l.); inscr. 'John XIX c. 23 & 24 v' (b.r.) under drawing, by Blake.

Pen, Indian ink, grey wash and watercolour; $16\frac{1}{2} \times 12\frac{3}{8}$ (42 × 31·4).

Given by the executors of W. Graham Robertson through the National Art-Collections Fund, 1949. PD.30—1949.

Coll.: Painted for Thomas Butts (d. 1846); Thomas Butts, Jnr. (d. 1862); his sale, Foster's, 29 June 1853 (92), bt. by R. Monckton Milnes (later Lord Houghton; d. 1885) (for 14s); his son, later Marquess of Crewe (d. 1945); bt. by W. Graham Robertson from him in 1904; offered for sale at Christie's 22 July 1949 (33); bt. in by the executors (for £945).

Exh.: Blake's own exhibition, 1809 (12);[1] B.F.A.C., 1876 (2); Carfax, 1906 (42); N.G.B.A., 1913 (26); Manchester, 1914 (28); B.F.A.C., 1927 (23); Paris, 1947 (15); Antwerp, 1947 (15); Zurich, 1947 (15); Tate, 1947 (15); Bournemouth, 1949 (4); Southampton, 1949 (4); Brighton, 1949 (4); Whitworth, 1969 (35).

Lit.: *Des. Cat.*, 1809, p. 60; Gilchrist, 1863, II, pp. 141, 211, cat. no. 83 (dated as 1809 or earlier); Russell, *Burl. Mag.*, XXVII, 1920, p. 33; Preston, 1952, p. 102–3; Keynes, *Works*, 1957, p. 584; Blunt, 1959, p. 70, no. 8; Preston in *Apollo*, LXXXIV, 1966, p. 384; C. Taylor in *Blake Studies*, I, 1968, p. 71–2.

Reprod.: D. Figgis, *The Paintings of William Blake*, 1925, pl. 46; *Blake Society*, 1923–4; Russell in *Apollo*, V, 1927, p. 260, fig. V; Sir Herbert Grierson, *And the Third Day*, 1948, facing p. 115; R. H. Greenough, *The Bible for my Grandchildren*, 1950, II, facing p. 106; Sir Geoffrey Keynes, *The Masters, Blake*, 6, 1965, p. 8, pl. XI.

The scene represented is taken from John xix. 23 and 24, and it shows the soldiers playing dice for Christ's cloak, with the Crucifixion in the background. The unusual prominence given to the soldiers may be indebted to the influence of a painting of the *Crucifixion* by Nicolas Poussin of 1645–6 in the Wadsworth Atheneum.[2] The soldiers in the Poussin are very close to the present work: for example, the kneeling figure on the left, and the outstretched arm and leg of the figure on the right. The soldier leaning on his lance has disappeared in Poussin's final version, although he is present in the preliminary studies in the Louvre.[3] A cross seen from the rear is an uncommon motif, and it also occurs in the Poussin (although not, admittedly, the central cross), while the mourning women are fairly similar in dress and pose. The Poussin was sold in the Lawrence Dundas sale, Christie's, 29 May 1794, where Blake could have seen it. An engraving by Bouzonnet-Stella of 1672[4] may also have been known to Blake, who was a haunter of print-shops from his earliest youth.

This watercolour may be one of a group, probably of the same period, on the theme of the Crucifixion within the larger set of Biblical illustrations made for Butts.[5] Blake seems to have emphasised the darker side of the Crucifixion, concentrating on the degradation of Christ's persecutors, in this case by making the soldiers more prominent in the composition than the figures around the cross.[6]

NOTES

1 Described by Blake as one of four drawings 'the Artist wishes were in Fresco on an enlarged scale to ornament the altars of churches, and to make England, like Italy, respected by respectable men of other countries on account of Art'. The other drawings were: *The Body of Abel found by Adam and Eve, Jacob's Ladder* and *The Angels hovering over the Body of Jesus in the Sepulchre.*

2 See Anthony Blunt, 'Poussin Studies XIV: Poussin's Crucifixion' in *Burl. Mag.*, CVI, no. 739, p. 450 ff., fig. 16, and also Anthony Blunt, *The Paintings of Poussin*, 1968, pl. 168. I am indebted to Mr Malcolm Cormack for this suggestion, and all references connected with it.

3 Reprod. Blunt, *op. cit.* 1959, figs. 17, 18 and 20.

4 G. Wildenstein, *Poussin et ses graveurs au XVIIe Siècle*, 1957, p. 112, no. 67.

5 Others that correspond in dimensions and style are: Keynes, *Bible*, 1957, pl. 138, *The King of the Jews* (dimensions slightly different) (Lord Glentanar); pl. 140, *The Crucifixion* (Fogg Museum, Cambridge, Mass.); pl. 141, *Christ taking leave of His mother* (Tate Gallery); pl. 144, *The Entombment* (Tate Gallery), and possibly pls. 145, 146, 147 and 148.

6 See notes to *The Spiritual Condition of Man*, cat. no. 33, note 7.

23 DEATH ON A PALE HORSE *Plate 11*

Signed 'WB inv' (b.r.), no date, *c.* 1800.

Pen, Indian ink, grey wash and watercolour; $15\frac{1}{2} \times 12\frac{1}{4}$ (39·3 × 31·1).

Given by the Friends of the Fitzwilliam Museum, 1914. 765.

Coll.: Painted for Thomas Butts (d. 1846); Thomas Butts, Jnr. (d. 1862); his sale, Foster's, 29 June 1853 (91), bt. by Colnaghi (for £1 17s 6d); 'Mr Thomas'; Alfred Aspland by 1876; Aspland sale, Sotheby's, 27 January 1885 (63), bt. by Colnaghi (for £5 10s 0d); Crawford J. Pocock (d. before 1890); offered at Christie's 12–14 May 1891 (585), (bt. in at 12 gns.); Mrs Crawford Pocock; her sale, Sotheby's, 8 July 1895 (127), bt. by Keppell (for £17 6s 6d); Frederick Hollyer; his sale, Sotheby's, 24 June 1903 (42),[1] bt. by Quaritch (for £60); W. A. White, New York; bt. back 1914 by Quaritch, bt. from them by Friends of the Fitzwilliam (for £60).

Exh.: B.F.A.C., 1876 (96); New York, 1905 (90a); N.G.B.A., 1913 (35); Manchester, 1914 (32); Nottingham, 1914 (23); Edinburgh, 1914 (20); B.F.A.C., 1927 (32).

Lit.: Gilchrist, 1863, II, p. 255 (list 3), cat. no. 12 (Mr Thomas from Mr Butts), 1880 ed. p. 242, no. 200;[2] Keynes, *Bible*, 1957, p. 46; Blunt, 1959, p. 100.

The subject is taken from Revelation vi. 8: 'And I looked, and behold a pale horse: and his name that sat on him was Death, and Hell followed with him.'

This watercolour is close in style to cat. no. 22, *The Soldiers casting lots for Christ's garments* which is dated 1800, and it probably belongs to the same year. Death is depicted as a king in armour, of the type of Urizen in the prophetic books of the Lambeth period. Death is seen, therefore, as a warlike destructive tyrant. A possible prototype may be found in the engraving of the same subject after John Hamilton Mortimer,[3] in which Death appears as a crowned skeleton. There is also a painted version of the same subject by Benjamin West,[4] and perhaps by Philip de Loutherbourg.[5]

NOTES

1 'Another Property', 24 June (i.e. added to Captain Butts' sale), lot 42.

2 Confused with '*And power was given him*' watercolour in Lessing J. Rosenwald collection.

3 By Joseph Haynes, pub. 1784. Reproduced cat. of John Hamilton Mortimer Exhibition, Eastbourne and London, 1968, p. 31, no. 44.

4 Dated 1802. Philadelphia Museum of Art. Reproduced D. Irwin, *English Neoclassical Art*, 1966, pl. 143.

5 Tate Gallery (T. 1138). Dated 1798. Painted for the Macklin Gallery as *Vision of the White Horse* but apparently representing the *Opening of the First and Second Seals* (Rev. vi. 2–4).

24 THE THREE MARYS AT THE SEPULCHRE *Plate 12*

Signed 'W B inv 1803' (b.l.) (commenced 1800).

Pen, Indian ink, grey wash and watercolour, over pencil; watermark 'Strasbourg Lily' (twice), with 'GR'; overprinted 'w (?) BRIDGES 1794'; $14\frac{9}{16} \times 15\frac{15}{16}$ (37·3 × 40·5).

Given by the executors of W. Graham Robertson through the National Art-Collections Fund, 1949. PD.31—1949.

Coll.: Painted for Thomas Butts (d. 1846); Thomas Butts, Jnr. (d. 1862); Captain F. J. Butts (d. 1905); offered for sale by Captain Butts at Sotheby's, 24 June 1903 (3) (bt. in for £120); bt. from the widow through Messrs Carfax by W. Graham Robertson, April 1906; offered for sale at Christie's, 22 July 1949 (37), bt. in by the executors for £1,255.

Exh.: B.F.A.C., 1876 (109); Carfax, 1904 (3); Carfax, 1906 (66); N.G.B.A., 1913 (32); Manchester, 1914 (30); Nottingham, 1914 (21); Edinburgh, 1914 (28); B.F.A.C., 1927 (27); Tate, 1947 (68); Bournemouth, 1949 (5); Southampton, 1949 (5); Brighton, 1949 (5).

Lit.: Gilchrist, 1863, II, p. 206, cat. no. 41; also 1880 and 1907 editions; Russell in *Burl. Mag.*, XXVII, 1920, p. 33; Preston, 1952, p. 104–5; Keynes, *Letters*, 1968, p. 45, no. 21, p. 68, no. 33, p. 72, no. 35, p. 75, no. 36; National Art-Collections Fund, *Annual Report*, 1949, p. 20, no. 16.

Inscribed on the back in pencil in the 'copper-plate hand' 'Mark Ch. 16 v. I' [*sic*] and on the mount '*Mark Ch: 16th: v: 6th:* "And the young man saith unto them be not affrighted ye seek Jesus of / Nazareth which was crucified he is risen, he is not here."'[1]

The watercolour is first mentioned in a letter to Butts of 2 October 1800. Blake, having arrived on 18 September at the cottage at Felpham which he rented near William Hayley, wrote: 'Having been so full of the Business of Settling the sticks & feathers of my nest, I have not got any forwarder with "the three Marys" or with any other of your commissions.'[3] In a letter to Butts of 6 July 1803,[3] Blake announces that he is still working on the watercolour: 'I have now on the Stocks the following drawings for you:

1. Jephthah sacrificing his Daughter; 2. Ruth & her mother in Law & Sister; 3. The three Maries at the Sepulcher; 4. The Death of Joseph; 5. The Death of the Virgin Mary; 6. St. Paul Preaching; & 7. The Angel of the Divine Presence clothing Adam & Eve with Coats of Skins.[2]

'These are all in great forwardness, & I am satisfied that I improve very much & shall continue to do so while I live, which is a blessing I can never be too thankful for both to God & Man.' On 16 August 1803[3] he wrote to Butts saying that he was sending seven drawings, probably including the *Three Marys*, and on 20 August he sent Butts an account amounting to £14 14s 0d for eleven drawings including the *Three Marys*, delivered on 8 July and 20 August 1803.[3]

The *Three Marys* closely resembles in style *Ruth parting from Naomi*, also mentioned in the letter of 6 July, and now in the Southampton Art Gallery. A representation of the same subject can be found in *An Allegory of the Spiritual Condition of Man*, cat. no. 33, p. 35, note 1.

NOTES

1 Mr Martin Butlin has suggested the 'copper-plate hand' must have been applied while this watercolour and others were in the possession of Thomas Butts (see Butlin, 1957, p. 47–8).

2 The other drawings are distributed as follows: 1. British Museum, Print Room; 2. Southampton Art Gallery; 4. Mr James Biddle, New York City; 5. Tate Gallery; 6. Rhode Island School of Design; 7. Fitzwilliam (cat. no. 25).

3 Keynes, *Letters*, 1968, p. 45, no. 21 (2 Oct. 1800); p. 68, no. 33 (6 July 1803); p. 72, no. 35 (16 Aug. 1803); p. 75, no. 36 (20 Aug. 1803).

25 THE ANGEL OF THE DIVINE PRESENCE CLOTHING ADAM AND EVE WITH COATS OF SKINS *Plate 13*

Signed and dated 'W B inv 1803' in ink (b.r.).

Pencil, grey wash, and watercolour.
$15\frac{1}{2} \times 11\frac{5}{16}$ (39·3 × 28·7) stuck down.

Given by the executors of W. Graham Robertson through the National Art-Collections Fund, 1949. PD.29—1949.

Coll.: Painted for Thomas Butts (d. 1846); Thomas Butts, Jnr. (d. 1862); Captain F. J. Butts (d. 1905); bt. from widow through Messrs Carfax by W. Graham Robertson in 1906; offered for sale at Christie's 22 July 1949 (2), bt. in by the executors for £1,365.

Exh.: B.F.A.C., 1876 (208); Carfax, 1906 (71); Tate, 1947 (70); Bournemouth, 1949 (2); Southampton, 1949 (2); Brighton, 1949 (2).

Lit.: Gilchrist, 1863, II, p. 206, cat. no. 45; Russell in *Burl. Mag.*, XXXVII, 1920, p. 33; Preston, 1952, p. 97–8; Keynes, *Bible*, 1957, p. 2; Piloo Nanavutty, in Pinto, 1957, p. 185; Keynes, *Letters*, 1968, p. 68, no. 33.

Reprod.: Figgis, 1925, pl. 2; Fitzwilliam Museum, colour postcard no. 16.

Inscribed on mount in 'copper-plate hand': 'Gen: ch: 3rd: v: 21st / Unto thine . . . Lord God / make coats of skins & clothed them' (last two lines under glue), and at the top: 'I was naked'.

This watercolour is mentioned in the letter to Butts of 6 July 1803 as being on the stocks, and it is given its full title as 'The Angel of the Divine Presence clothing Adam & Eve with Coats of Skins'.[1] The Angel of the Divine Presence is identified by Blake here with Jehovah, in the Old Testament the creator of heaven and earth.[2] But in Blake's system he is more particularly the creator of the material universe. The Angel of the Divine Presence is, therefore, Satanic, for he creates man's material existence, which is a fall from the eternal state. The Angel of the Divine Presence can also be identified with the figure of Urizen in the Illuminated Books of the Lambeth period, where he appears as the restrainer of desire and upholder of tyranny and hypocrisy in all its forms.[3] In this watercolour the act of clothing Adam and Eve emphasises their Fall and is seen as part of the Satanic design to separate man from the Divine light, expressed in the enfolding gesture of the Angel of the Divine Presence and the enclosing arbour in which they stand.

There is a possible companion picture, '*The Angel of the Divine Presence Bringing Eve to Adam*', now in the Metropolitan Museum, New York (inv. no. 0.6.1322.2).[4]

NOTES

1 See Keynes, *Letters*, 1968, p. 68, no. 33.

2 The Angel of the Divine Presence is identified with Jehovah in *A Vision of the Last Judgment*: 'The Aged Figure with Wings, having a writing tablet & taking account of the numbers who arise, is That Angel of the Divine Presence mention'd in Exodus, xiv c. 19 v. & in other Places; this Angel is frequently call'd by the Name of Jehovah Elohim, The "I am" of the Oaks of Albion' (Keynes, *Works*, 1957, p. 610), and in the *Laocoön* engraving, the figure of Laocoön is identified as both Jehovah and the Angel of the Divine Presence, and the father of Satan and Adam (Keynes, *Works*, 1957, p. 775). See also Damon, 1965, p. 23: 'Angel of the Divine Presence'.

3 For discussion of the depiction of Urizen in Blake's work see Blunt, 1938–9; Butlin, 1966; and Bindman, 1968.

4 See Gilchrist, 1907, p. 443; Preston, 1952, p. 98; reproduced in Keynes, *Bible*, 1957, pl. 6.

26 THE ASCENSION *Plate 14*

Signed 'W B / inv' (b.l.), no date, c. 1805–6; inscr. 'Acts I c. 9–10 v' (b.r.).

Pen, pencil, Indian ink and watercolour; original sketches in pencil underneath show changes; size of sheet $21\frac{9}{16} \times 17$ (52·3 × 43)—irregular, size of painted area, within wash borders, $16\frac{7}{8} \times 12\frac{3}{8}$ (42·5 × 31·9).

Given by the executors of W. Graham Robertson through the National Art-Collections Fund, 1949. PD.32—1949.

Coll.: Painted for Thomas Butts (d. 1846); Thomas Butts, Jnr. (d. 1862); Captain F. J. Butts (d. 1905); offered for sale at Sotheby's, 24 June 1903 (17) (bt. in for £115); bt. by W. Graham Robertson, February 1904; offered for sale at Christie's, 22 July 1949 (38); bt. in by the executors (for £7,350).

Exh.: B.F.A.C., 1876 (63); Carfax, 1904 (14); Carfax, 1906 (44); Whitechapel, 1906 (94); N.G.B.A., 1913 (33); Manchester, 1914 (33); B.F.A.C., 1927 (30); Paris, 1947 (21); Antwerp, 1947 (21); Zurich, 1947 (21); Tate, 1947 (21); Bournemouth, 1949 (2); Southampton, 1949 (2); Brighton, 1949 (2); Goldsmiths' Hall, 1959 (83); Whitworth, 1969 (37).

Lit.: Gilchrist, 1863, II, p. 229, cat. no. 166; Russell in *Burl. Mag.*, XXVII, 1920, p. 34; Preston, 1952, p. 106–7; Keynes, *Bible*, 1957, p. 46.

Reprod.: L. Binyon, *The Drawings and Engravings of William Blake*, 1922, pl. 76; R. H. Greenough, *The Bible for my grandchildren*, 1950, II, pl. facing p. 114.

Inscribed in the 'copper-plate hand' at the bottom over the wash line: 'The Ascension' and at the top 'VII'.[1]

The watercolour is not dated but there are various pointers to a date of 1805–6. It is close in style to the Butts watercolour of the *Assumption of the Virgin* (Royal Collection, Windsor Castle) dated 1806,[2] which shares a symmetrical composition, in which the left-hand side of the picture is almost a mirror image of the other side, a characteristic of later Butts watercolours. There is a pencil study for the *Ascension*, showing Christ apparently ascending through a Gothic arch, on the verso of a study for the *Death of the Strong Wicked Man* in Blair's *Grave*, dated by Keynes 'about 1805' (Victoria and Albert Museum, inv. no. 8765c).[3]

NOTES

1 The subject is taken from Acts i. 9–10: 'And when he had spoken these things, while they beheld, he was taken up; and a cloud received him out of their sight. And while they looked stedfastly toward heaven as he went up, behold, two men stood by them in white apparel.'

2 See A. P. Oppé, *English Drawings at Windsor Castle*, 1950, frontispiece and cat. no. 63.

3 Keynes, *Pencil Drawings*, 1927, no. 29.

27 QUEEN KATHERINE'S DREAM *Plate 15*

Signed and dated 'W B inv 1807' (b.l.).

Pen, grey wash, traces of pencil underdrawing, touched with colour; faded and foxed; $15\frac{11}{16} \times 12\frac{5}{16}$ (39·9 × 31·4).

Given by the Friends of the Fitzwilliam, 1911. 712.

Coll.: Painted for Thomas Butts (d. 1846); Thomas Butts, Jnr. (d. 1862); Thomas Butts' sale, Sotheby's, 26 March 1852 (166), bt. by Sir Charles Wentworth Dilke (d. 1869) (for £9); Sir Charles Wentworth Dilke, 2nd Bart. (d. 1911); Dilke sale, Christie's, 10 April 1911 (127), bt. by Sydney Cockerell for the Friends of the Fitzwilliam (for 50 gns.).

Exh.: Manchester, 1857 (130A); Dublin, 1865 (not in cat.) B.F.A.C., 1876 (81); New Gallery, 1891 (not in cat.);

Carfax, 1906 (58); N.G.B.A., 1913 (46); B.F.A.C., 1927 (45); Nottingham, 1961 (39); Arts Council, 1964 (37).

Lit.: Gilchrist, 1863, I, p. 3, II, p. 209, cat. no. 72, also 1880 and 1907 editions; F. Antal, *Fuseli Studies*, 1956, pp. 85, 116, n. 109, pl. 31a; W. M. Merchant, *Shakespeare and the Artist*, 1959, p. 81 ff., pl. 33; Merchant in *Apollo*, LXXIX, 1966, p. 323–34 (plates mixed up).

Reprod.: Russell in *Apollo*, V, 1927, p. 261, fig. VI.

This drawing is on the same kind of mount as those with the 'copper-plate hand', but it has been cut down.

The subject is the same as cat. no. 2 although the treatment is different. There are two other versions of the subject by Blake; one in the British Museum, from the extra-illustrated volume compiled by the Rev. Joseph Thomas,[1] but of a slightly different composition and dated 1809; and another version painted for Sir Thomas Lawrence in 1827,[2] closely following the present composition.

The interesting relationship between compositions by Fuseli and Blake's versions of *Queen Katherine's Dream* is discussed by Antal,[3] and Merchant points out a prototype for the attendant figures of Griffith and Patience in Fuseli's illustration of the same subject, engraved by Blake for Rivington's edition of Shakespeare, 1805.[4]

Antal suggests that Blake borrowed the composition from Fuseli's version of the same subject engraved by Bartolozzi in 1788,[5] but except in the pose of Queen Katherine the composition is not very close. The dating in the present catalogue of cat. no. 2 suggests that Blake may have attempted the subject before Fuseli, and it is possible that in fact Fuseli's treatment was influenced by Blake. Antal also suggests that the circular movement of the angels that make up the vision, and which looks forward to the engraved plate of the *Whirlwind of Lovers* in the

Illustrations to Dante, may have been influenced by a similar circle of angels in Fuseli's drawing of *The Dream of Guyon* from Spenser's *Faerie Queene*,[6] probably dating from the 1790s.

NOTES

1 See T. S. R. Boase, 'An Extra-Illustrated Second Folio of Shakespeare', *British Museum Quarterly*, XX, 1955, 4–8.

2 Lessing J. Rosenwald collection, National Gallery of Art, Washington, D.C. (inv. no. B-11, 197). Wrongly dated 1807 by Gilchrist (1863, II, p. 209, no. 73) but in vol. I, p. 357–8 he describes the Lawrence drawing as one of 'the last drawings executed, or at least finished, by Blake', and having been commissioned by Sir Thomas Lawrence. Gilchrist also mentions the Lawrence drawing, with a version of *The Wise and Foolish Virgins*, as being 'both repetitions, though not literal ones, of careful drawings made for Mr. Butts'.

3 See Antal, *Fuseli Studies*, 1956, pp. 85, 116, n. 109.

4 See W. M. Merchant, *Shakespeare and the Artist*, 1959, pl. 30.

5 Antal, *op. cit.* pl. 31b.

6 Albertina, Vienna. Reprod. Antal, *op. cit.* pl. 46.

28 HAYLEY'S 'BALLADS'

By William Hayley. Published by Richard Phillips, London, 1805.

Five plates designed and engraved by Blake; this copy only contains three of these plates (copy lacks plates II and V).

Bequeathed by Charles B. Marlay in 1912.[1]

Lit.: Gilchrist, 1863, I, p. 199; II, p. 257; Keynes, *Bibliography*, 1921, p. 207–9, cat. no. 74; Bentley, 1964, p. 121, no. 374.

NOTE

1 An inscription on the fly-leaf reads 'From the Collection of Catherine M. Louisa Fordall (?)'.

29 BLAIR'S 'THE GRAVE'

By Robert Blair; published by R. H. Cromek, London, 1808.

Engraved title and eleven plates designed by Blake and engraved by L. Schiavonetti. Frontispiece engraved by Schiavonetti after a portrait of Blake by T. Phillips.

Lit.: Gilchrist, 1863, I, pp. 200–7, 217–23; II, p. 261; also 1880 and 1907 editions; Keynes, *Bibliography*, 1921, p. 219–21, cat. no. 81; Bentley, 1964, p. 96, no. 350A.

1. 1st edition, 1808.
 Rebound.
 Given by J. H. Allen, 1910.

2. 2nd edition, 1813.
 Purchased 1892 from Tregaskis for £1 15s 0d.

3. Plate VI only, proof.
 As in 1808 edition, but with artists' names scratched, and before the verses.
 Given by the Rev. Francis and Miss Annora Palgrave, December 1941.

30 JERUSALEM, THE EMANATION OF THE GIANT ALBION

Designed 1804.

Relief etchings on paper, watermarks 'J WHATMAN 1831', and '(ditto) 1832'; size of leaf $11\frac{1}{4} \times 9\frac{1}{16}$ (28·5 × 23); plate size approx. $8\frac{3}{4} \times 6\frac{1}{2}$ (22·2 × 16·5); 100 plates on 100 leaves; plate 1: frontispiece; plate 2: title-page; plates 3–100: text and full-page illustrations; up to 81 lines to a full page of text. Printed in red-brown, uncoloured; bound in contemporary, citron morocco, elaborately tooled in gold.

Given by Charles Fairfax Murray (d. 1919) in 1912.

Coll.: Samuel Boddington;[1] possibly Francis Bedford, the bookbinder; his sale, Sotheby's, 21 March 1884 (120), bt. by Messrs Quaritch (for £5 12s 6d).[2]

Lit.: Gilchrist, 1863, I, p. 183–95; II, p. 262; also 1880 and 1907 editions; *Catalogo*, pt. 2, 1899, p. 16, no. 143; Keynes, *Bibliography*, 1921, pp. 161–9, 170, copy G; Keynes and Wolf, *Census*, 1953, pp. 104–12, 114, copy H.

Reprod.: Bentley, *Records*, 1969, pl. LIV (pl. 46 only).

The title-page is dated 1804, but no copy is known to have been completed by Blake before 1818. Only four copies executed by Blake are known, the latest one alone being coloured; but the plates were in existence after Blake's death in 1827 and at least three copies, of which this is one, were printed, probably by Frederick Tatham, in 1832 or soon after.

NOTES

1 Samuel Boddington purchased a plain copy of the *Canterbury Pilgrims* from John Linnell on 30 March 1835 (Keynes, *Letters*, 1968, p. 146), and also a copy of *For the Sexes* (Keynes and Wolf, copy D) from Tatham, perhaps about 1833.

2 Professor G. E. Bentley, Jr. suggests that the copy owned by Francis Bedford is more likely to be Keynes and Wolf, copy G.

BLAKE'S EXHIBITION AND THE YEARS OF OBSCURITY
1809–c. 1818

Despite the loyal patronage of Butts and others, the years after Blake's return from Felpham in 1803 were marked by a growing failure to establish himself with a wide public. Although he was able to sell almost everything that he produced to his admirers, he became increasingly isolated while his earlier friends Fuseli and Flaxman were achieving positions of influence. After his unfortunate experience with the publisher Cromek over Blair's *Grave* and the *Canterbury Pilgrims*, he made one final attempt to gain himself a wide public, by putting on an exhibition of his own work with *A Descriptive Catalogue*, in 1809, in his brother James's house. The exhibition contained work from different periods, including the watercolour of *Soldiers Casting Lots for Christ's Garments* (cat. no. 22).[1]

The disastrous failure of the exhibition was followed by a period of obscurity in which only isolated glimpses of Blake's activity can be gleaned from contemporary sources, until his meeting with John Linnell in 1818. He continued working with his accustomed energy, however, and the Fitzwilliam possesses one major work which is dated within this period, the severely damaged *Allegory of the Spiritual Condition of Man* of 181(1?), and an important set of illustrations which also probably belongs to this period, the *Paradise Regained* series of c. 1816–18. The *Allegory of the Spiritual Condition of Man* is a work of great complexity even for Blake, and it should, perhaps, be seen as the equivalent in intention of one of his own

Illuminated Books, but in the form of a painting. It is probably connected with Blake's numerous projects for the *Last Judgment*, which survive in engraved, painted and written form, and which culminated in a lost 'Fresco picture of the Last Judgment, containing upwards of one thousand figures, many of them wonderfully conceived and grandly drawn'.[2]

The watercolours for *Paradise Regained* are Blake's only attempt to illustrate Milton's poem. They are painted in a more delicate and miniature-like technique than his earlier illustrations to Milton, but they are close to the illustrations to *L'Allegro and Il Penseroso* (Pierpont Morgan Library, New York), which also exist only in one version. The illustrations to *Paradise Regained* seem to lack the counterpoint between a literal illustration of the text and Blake's criticism of it in terms of his own philosophy, that is a notable feature of his illustrations to *L'Allegro and Il Penseroso*[3] and to Dante's *Divine Comedy*.[4]

NOTES

1 For a brief description of a visit to Blake's exhibition see Symons, 1907, p. 283–4 (Henry Crabb Robinson's account from his reminiscences).

2 Smith, 1829, p. 480; also A. S. Roe, 'A Drawing of the Last Judgment', *Huntington Library Quarterly*, XXI, 1957, p. 37–55.

3 See Blake's own commentary on these illustrations, Keynes, *Works*, 1957, p. 617–19.

4 For a full discussion of Blake's interpretation of Dante see A. S. Roe, *Blake's Illustrations to the Divine Comedy*, 1953.

31 THE DESCRIPTIVE CATALOGUE

A / Descriptive Catalogue / of / Pictures Poetical and Historical Inventions / painted by / William Blake / in Watercolours... // London: Printed by D. N. Shury, 7 Berwick Street, Soho / for J. Blake, 28 Broad Street, Golden Square. 1809.

Inscr. 'At N 28 Corner of Broad Street Golden Square' in Blake's hand, on title-page.

38 leaves, bound with original wrappers in blue morocco gilt.

Given by Charles Fairfax Murray, 1912.

Lit.: Gilchrist, 1863, I, pp. 31, 226–8, II, p. 117–43 (printed in full without preface), also 1880 and 1907 editions; *Catalogo*, 1899, pt. II, p. 16, no. 144; Keynes, *Bibliography*, 1921, p. 85–9, cat. no. 30, copy G; *Writings*, 1957, p. 560–86; Bentley, 1964, p. 45, no. 31.

32 CHAUCER'S CANTERBURY PILGRIMS

Designed in 1810.

Line engraving; engraved surface $12 \times 36\frac{7}{8}$ (30.5×93.5); plate mark: cut impression; printed in black on paper.

Given by the Rev. Francis and Miss Annora Palgrave, 1941.

Lit.: Gilchrist, 1863, I, pp. 225–31, 242–4; II, p. 257; Keynes, *Separate Plates*, 1956, p. 45–9, cat. no. XVII, reprod. pls. 29 and 32.

Second state of five. In the second state Blake has gone over the whole plate with the graver, increasing contrasts everywhere by deepening lines and adding cross-hatching. Chaucer's horse at the left-hand end has become so much darkened as to be almost black. Dark streaks have been added in the sky at the right-hand end. The address is still in the inscription. A small oblong building has been added in the fold of the hills above the fifth group of buildings from the right-hand end.

At least five other copies of this state are recorded: in the Print Room of the British Museum, the Boston Museum of Fine Arts, the Lessing J. Rosenwald collection (National Gallery of Washington, D.C.) and in the collection of Sir Geoffrey Keynes. A fifth one was part of the W. Graham Robertson collection, sold at Christie's, 22 July 1949, lot 89 (bt. by Agnew).

33 AN ALLEGORY OF THE SPIRITUAL CONDITION OF MAN *Plate 16*

Signed and dated, in gold letters 'P——d in / ——o (i.e. fresco) by W^{m.} Blake / 181(1?)' (b.l.).

Tempera on canvas; $59\frac{3}{8} \times 47\frac{3}{4}$ (151.6×121.3).

Given by the executors of W. Graham Robertson, through the National Art-Collections Fund, 1949. PD.27—1949.

Coll.: Thomas Butts; his son, Thomas Butts, Jr.; and grandson, Captain F. J. Butts; bt. from his widow by W. Graham Robertson through the Carfax Gallery, London, 1906; Graham Robertson sale, Christie's, 22 July 1949 (52), bt. in by his executors (for £420).

Exh.: Bournemouth, 1949 (1); Southampton, 1949 (1); Brighton, 1949 (1); London, 1951 (1).

Lit.: Gilchrist, 1863, II, p. 231, no. 199; 1907, p. 453, no. 199; Russell in *Burl. Mag.*, xxvii, 1920, p. 34; Preston, *The Spiritual Condition of Man*, 1949 (with plates); 1952, p. 96, no. 28; Desirée Hirst in *Country Life*, CVII, 1950, p. 456; Desirée Hirst, *Hidden Riches*, 1964, p. 158–9.

This painting is Blake's largest surviving picture.[1] There are many paint losses, and much abrasion of the surface.[2] It was first mentioned in W. M. Rossetti's list of Blake's works in vol. II of Gilchrist's *Life*, 1863, as belonging to the Butts family, and it is described as follows: 'An Allegory of the Spiritual Condition of Man. / The conception of the subject seems to approach to that of a Last Judgment, though not recognisable distinctly as such. Faith, Hope, and Charity, Adam and Eve, Satan, can be traced among the figures.' There is no reason to suspect that the title goes back any further than Rossetti, or that his identification of the figures carries any authority.

Mr Kerrison Preston has interpreted the theme as the attainment by the soul of man of a spiritual state leading to unity with God, based on the theological virtues of Faith, Hope and Charity,[3] while Miss Desirée Hirst[4] has suggested that it illustrates the doctrines of the Kabbala in the Christianised version. It is a particularly complex work and, in the absence of a commentary by Blake himself, as there is for the *Last Judgment* at Petworth,[5] any interpretation must be tentative.

It is possible that the whole work, like the painting of *Hervey's Meditations*,[6] is based on a text, as yet unidentified. Blake read widely in the devotional literature of the eighteenth century, and he illustrated on occasions works that are little read today.[7] Indeed, if Blake had not carefully labelled each figure in the painting of Hervey's *Meditations* the source would have been extremely difficult to identify.

MARGINAL SCENES

If read continuously down from top left and up to top right, the marginal scenes seem to show the progress of man from the Creation to the Redemption by Christ in the Last Judgment. At the same time the scenes on each side are probably intended to be contrasted, although as a whole rather than in individual scenes. Those on the left are predominantly from the Old Testament, with one exception, the *Crucifixion*, while those on the right are from the New Testament, with the possible exception of the unidentified scene of martyrdom.

The scenes, from *top left*, can be read as follows:

I. THE CREATION BY THE ANGEL OF THE DIVINE PRESENCE *Plate 17*

The Angel of the Divine Presence is the creator of man's material nature;[8] in cat. no. 25 he can be seen clothing Adam and Eve with coats of skins. It is not possible to see whether the Angel of the Divine Presence conforms to the type of the old man with the white beard, because the head is too badly damaged.

2. ADAM AND EVE IN THE GARDEN OF EDEN *Plate 17*

The figures of Adam and Eve are damaged. Their hands seem to be in an attitude of prayer towards the Angel of the Divine Presence, but it is not clear. What appear to be a pair of animals (lions?) can be seen to their left.

3. NOAH'S ARK, WITH RAINBOW BENEATH *Plate 17*

Noah's ark was the sole survivor of the world before the Flood, and thus preserves man's connection with the world before the Fall.[9] Noah and his sons Shem and Japhet 'represent Poetry, Painting & Music, the three Powers in Man of conversing with Paradise, which the flood did not Sweep away'.[10]

The rainbow stands below the Ark, in contrast to *Hervey's Meditations*, where it bestrides the Ark. As in the latter work, the Flood is the great division between Eden and the 'Vegetable World'.

4. *left*: ABRAHAM AND ISAAC *Plate 18*

According to Blake, Abraham was originally a Druid, practising a primitive religion based on human sacrifice, hence his refusal to sacrifice Isaac could be seen as a renunciation of Druidism, and the beginning of a new era: 'Abraham was called to succeed the Druidical age, which began to turn allegoric and mental signification into corporeal command, whereby human sacrifice would have depopulated the earth'.[11] In *Hervey's Meditations*, above a similar scene of the sacrifice of Isaac is written: 'Abraham believed God'. The stars above Abraham represent the Children of Israel: 'The Children of Abraham, or Hebrew Church, are represented as a Stream of Figures, on which are seen Stars somewhat like the Milky Way'.[12]

4. *right*: MOSES DESTROYING THE EGYPTIANS IN THE RED SEA *Plate 18*

Moses is an ambiguous figure in Blake's philosophy, and it is probable that Blake had different roles for him at different periods. In *Hervey's Meditations* he is shown with Elias (Elijah) in adoration of Christ, presumably therefore as a prophetic figure, and in the present scene he is seen destroying the Satanic Pharaoh of Egypt. In *Milton, a Poem*, however, he is listed with Abraham, Solomon, Paul, Constantine, Charlemagne and Luther as 'the Male-Females, the Dragon Forms, / Religion hid in War, a Dragon red & hidded Harlot',[13] and he also received from the Angel of the Divine Presence the Decalogue, the 'letter that killeth'. His role here is possibly as the leader of the Children of Israel into the wilderness, under the malign influence of the Angel of the Divine Presence, whom Blake associates with 'the angel of God, which went before the camp of Israel, removed and went behind them',[14] before Moses cast the Egyptians into the sea.

5. JUDGMENT OF SOLOMON *Plate 18*

In *Hervey's Meditations* Solomon is seen lower down the staircase than Aaron, passing by King David. Here Solomon is shown in his Satanic role of dispensing worldly justice in usurpation of divine justice. He seems to be holding in his left hand a pair of compasses, a common Blakean symbol of materialism.[15] Solomon also carries a pair of compasses in *Hervey's Meditations*.

6. THE BABYLONIAN CAPTIVITY *Plate 19*

The scene is taken from Psalm cxxxvii. 2–3: 'We hanged our harps upon the willows in the midst thereof. / For there they that carried us away captive required of us a song'[16]

Babylon is the contrary to Jerusalem, and is the city of worldly desire,[17] described in Revelation as 'the mother of harlots and abominations of the earth'. The Israelites have, therefore, fallen into a state of sin where they are captive to their worldly desires and cut off from God.

7. THE CRUCIFIXION, SEEN FROM BEHIND *Plate 19*

The three crosses are seen from behind, as in cat. no. 22, *The Soldiers casting lots for Christ's Garments*. By showing the Crucifixion from behind Blake has shown it as a result of the form of justice implied in the previous episodes. The inevitable consequence of the justice of Solomon and the submission to Babylon is to create a community that fails to recognise the Saviour and executes him as a common criminal.[18] In the *Four Zoas* (VIII, 325–30), Christ is crucified at Babylon.[19]

Bottom left: A GROUP OF BUILDINGS

A group of buildings by a river can be made out. To the far left is a large classical building with a dome slightly resembling St Peter's, while behind it is a smaller building with a classical portico. In the foreground and opposite bank are what appear to be Druid temples. The domed building may be intended to be a church to symbolise institutional religion. After 1803 Blake became hostile to Greek art and philosophy, seeing it as a perverted imitation of Hebrew originals.[20] Greek philosophy is also described as a 'remnant of Druidism'.[21]

Bottom right: A SHEPHERD PIPING, UNDER A TREE. RIVER AND TREES IN BACKGROUND

This scene is probably intended to provide a contrast to the buildings on the other side, perhaps symbolising the Church Universal and the state of innocence.[22]

The scenes from lower *right* upwards follow the New Testament, with one exception, from the revelation of the divinity of Christ to the Last Judgment presided over by Christ.

1. THE THREE MARYS AT THE SEPULCHRE *Plate 20*

The angel reveals to the three Marys that Christ has risen.[23] Christ is, therefore, revealed as a 'spiritual body', the recognition of which is necessary for redemption. Perhaps intended as a counterpart to the Crucifixion on the other side.

2. PENTECOST *Plate 20*

Acts of the Apostles ii. 1–47. On the day of Pentecost, the Apostles were filled with the Holy Ghost, 'And there appeared unto them cloven tongues like as of fire, and it sat upon each of them.' Blake probably intended the Pentecost episode to show the role of prophecy in the redemption of man, for prophecy was not prediction of the future but apprehension of the divine. Thus artists and poets were prophets in that they were allowed glimpses into the eternal world.[24]

3. A MARTYRDOM BY FIRE, AND ST PETER (?) PRAYING IN PRISON *Plate 21*

The martyr has not so far been firmly identified. Mr Kerrison Preston, on a suggestion from Dr C. H. Talbot, suggests the martyr Eleutherus, who was burnt at the stake in A.D. 189 after conversion by Lucius of Britain.[25] In fact there seems to have been no such martyr, but according to Bede (*Historia Ecclesiae*, c. IV), Lucius, a king of Britain of the second century, petitioned Eleutherus, Bishop of Rome, to send teachers to Britain. The story was taken up by later chroniclers, but there is no legend of the martyrdom of either Lucius or Eleutherus.

The two scenes were possibly intended to show redemption through the purgation of the body, the prison scene showing man as prisoner of the flesh, and the martyrdom his purgation by fire. The scene corresponds to no other work by Blake.

4. THE SEVEN-HEADED BEAST OF REVELATION *Plate 21*

See Revelation xii. 3–10.

The seven-headed beast, who is Satan, is cast out before the Last Judgment. He also appears in similar guise in all Blake's versions of the Last Judgment.

5. ANGELS BLOWING THE LAST TRUMP *Plate 22*

A group of figures to left of angels can be seen, rising upwards towards salvation.

6. CHRIST IN GLORY SEATED ON FLAMES *Plate 22*
Christ's posture is a reversal of that of the Angel of
the Divine Presence on the other side. See *Hervey's
Meditations* where the flames at the top are inscribed:
'God out of Christ is a consuming fire'.

CENTRAL GROUPS

The central groups remain problematic in detail, although
it is clear that they are closely related in theme to the
marginal scenes. At the top can be seen (somewhat damaged)
the Holy Ghost. To Blake the Holy Ghost is the divine in
man, the 'Eternal Humanity Divine', or Jesus, whose
gifts to men are 'Imagination, Art and Science and all
Intellectual gifts'.[26] The central groups, therefore, are
directed towards the apprehension of man's true humanity.
It is possible that Blake also intended there to be a polarity
between left and right within the central group, following
the left–right polarity of the marginal scenes.

Centre bottom: FAITH, CHARITY AND HOPE
Identified as the theological virtues by W. M. Rossetti[27]
and accepted by all critics since. The figures of Faith and
Hope are contrasted, and are again probably intended to
be associated with the marginal scenes. Faith is shown
looking downwards towards a book, while Hope, held
down by the anchor, looks upward, towards Heaven.
Faith is traditionally represented as a female figure
carrying a cross and communion cup, but Blake follows the
traditional iconography of Hope.[28]

The figure between them, assumed to be of Charity, is
more problematic. From the sixteenth century onwards
Charity was universally shown as a female figure,[29] either
suckling or protecting a group of children, a motif used by
Blake himself in the Butts painting of *Faith, Hope and
Charity*.[30] In the present painting the figure assumed

to be of Charity is represented crowned, carrying a sceptre
in her left hand, making a gesture of blessing towards the
spectator. She stands in an aura that illuminates the area
around her whole body. It should be noted that the large
female figure above her corresponds more readily to the
concept of Charity used by Blake in the Butts painting.
Although the babes are not suckling, her breasts are bared.
Two infants seem to be trying to bathe within her aura,
while she is grasping the hand of one infant, and about to
take the hand of another. A possible explanation of the
crowned figure, and one that must remain extremely
tentative, is that Blake was aware of an interpretation of
Charity that was current in Italy in the later thirteenth
and fourteenth centuries. According to R. Freyhan,[31] the
Augustinian distinction between Caritas as *amor proximi*
and *amor dei* was expressed by two different kinds of
representation of Caritas; the former by one or all of the
six Acts of Mercy; and the latter, following Niccolo
Pisano's Siena Cathedral pulpit (1266–8),[32] by a cornu-
copia issuing flames or, as in Ambrogio Lorenzetti's altar-
piece in the Palazzo Municipale at Massa Maritima, by an
arrow in one hand and a burning heart in the other. Other
representations can be found of the same period showing
Caritas holding a cornucopia overflowing with fruits and
wearing a crown.

Kerrison Preston describes the female figure above the
crowned figure as the 'Spirit of Love, soaring to heaven on
her middle course between Wantonness on the one hand
and Abstinence (or Repression) on the other'. These two
figures are certainly intended to be contrasting but their
exact significance is not clear. It would be likely, if Blake
intended to represent Charity in two different states, that
the two figures are Faith and Hope also in different states;
Faith being enclosed in a net-like garment and Hope flying
upwards, free of her anchor.

The praying female figure, upheld by angels, below the Holy Ghost, has been identified by Mr Preston as the 'Soul of Man', and W. Graham Robertson saw the whole picture as symbolising the Immaculate Conception and this figure as representing the Virgin Mary.[33] Mr Preston sees the standing figure on the left holding a sceptre (?) (identified by Miss Piloo Nanavutty as a 'long-stemmed lotus-bud', an Indian emblem of creation or fertility),[34] as Enitharmon, and the figure on the right singing praises as Los. Although damaged the latter figure seems rather to be female, and both figures may be extensions into a third state of those beneath.

NOTES

1. The lost paintings of *The Last Judgment* and the *Ancient Britons* were larger, according to descriptions (see Smith, 1829, p. 480 for the former, and for the latter, T. Wemyss Reid, *The Life, Letters and Friendships of Richard Monckton Milnes, First Lord Houghton*, II, p. 222, letter from Seymour Kirkup).

2. The picture was in a much damaged condition when it was relined and restored in 1906 by Stanley Littlejohn of the British Museum. Some overpainting was done, but this was removed and the whole picture carefully restored by Dr John Hell in 1950. For a discussion of the technique of tempera painting see the introduction to the previous section, note 2.

3. Preston, 1949, p. 6.

4. Letter in *Country Life*, CVII, 1950, p. 456.

5. Keynes, *Letters*, 1968, p. 128–32, nos. 87–9.

6. *Epitome of James Hervey's 'Meditations among the Tombs'*, Tate Gallery (see Butlin, 1957, p. 52–3, no. 39, pl. 23).

7. See, for example, the description of the lost painting of *The Spiritual Preceptor*, from Swedenborg in the *Descriptive Catalogue*, Keynes, *Works*, 1957, p. 581.

8. See catalogue entry for cat. no. 22 for further discussion of the Angel of the Divine Presence.

9. Damon, 1965, p. 300.

10. *A Vision of the Last Judgment*; Keynes, *Works*, 1957, p. 609.

11. *Descriptive Catalogue*. Keynes, *Works*, 1957, p. 578.

12. *A Vision of the Last Judgment*, Keynes, *Works*, 1957, p. 610.

13. Keynes, *Works*, 1957, p. 528.

14. Exodus xiv. 19. See also *A Vision of the Last Judgment*. Keynes, *Works*, 1957, p. 610.

15. Painting of the same subject in the Fitzwilliam, cat. no. 21.

16. Painting of the same subject in the Fogg Museum, Harvard University. Keynes, *Bible*, 1957, no. 78.

17. Damon, 1965, p. 33.

18. *Everlasting Gospel*. Keynes, *Works*, 1957, p. 748–59.

19. Keynes, *Works*, 1957, p. 349.

20. Letter to Hayley, 23 October 1804. Keynes, *Letters*, 1968, p. 137.

21. *Jerusalem*, p. 52. Keynes, *Works*, 1957, p. 682.

22. See *Songs of Innocence and of Experience*, in particular 'The Garden of Love' (*Experience*) in which a chapel is built on the green, perhaps intended to contrast with 'The Echoing Green' in *Songs of Innocence*. See cat. nos. 5 and 6.

23. See cat. no. 24 for another version of the subject.

24. *Descriptive Catalogue*. Keynes, *Works*, 1957, p. 576.

25. Preston, 1949, p. 10.

26. *A Vision of the Last Judgment*, Keynes, *Works*, 1957, p. 604.

27. Gilchrist, *op. cit.* p. 231, no. 199.

28. For example the set of engravings of the theological virtues by H. Goltzius, engraved by J. Saenredam. Faith carries a cross and communion cup, Charity a suckling child and two children, and Hope is seated on an anchor looking upwards. A bible is occasionally associated with Faith, but the anchor invariably accompanies the figure of Hope.

29. E. Wind, 'Charity', in *Journal of the Warburg Institute*, I, no. 4, p. 322–30.

30. Formerly Rothschild collection. Keynes, *Bible Illustrations*, 1957, no. 158.

31. R. Freyhan, 'The Evolution of the Caritas figure in the Thirteenth and Fourteenth centuries', in *Journal of the Warburg and Courtald Institutes*, XII, 1948, p. 68–86.

32. *Ibid.*, pl. 14a.

33. Gilchrist, 1907, p. 453.

34. See Preston, 1949, p. 12.

34 PARADISE REGAINED—twelve designs

Signed but not dated, c. 1816–18.

Pen, Indian ink, grey wash and watercolour.

Bequeathed by T. H. Riches in 1935, received 1950. PD. 14–25—1950.

Coll.: Bt. from Blake by John Linnell, 1825;[1] Linnell trustees; Linnell sale, Christie's, 15 March 1918 (151), bt. by Messrs Carfax for T. H. Riches (for 2,100 gns.); Mrs T. H. Riches (d. 1950).

Exh.: B.F.A.C., 1876 (189–200);[2] Agnew, 1923 (62–73).

Lit.: Gilchrist, 1863, I, p. 335; II, p. 215–16, cat. no. 100A–L; Figgis, 1925, p. 69–70; Keynes, *Milton*, 1926, p. 278–9; *Studies*, 1949, p. 144; *Letters*, 1968, p. 145, no. 122a (John Linnell's cash account book, p. 148, no. 124 (accounts between Blake and John Linnell).

Reprod.: Figgis, 1925, pl. 23–34; Keynes, *Milton*, 1926.

Gilchrist dates the series 1825, but this was the year in which Linnell bought the series from Blake. On stylistic grounds they seem to have been done some years earlier, and they are close in style to the illustrations to Milton's *L'Allegro and Il Penseroso* in the Pierpont Morgan Library, New York. Furthermore the watermark 'M & J Lay 1816', which is to be found on A, F, and K, is also found on the Pierpont Morgan watercolours. The Pierpont Morgan watercolours can probably be dated to the years 1816–18,[3] when Blake was attempting to complete the series of Miltonic illustrations for Thomas Butts, but the latter's failure to purchase the *Paradise Regained* series from Blake may be evidence of a growing lack of sympathy between the two.

One of a set of watercolour copies by J. T. Linnell was exhibited in 1913 (Tate, 1913 exh. cat., no. 53), lent by the Linnell Trustees.

All quotations are taken from *The Poems of John Milton*, ed. by John Carey and Alastair Fowler, Longmans, 1968.

A. THE BAPTISM OF CHRIST — *Plate 23*

PD.14—1950.

Signed 'W Blake inv.' (b.r.), and inscr. '2' below picture area.[4]

$6\frac{13}{16} \times 5\frac{3}{8}$ ($17 \cdot 4 \times 13 \cdot 6$); watermark 'M & J Lay 1816'.

Lit.: Hagstrum, 1964, p. 53–4.

St John baptising Christ while the Spirit descends 'in likeness of a dove'. Satan, 'the adversary', in form of a young man, observes the event 'then with envy fraught and rage / Flies to his place' (Book 1, 29–39).

B. CHRIST TEMPTED BY SATAN TO TURN THE STONES INTO BREAD — *Plate 24*

PD.15—1950.

Signed 'W Blake inv.' (b.r.), and inscr. '2' below picture area.

$6\frac{5}{8} \times 5\frac{3}{16}$ ($16 \cdot 8 \times 13 \cdot 3$).

Exh.: N.G.B.A., 1913 (52i); Manchester, 1914 (59i); Nottingham, 1914 (43i); Edinburgh, 1914 (34); B.F.A.C., 1927 (50i).

Christ enters the Wilderness after the Baptism, and after forty days he is met by Satan in the guise of 'an aged man in rural weeds'. Satan tempts Christ to change the stones into bread to provide himself with sustenance. Christ refuses, pointing out that his sustenance derives from Heaven (Book 1, 337–45). Their gestures, therefore, contrast the spirituality of Christ

with the materialism of the adversary. An alternative design for this subject is in the Frick Collection, New York.

C. ANDREW AND SIMON PETER SEARCHING FOR CHRIST *Plate 25*

PD.25—1950.

Signed 'W Blake inv.' (b.r.), and inscr. '3' below picture area.

$6\frac{11}{16} \times 5\frac{7}{16}$ ($17 \times 13 \cdot 8$).

The two disciples, Andrew and Simon Peter,[5] seek Christ in vain during his withdrawal to the wilderness, near to the place of the Baptism, wondering whether he has been, like Moses and Elijah, 'caught up to God', before his return to earth. The two attendant angels are not mentioned in Milton's text. The town in the background is presumably 'Jericho the city of palms' (Book II, 7—24).

D. MARY'S LAMENTATION FOR CHRIST *Plate 26*

PD.16—1950.

Signed 'W Blake inv.' (b.r.), and inscr. '4' below picture surface.

$6\frac{11}{16} \times 5\frac{3}{8}$ ($17 \times 13 \cdot 6$).

Exh.: Brussels, 1929 (6).

Mary, at her distaff, meditates on her fate as mother of the Son of God, lamenting the absence of Christ in the wilderness (Book II, 60—108). The angels are not mentioned in Milton's text, but for a similar conception of Mary's dwelling-place see Blake's illustrations to *On the Morning of Christ's Nativity*, nos. 1 and 6.[6]

E. SATAN ADDRESSING HIS POTENTATES *Plate 27*

PD.17—1950.

Signed 'W Blake inv.' (b.r.), and inscr. '5' below picture surface.

$6\frac{13}{16} \times 5\frac{1}{4}$ ($17 \cdot 3 \times 13 \cdot 3$).

Satan, again as a young man, announces the failure of his first attempt to corrupt Christ, and calls upon the aid of the 'Powers of fire, air, water, and earth beneath' (Book II, 118—48).

F. CHRIST REFUSING THE BANQUET *Plate 28*

PD.18—1950.

Signed 'W Blake inv.' (b.l.), and inscr. '6' below picture surface on right.

$6\frac{3}{4} \times 5\frac{5}{16}$ ($17 \cdot 1 \times 13 \cdot 5$); watermark 'M & J Lay 1816'.

Lit.: Digby, 1957, p. 42.

(Book II, 337—91). Satan appears again in disguise, 'Not rustic as before, but seemlier clad / As one in city, or court, or palace bred' (Book II, 299—300). He tempts Christ fruitlessly with sensual pleasures. The female figures in the foreground, two naked and one scaled, are presumably 'ladies of the Hesperides, that seemed / Fairer than feigned of old'. The angels in the centre background are, perhaps, a reference to Christ's reply to Satan: 'I can at will, doubt not, as soon as thou, / Command a table in this wilderness, / And call swift flights of angels ministrant / Arrayed in glory on my cup to attend.'

Satan presides over the scene, arms extended, in a manner similar to Death in the *Lazar House* (cat. no. 17). The crown held by Satan in his left hand is

not mentioned in Milton's description of the banquet, but may be a reference to 11. 457–9: 'What if with like aversion I reject / Riches and realms: Yet not for that a crown / Golden in show, is but a wreath of thorns.'

G. SATAN TEMPTS CHRIST WITH THE KINGDOMS OF THE EARTH

Plate 29

PD.19—1950.

Signed 'W Blake inv.' (b.r.), and inscr. '7' below picture surface.

$6\frac{5}{8} \times 5\frac{3}{16}$ (16·8 × 13·1).

Exh.: N.G.B.A., 1913 (52 ii); Manchester, 1914 (59 ii); Nottingham, 1914 (43 ii); Edinburgh, 1914 (35); B.F.A.C., 1927 (50 ii).

(Book III, 251–426): Satan tempts Christ with the offer of earthly dominion by assuming the imperial throne of David. Satan and Christ are shown on top of a mountain, but instead of a vista encompassing the empires of the world, as in Milton's description, Blake shows people bowing down and making sacrifices to an idol. (See the *Sacrifice to Moloch*, from the illustrations to *On the Morning of Christ's Nativity*, no. 5.[6] This may refer to Christ's reply to Satan, who had suggested to Christ that by assuming the throne of David he could then rescue the lost tribes of Israel. 'Nor in the land of their captivity / Humbled themselves, or penitent besought / The God of their forefathers; but so died / Impenitent, and left a race behind / Like to themselves, distinguishable scarce / From Gentiles, but by circumcision vain, / And God with idols in their worship joined.'

H. CHRIST'S TROUBLED SLEEP

Plate 30

PD.20—1950.

Signed 'W Blake inv.' (b.r.), inscr. '8' below picture surface.

$6\frac{5}{8} \times 5\frac{1}{4}$ (16·8 × 13·3).

Exh.: N.G.B.A., 1913 (52 iii); Manchester, 1914 (59 iii); Nottingham, 1914 (43 iii); Edinburgh, 1914 (40); B.F.A.C., 1927 (50 iii).

Satan returns Christ to the wilderness, 'and soon with ugly dreams / Disturbed his sleep;'. Having failed to tempt Christ by earthly rewards, Satan now attempts to frighten him with a storm and phantoms (Book IV, 401–25).

I. MORNING CHASING AWAY THE PHANTOMS

Plate 31

PD.21—1950.

Signed 'W Blake inv.' (b.r.), and inscr. '9' below picture surface.

$6\frac{1}{2} \times 5\frac{1}{8}$ (16·5 × 13)

Exh.: N.G.B.A., 1913 (52 iv); Manchester, 1914 (59 iv); Nottingham, 1914 (43 iv); Edinburgh, 1914 (41); B.F.A.C., 1927 (50 iv).

'Thus passed the night so foul till morning fair / Came forth with pilgrim steps in amice grey; / Who with her radiant finger stilled the roar / Of thunder, chased the clouds, and laid the winds, / And grisly spectres, which the Fiend had raised / To tempt the Son of God with terrors dire' (Book IV, 426–31).

J. CHRIST PLACED ON THE PINNACLE OF
THE TEMPLE *Plate 32*

PD.22—1950.

Signed 'W Blake inv.' (b.l.), and inscr. '10' (b.r.)
below picture surface.

$6\frac{9}{16} \times 5\frac{1}{4}$ (16·6 × 13·3).

Christ's final trial, in which he reveals Himself
finally as the Son of God by standing on the pinnacle
of the Temple. Satan falls, 'smitten with amaze-
ment'. The angels wait to carry Christ away (Book
IV, 549–71).

K. ANGELS MINISTERING TO CHRIST *Plate 33*

PD.23–1950.

Signed 'inv / W Blake' (b.l.), and inscr. '11' (b.r.)
below picture surface.

$6\frac{1}{2} \times 5\frac{3}{8}$ (16·5 × 13·6); watermark 'M & J Lay /
1816'.

Exh.: Brussels, 1929 (17).

Christ being fed by angels, while 'angelic choirs /
Sung heavenly anthems of his victory / Over
temptation, and the tempter proud' (Book IV,
581–95).

L. CHRIST RETURNS TO HIS MOTHER *Plate 34*

PD.24—1950.

Signed 'W Blake inv.' (b.r.), and inscr. '12' below
picture surface (possibly over other numbers).

$6\frac{5}{8} \times 5\frac{1}{4}$ (16·8 × 13·3).

Blake here illustrates the last lines of the poem: 'he
unobserved / Home to his mother's house private

returned' (Book IV, 638–9). Andrew and Simon
Peter are shown as present at Christ's homecoming,
but this is not mentioned in the text.

NOTES

1 On 10 October and 19 November 1825, Linnell made payments to
Blake of £5, totalling £10 (Keynes, *Letters*, 1968, p. 148,
Blake–Linnell accounts). According to Gilchrist, I, p. 335,
Linnell had tried to persuade Francis Chantrey to buy them from
Blake for £20, and on 8 February 1827 he left them with Sir
Thomas Lawrence at a price of £50. (See Keynes, in *T.L.S.*
13 June 1958, p. 332.) *Ivimy Papers*, 7 April 1832 'left Par.
Regained with Mr. Rogers' (? Samuel Rogers). Recovered by
Linnell, 14 April 1832.
 W. M. Rossetti wrote to Mrs Gilchrist 13 December 1862:
'I will consider about the Paradise Regained. The designs were
shown to me by John Linnell as being more than usually beautiful,
and I do not directly *dissent* from the terms used in the slip you
send me; only my feeling is that Blake has here been less inspired
than usual, and the result comparatively tame' (Rossetti, 1903,
p. 11).

2 Described as having been painted for Thomas Butts.

3 Thomas Dibden, the bibliographer, describes a visit from Blake in
1816–17 as follows: 'The immediate subject of our discussion—and
for which indeed he professed to have in some measure visited me—
was "the minor poems of Milton".' (T. Dibden, *Reminiscences
of a Literary Life*, 1836, p. 600–1.) This cryptic reference
suggests that Blake was seeking advice about his own illustrations
for *L'Allegro and Il Penseroso*, for his other illustrations to the
Minor Poems were finished much earlier (i.e. *Comus*, and *On the
Morning of Christ's Nativity*).

4 It is not clear why Blake numbered this watercolour '2'; the
figure '2' possibly corrects a figure '1'.

5 This watercolour was wrongly identified by W. M. Rossetti
as 'Christ and the Baptist, with two Angels'. It was first correctly
placed in order by Keynes, in *Milton*, 1926.

6 Versions in the Huntington Library, San Marino, and the Whit-
worth Art Gallery, Manchester.

35 A PROPHET IN THE WILDERNESS

Not signed or dated. *Plate 35*

Pen, Indian ink, body colour, heightened with white; scraped in parts; $6\frac{1}{4} \times 4\frac{11}{16}$ ($15\cdot9 \times 11\cdot9$).

Purchased from T. H. Riches Fund, 1944. 2717.

Coll.: First owner or owners not known; Dr John Hillier Blount (1822–66);[1] his daughter, Miss Eleanor Blount; her niece, Mrs William Tennant, née Catherine Mary Blount; Christie's (different properties), 21 July 1944 (21), bt. by Messrs Eisemann (for £102 18s); purchased from them (for £113 4s).

This watercolour was bought as a possible rejected design for the *Paradise Regained* series (cat. no. 34) of Christ in the Wilderness. It differs, however, from the latter in medium and slightly in size, and the radiance is of a different form. The facial type is close to that of Christ in the *Paradise Regained* series, but this does not allow a positive identification, because Blake frequently used the same facial type for different prophets—as, for example, in *Isaiah foretelling the Destruction of Jerusalem*, pencil and Indian ink drawing on woodblock (British Museum Print Room). The figure could, therefore, be either Christ or Ezekiel in the wilderness.

NOTE

1 Dr Blount took his M.D. at King's College, London, in 1846, and became Medical Officer of Windlesham and Bisley district. He left England for Calcutta in 1866, and died there the same year. The circumstances under which he acquired the watercolour are unknown, but according to his daughter he would often receive gifts of paintings as payment for medical services. (Information kindly conveyed by Lady Tennant.) For further details of Dr Blount see H. Blount, *A History of the Blount Family*, 1960 (privately printed).

THE LAST YEARS:
THE PATRONAGE OF JOHN LINNELL—1818–1827

John Linnell was introduced to Blake in 1818 by the son of Blake's old friend George Cumberland, who later commissioned a bookplate from him. Linnell gradually took over the role of Thomas Butts in supporting Blake by commissioning illustrations, but Linnell also hoped to enable Blake to stand on his own feet by publishing his designs in a more commercial manner.[1] The accounts between Blake and Linnell are still in existence, and they record the purchase of a number of items that are now in the Fitzwilliam.[2] In 1819 Linnell bought from Blake a copy of *Songs of Innocence and of Experience* (cat. no. 5), in 1821 *The Marriage of Heaven and Hell* (cat. no. 9), and possibly in 1822 *Europe* (cat. no. 15) and *America* (cat. no. 13).

In 1822 Linnell commissioned Blake to make a number of copies of watercolours that he had presumably seen at Thomas Butts' house, including three from the *Paradise Lost* series, of which *St Michael foretelling the Crucifixion* is in the Fitzwilliam, and also of *The Wise and Foolish Virgins*, a design that Blake was to repeat later for Sir Thomas Lawrence.

Linnell's reluctant purchase of the *Paradise Regained* series (cat. no. 34) in 1825 has already been mentioned, and the progress of the publication of the engravings for the *Book of Job* in the same year can be closely followed in the Fitzwilliam collection. Blake was to make a set of 21 copper engravings based on the two watercolour series already purchased by Butts and Linnell. The engraving began in 1823, and in that year Blake probably made the set of reduced drawings in a small sketchbook which passed into Linnell's collection. The Fitzwilliam also possesses a remarkable set of unfinished proofs of all the engravings, apart from the title-page, which again came from Linnell's collection, as well as four proofs coloured by Blake himself, and two published sets.

The last year of Blake's life, 1827, is represented by a set of the engraved *Illustrations to Dante*, with a letter to John Linnell describing their progress, and another to George Cumberland in Bristol, dated 12 April 1827, in which Blake gives intimations of his impending death: 'I have been very near the Gates of Death & have returned very weak & an Old Man feeble & tottering. but not in Spirit & Life not in The Real Man The Imagination which Liveth for Ever.'

NOTES

1 See Story, 1892, I, p. 158.
2 The Blake–Linnell accounts have been published in full in Keynes, *Letters*, 1968, which also contains valuable extracts from Linnell's journal and account books.

36 THORNTON'S 'VIRGIL'

By Robert John Thornton, M.D.; 3rd edition, 2 vols., London, Rivingtons, 1821.

Lit.: Gilchrist, 1863, I, p. 270–5, II, p. 258; also 1880 and 1907 editions; Keynes, *Bibliography*, 1921, p. 211–14, cat. no. 77; *The Illustrations of William Blake for Thornton's Virgil*, 1937; Bentley, 1964, p. 161, no. 411.

Of the 230 illustrations, Blake was responsible for designing and executing 4 engravings, and 17 woodcuts illustrating Ambrose's imitation of the Eclogues. The Museum's collection comprises the following proof plates of the woodcuts:

1. Nos. VI–IX, printed on one sheet.[1]

 Given by C. Fairfax Murray in 1905.

 Coll.: see cat. no. 4.

 Inserted in holograph MS. *An Island in the Moon* (cat. no. 4).[2]

2. Nos. I–XVII, after the blocks had been cut down to fit the page.

 Given by Mrs T. T. Greg, 1924.

3. Nos. I–XVII, after the blocks had been cut down to fit the page, mounted on separate leaves in a small notebook.

 Bequeathed by T. H. Riches in 1935, received 1950. P.59—1950.

 Coll.: John Linnell; his daughter, Mary Linnell;[3] the Riches family.

4. Nos II–IX, XII, after the blocks had been cut down to fit the page.

 Purchased from the T. H. Riches Fund, 1941 (from W. H. Robinson, bookseller, for £10).

NOTES

1 All the blocks, except the first, after they left Blake's hands were found to be too large for the page for which they were intended, and were cut down regardless of the designs; proofs taken from the blocks before this was done show that they originally measured 35 to 40 × 84 mm. and they have therefore lost about 5 × 10 mm. Proofs from the blocks in this state are extremely rare; those which are in existence show that the designs were cut four at a time on single blocks of wood, which were afterwards divided up.

2 On the third leaf of the MS is a letter reading: 'The proof of Thornton's / "Pastorals" now in your possession, / is one of two which were / taken by Blake himself at / Fountain Court at his own press / in my father's presence, and / signed at the same time. / I possess the companion / proof and a letter of my father's / describing the transaction. / The "Pastorals" are described / in the 30th chapter of Gil / christ's "Life" (1st. Ed.) and / as you know, are very highly / esteemed by admirers of Blake / Yours faithfully / A. H. Palmer.'

3 Inscribed on the inner cover 'Mary Linnell', and on the fly-leaf 'Mary Linnell / given to her by her Papa'.

37 THE ARCHANGEL MICHAEL FORE-TELLING THE CRUCIFIXION *Plate 36*

Not signed or dated; begun 1822.[1]

Pen, Indian ink, grey wash and watercolour; $19\frac{3}{4} \times 15\frac{1}{8}$ (50·2 × 38·5).

Bequeathed by T. H. Riches in 1935, received 1950. PD.49—1950.

Coll.: Painted for John Linnell (d. 1882); the Linnell Trustees; Linnell sale, Christie's, 15 March 1918 (154), bt. by Messrs Carfax for T. H. Riches (for 380 gns); Mrs T. H. Riches (d. 1950).

Exh.: B.F.A.C., 1876 (212, 213, or 214);[2] Agnew, 1923 (75); B.F.A.C., 1927 (48); Brussels, 1929 (5); R.A., 1934 (777); *Comm. Cat.* 1935 (711); Port Sunlight, 1950 (13).

Lit.: Gilchrist, 1863, II, p. 212, cat. no. 93; Figgis, 1925, p. 89; Keynes, *Milton*, 1926, p. 359; *T.L.S.* 1958, p. 332.

Reprod.: Keynes, *Milton*, 1926, pl. facing p. 344.

One of three[3] watercolours made in 1822 for John Linnell after earlier designs for *Paradise Lost*. Two series of watercolours for *Paradise Lost*, dated 1807 and 1808, each contain a version of the same subject.[4] The subject is taken from *Paradise Lost*, Book XII, 411–19.

NOTES

1 An entry in John Linnell's manuscript journal records under 9 May 1822: 'Mr Blake began copies from his drawings from Milton's P.L'. See Keynes in *T.L.S.* 13 June 1958, p. 332.

2 No. 212 corresponds most closely to the measurements of the present drawing. Nos. 213 and 214 would be the two other drawings from the series now at Melbourne.

3 The two companion watercolours, now at Melbourne, are of *Satan watching the Endearments of Adam and Eve* and *The Creation of Eve*.

4 The 1807 series is now in the Huntington Library, San Marino, California (see R. R. Wark, *Catalogue of William Blake's Drawings and Paintings in the Huntington Library*, 1957, p. 15–26) and that from the 1808 series is in the Museum of Fine Arts, Boston, which owns nine of the original set of twelve.

38 THE WISE AND FOOLISH VIRGINS

Plate 37

Signed 'W Blake inv' (b.r.), no date, *c.* 1822.

Pen, Indian ink, grey wash and watercolour; $14\frac{5}{16} \times 13\frac{1}{4}$ (36·3 × 33·7).

Bequeathed by T. H. Riches in 1935, received 1950. PD.50—1950.

Coll.: Obtained from Blake by John Linnell (for whom it was painted); Linnell Trustees; Linnell sale, Christie's, 15 March 1918 (155); bt. by Messrs Carfax for T. H. Riches (for 260 gns.); Mrs T. H. Riches (d. 1950).

Exh.: B.F.A.C., 1876 (215); Ickworth, 1969 (82).

Lit.: Gilchrist, 1863, II, p. 212, cat. no. 94 (dated 1822); Story, 1893, p. 70; Butlin, 1957, p. 52; Keynes, *Bible*, 1957, p. 38; *T.L.S.* 30 June 1958, p. 332.

One of a total of six versions of the same subject. The present example was probably painted for Linnell *c.* 1822, almost certainly in similar circumstances to *The Archangel Michael foretelling the Crucifixion* (cat. no. 37).[1] The first version was painted for Butts,[2] and appears in an account of 12 May 1805.[3] This version was presumably used as a prototype for the Fitzwilliam example. Other versions, except that in the Paul Mellon collection, all appear to be later, one painted for Sir Thomas Lawrence dates from 1826–7,[4] and Butlin dates the Tate Gallery example to the same period. The Paul Mellon version may be close in date to the present example. A further version, now in Santa Barbara, is described by Butlin as the last of the series.[5] Martin Butlin has recently suggested that the Tate and Santa Barbara versions may be copies, possibly by a member of the Linnell family.

The subject is taken from Matthew xxv. 1–9. The five wise virgins stand with their lamps on the left and tell the foolish ones, who kneel in distracted attitudes on the ground, to go and buy oil from 'them that sell'. An angel with a trumpet in the sky above heralds the approach of the bridegroom.

NOTES

1 Gilchrist gives 1822 as the date of the present example.

2 Metropolitan Museum, New York (inv. no. 14.81.2).

3 Keynes, *Letters*, 1968, p. 117, no. 68; Bentley, *Blake Records*, 1969, p. 572.

4 Collection of Mr Philip Hofer, Cambridge, Mass.

5 See Butlin, 1957, p. 51–2 for further discussion, and also his article in the *Burlington Magazine*, C, 1958, p. 41, and also n. 5.

39 ILLUSTRATIONS TO THE BOOK OF JOB

Plates 38–61

Not signed or dated, but inscribed on accompanying wrapper, in ink: 'These are M^r Blakes reduced Drawings / & studies for the Engravings of The Book of Job / Done for me / John Linnell'.

Thirty leaves previously bound, containing pencil drawings, some with watercolour and Indian ink added; approx. $8\frac{3}{4} \times 5\frac{3}{4}$ (22·5 × 14·5).

Bequeathed by T. H. Riches in 1935, received 1950. PD.26/48A—1950.

Coll.: John Linnell (d.1882); the Linnell Trustees; John Linnell sale, Christie's, 15 March 1918 (150), bt. by Messrs Carfax for T. H. Riches (for 480 gns.); Mrs T. H. Riches (d. 1950).

Exh.: N.G.B.A., 1913 (83); Manchester, 1914 (116–21); Nottingham, 1914 (75–8); Edinburgh, 1914 (82–5).

Lit.: Binyon and Keynes, *Job*, 1935, fascicle, I, p. 20–49; Keynes, *Studies*, 1949, c. XII, 'The history of the Job designs', p. 119–34; *Letters*, 1956, pp. 183–4, 196.

Reprod.: Keynes, *Drawings*, 1927, pls. 57–78; Binyon and Keynes, *Job*, 1935, fascicle IV, the complete set in colour.

The role of these drawings is made clear by John Linnell's inscription on an accompanying wrapper, quoted above. They were intended to be reductions of the watercolour set of illustrations to the *Book of Job*, for the purpose of engraving them, the final engraved designs being approximately half the area of the first set of watercolours. There are three sets of watercolours connected with the *Book of Job*, and they and the present set of drawings have been excellently reproduced and exhaustively compared with each other in the volume by Binyon and Keynes cited above.

The first set was almost certainly that from the Butts collection, now in the Pierpont Morgan Library, New York, although no record of any transaction is known. The Butts set seems to have been used as a model by John Linnell for another series now largely in the Fogg Museum, Harvard University,[1] begun by Linnell and finished by Blake, for there are two entries in A. H. Palmer's transcript of Linnell's Journal, reading as follows: [7 September 1821] 'Traced outlines from Mr Blake's designs for Job all day', and [10 September 1821] 'Traced outlines etc. from Mr Blake's drawings of Job all Day. Mr Blake finishing the

outlines all day Monday 10th'.[2] On 25 March 1823 a formal agreement[3] was made by Blake and Linnell for the former to produce engraved designs of the *Book of Job*, and it is probably in this year that he made the present drawings. A further series of watercolours, including the title-page, known as the New Zealand set because it reappeared in that country in 1928, is identified by Binyon and Keynes as the final set of reduced versions for the engravings, because of their closeness to the engravings, although they retain some similarities to the earlier versions.[4] This argument is not altogether convincing, and the authorship of the New Zealand set must remain an open question[5] with the strong possibility that they may be copies by a member of the Linnell family. The New Zealand set, now in the possession of Mr Paul Mellon, is known to have belonged to Albin Martin, a pupil of John Linnell, who was probably the original owner. The date of publication of the engravings is given on the title-page as 8 March 1825, but they were probably not finally finished until early in 1826.

The pencil drawings do not contain a design for the title-page[6] of the published engravings, but they do contain, in addition to the published design, an alternative design for *Every man also gave him a piece of money*, which was not engraved. The pencil drawings are the only set to contain this unpublished design, but it exists in two independent versions, one of which, in the British Museum, is more finished.[7] Of the watercolour sets only the New Zealand set contains a design for the title-page, but apart from this addition the watercolour sets are identical in distribution of subjects with each other, and correspond, with individual variations, to the published engravings.

The order of the present set of pencil drawings cannot be established with certainty because the leaves are no longer stitched and no possible rearrangement of the leaves

corresponds exactly to the order of the engravings. The order in which they are placed below is closest to the numbering of the engravings. The number in the top right-hand corner of most of the pencil drawings, in a later hand, refers to the number of the engraved plate. The sizes quoted below are of the design, not of the full page and, generally, only the design has been reproduced here.

1. Verso: Two sketches in pencil for the daughter kneeling at the right of Job's wife in pl. 1, *Job and his family*; PD.48A—1950. Recto blank. *Plate 38*

 $3\frac{1}{8} \times 1\frac{3}{4}$ (7·9 × 4·5), approx.

 Martin Butlin suggests, on the basis of the stitch-holes, that the sketches may have been on the recto leaf and therefore upside down in relation to the following drawings.

2. Recto: Study for pl. 1, *Job and his family*, with an enlarged study below of the daughter on Job's left; PD.27—1950. Verso blank. *Plate 39*

 Pencil, Indian ink with some white heightening; $2\frac{7}{8} \times 4\frac{3}{4}$ (7·3 × 12).

 This drawing is probably preliminary to no. 3, which is more highly finished. Some light stains on the recto also seem to match up with the verso of no. 1. Keynes suggests that no. 3 is later because the heads of the two daughters on either side of Job are nearer the engraving than in no. 2.[8]

3. Recto: *Job and his family*, for pl. 1;[9] PD.26—1950. Verso blank. *Plate 40*

 Inscr. '1' (t.r.) in pencil, on recto.

 Pencil, Indian ink, grey wash, with some white heightening; $3\frac{5}{8} \times 4\frac{3}{4}$ (9·2 × 12).

Suggestions of a marginal design are lightly indicated in pencil above and below the design.

4. Recto: *Satan before the throne of God*, for pl. 2;[10] slight indications of marginal design in pencil; PD.28—1950. Verso blank. *Plate 41*

 Inscr. '2' (t.r.) in pencil, on recto.

 Pencil, Indian ink with blue and grey wash; $5\frac{7}{16} \times 3\frac{13}{16}$ (13·9 × 9·8).

5. Recto: *Job's sons and daughters overwhelmed by Satan*, for pl. 3; slight indications of marginal design; PD.29—1950. Verso blank. *Plate 42*

 Inscr. '3' (t.r.) in pencil, on recto.

 Pencil, Indian ink and grey wash; $5 \times 3\frac{3}{4}$ (12·7 × 9·5).

6. Recto: *The Messengers tell Job of his misfortunes*, for pl. 4; PD.30—1950. Verso blank. *Plate 43*

 Inscr. '4' (t.r.) in pencil, on recto.

 Pencil, Indian ink and colour washes; $3\frac{5}{16} \times 4\frac{5}{8}$ (8·4 × 11·7).

7. Recto: *Satan going forth from the presence of God*, for pl. 5; PD.31—1950. Verso blank. *Plate 44*

 Inscr. '5' (t.r.) in pencil, on recto.

 Pencil, Indian ink and colour washes; $5\frac{1}{4} \times 4\frac{3}{16}$ (13·3 × 11·2).

8. Recto: *Satan smiting Job with boils*,[11] for pl. 6; PD.32—1950. Verso blank. *Plate 45*

 Inscr. '6' (t.r.) in pencil, on recto.

 Pencil, Indian ink and grey wash; $3\frac{13}{16} \times 4\frac{9}{16}$ (9·7 × 11·5).

9. Recto: *Job's comforters*, for pl. 7; PD.33—1950. Verso blank. *Plate 46*

Inscr. '7' (t.r.) on recto.

Pen and pencil with touches of grey wash; $3\frac{5}{8} \times 4\frac{1}{2}$ ($9\cdot2 \times 11\cdot4$).

10. Recto: *Job's despair*, for pl. 8;[12] PD.34—1950. Verso blank. *Plate 47*

Inscr. '8' (t.r.) on recto.

Pencil, Indian ink, blue and grey wash; $3\frac{1}{2} \times 4\frac{3}{4}$ ($8\cdot9 \times 12$).

11. Recto: *A spirit passes before Job's face*, for pl. 9; PD.35—1950. Verso blank. *Plate 48*

Inscr. '9' (t.r.) on recto.

Pencil, Indian ink and blue and grey wash; $5\frac{1}{2} \times 3\frac{9}{16}$ ($13\cdot9 \times 9$).

12. Recto: *Job rebuked by his friends*, for pl. 10; PD.36—1950. Verso blank. *Plate 49*

Inscr. '10' (t.r.) on recto.

Pencil with blue and grey washes; $3\frac{1}{2} \times 4\frac{7}{8}$ ($8\cdot9 \times 12\cdot4$).

13. Recto: *Job's evil dreams*, for pl. 11; PD.37—1950. Verso blank. *Plate 50*

Inscr. '11' (t.r.) on recto.

Pencil, Indian ink, and blue and grey washes; $3\frac{5}{8} \times 4\frac{5}{8}$ ($9\cdot2 \times 11\cdot7$).

14. Recto: *The wrath of Elihu*, for pl. 12; PD.38—1950. Verso blank. *Plate 51*

Inscr. '12' (t.r.) on recto.

Pencil and grey wash; $3\frac{5}{8} \times 4\frac{7}{8}$ ($9\cdot2 \times 12\cdot4$).

15. Recto: *The Lord answering Job out of the whirlwind*,[13] for pl. 13; PD.39—1950. Verso blank. *Plate 52*

Inscr. '13' (t.r.) on recto.

Pencil, Indian ink and grey wash; $3\frac{7}{8} \times 4\frac{1}{2}$ ($9\cdot9 \times 11\cdot4$).

16. Recto: *When the morning stars sang together*, for pl. 14; PD.40—1950. Verso blank. This drawing is inscribed with what appears to be a kind of signature, beginning 'done by' followed by a series of symbols, including a hand and an eye. They have no precedent in Blake's work, and they remain not entirely clear.[14]

Inscr. '14' (t.r.) on recto. *Plate 53*

Pencil and Indian ink; $5\frac{3}{4} \times 3\frac{5}{8}$ ($14\cdot6 \times 9\cdot2$).

17. Recto: *Behemoth and Leviathan*, for pl. 15; PD.41—1950. Verso blank. *Plate 54*

Inscr. '15' (t.r.) on recto.

Pencil and Indian ink; $5\frac{5}{8} \times 3\frac{7}{8}$ ($14\cdot6 \times 9\cdot9$).

18. Recto: *The fall of Satan*, for pl. 16; PD.42—1950. Verso blank. *Plate 55*

Inscr. '16' (t.r.) on recto.

Pencil with blue and grey washes; $5\frac{1}{4} \times 3\frac{5}{8}$ ($13\cdot3 \times 9\cdot2$).

19. Recto: *The vision of Christ*, for pl. 17; PD.43—1950. Verso blank. *Plate 56*

Inscr. '17' (t.r.) on recto.

Pencil and grey wash; $3\frac{3}{4} \times 4\frac{11}{16}$ ($9\cdot7 \times 11\cdot9$).

20. Recto: *Job's sacrifice*, for pl. 18. *Plate 57*
Verso: *Job and his daughters*, for pl. 20. PD.44—1950.

Inscr. '18' (t.r.) on recto.

Recto: pen, pencil and grey washes; $4\frac{7}{8} \times 3\frac{5}{8}$ ($12\cdot4 \times 9\cdot2$).

Verso: very slight pencil sketch; $3\frac{3}{4} \times 4\frac{1}{8}$ ($9\cdot5 \times 10\cdot5$).

21. Recto: Rejected design for *Every man also gave him a piece of money*;[15] PD.46—1950. Verso blank.

Not numbered. *Plate 58*

Pencil with blue and grey washes; $5\frac{3}{8} \times 4\frac{1}{8}$ (13·3 × 11·5).

22. Recto: *Job and his family restored to prosperity*, for pl. 21; PD.48—1950. Verso blank. *Plate 59*

Inscr. '21' (t.r.) on recto.

Pencil and grey washes; $3\frac{11}{16} \times 4\frac{3}{4}$ (9·4 × 12).

23. Recto: *Every man also gave him a piece of money*, for pl. 19; PD.45—1950. Verso blank. *Plate 60*

Inscr. '19' (t.r.) on recto.

Pencil, Indian ink and grey washes; $3\frac{1}{4} \times 4\frac{3}{8}$ (8·3 × 11·1).

24. Recto: *Job and his daughters*, for pl. 20; PD.47—1950.

Inscr. '20' (t.r.) on recto. Verso blank. *Plate 61*

Pencil and Indian ink; $3\frac{7}{8} \times 4\frac{7}{8}$ (9·9 × 12·4).

This composition develops from an outdoor scene in the Butts version, with Job's vision appearing in the clouds, to an indoor scene with separate panels in the background in the published engraving. The present drawing seems to be at an intermediate stage, with slight indications of the sheep in the foreground but with the upper panels arranged roughly as in the final engraving.[16]

The first leaf of the sketchbook before the designs contains on the verso a profile head in pencil and another indeterminate head which may be by Blake. The second leaf, on the same sheet as no. 1, has on the recto a rough charcoal sketch, probably of some trees. There are five blank leaves at the end.

The leaves that make up the sketchbook are contained in wrappers that were used by Blake, formed by two folded leaves from William Hayley's *Ballads*, 1802, but now cut in half. Blake seems to have had a stock of proofs of this book, which he used for occasional sketches.[17] The outermost wrapper, to judge from the soiling, is made from p. 37 of the *Ballads* on the inside and p. 38 on the outside, and the innermost from p. iii–iv of the Preface of the book. On p. 38 (i.e. outercovers of wrappers) there are fifty attempts in pencil to draw a monogram of the initials W B, some followed by the letters *inv* or *inv. & sc*, and in one case by the date 1823, also one A D. They seem too hesitant to be by Blake himself, except for the monogram 'W B inv & sc' followed by the date 1823, and may have been made by one of the Linnell children. On p. 37 (i.e. inside cover) in Blake's handwriting, is a list of apostles with initials after their names, as follows: 'Peter P, Andrew a, James J, John J, Philip P, Bartholomew B, Thomas M, Matthew 7 (?), James J (? or 8), Taddeus T (?), Judas, Simon'. This list could have been written any time after 1802, and is probably a list of subjects for paintings, perhaps in connection with the Butts series of Biblical illustrations. On the same page there is also a rough sketch, possibly for the head of Job, from behind. On the other half of the same leaf, at the end, are two rough sketches of a dog's head, probably not by Blake. The innermost wrapper has inscribed on it, in John Linnell's handwriting, the description of the drawings quoted in early part of this catalogue entry.

NOTES

1 19 of the series are now in the Fogg Museum, and the others are distributed as follows: no. 21: Rosenwald collection, National Gallery of Art, Washington; no. 2: formerly Templeton Crocker collection.

2 Keynes in *T.L.S.* 13 June 1958, p. 332.

3 Quoted in Keynes, *Blake Studies*, 1949, p. 137–9.

4 Published separately in facsimile, ed. by P. Hofer, *Illustrations of the Book of Job by William Blake*, 1937.

5 See Binyon and Keynes, *op. cit.* p. 47–50 for a detailed discussion by Binyon of the problem.

6 An independent pencil study for the title-page is reproduced in Binyon and Keynes, *op. cit.* fascicle 1, p. 21. Rosenwald collection, National Gallery of Art, Washington.

7 British Museum version reprod. Binyon and Keynes, *op. cit.* fascicle 1, p. 43. The other drawing is now in the collection of Mr Kerrison Preston. Damon, 1924, p. 235, discusses the significance of Blake's rejection of this design.

8 Binyon and Keynes, *op. cit.* fascicle 1, p. 22–3.

9 For a watercolour sketch, formerly belonging to A. Weston, see Keynes, *Bible Illustrations*, 1957, pl. 67.

10 An early design for the lower part of the composition is now in the collection of J. W. Warrington, U.S.A., reprod. Keynes, *Bible Illustrations*, 1957, pl. 65.

11 There is a tempera painting of the same subject in the Tate Gallery. Butlin, 1957, no. 49.

12 For an early version of the subject see cat. no. 18, and for a discussion of other early attempts at this composition see Binyon and Keynes, *op. cit.* fascicle 1, p. 3–6.

13 For an earlier watercolour of the subject now in the National Gallery of Scotland see Preston, 1952, p. 108–9, pl. 34.

14 For J. H. Wicksteed's explanation see Binyon and Keynes, *op. cit.* fascicle 1, p. 19, also Keynes, *Blake Studies*, 1949, p. 148–9.

15 See note 7 above.

16 A drawing with watercolour washes, now in the collection of Dr R. E. Hemphill, belongs to an early stage of the development of the composition.

17 For example a drawing of Mrs Blake in the Tate Gallery; Butlin, 1957, no. 74, pl. 26. See Bentley in *Studies in Bibliography*, XIX, 1966, p. 232–43.

40. ILLUSTRATIONS OF / THE / BOOK OF / JOB / INVENTED & ENGRAVED / BY WILLIAM BLAKE / 1825.

Engraved surface approx. $8\frac{3}{4} \times 6\frac{3}{4}$ (22 × 17); 22 engravings, including engraved title, designed and engraved by Blake.

Lit.: Gilchrist, 1863, I, p. 282–91; II, p. 258 (reproduced in full); also 1880 and 1907 editions; Keynes, *Bibliography*, 1921, p. 179–82, cat. no. 55; Binyon and Keynes, *Job*, 1935, fascicle 1; Bentley, 1964, p. 94, no. 339; Keynes, *Letters*, 1968, p. 144–51, nos. 122 (*a*)–126.

1. Progress proofs of the designs, without title-page.

Bequeathed by T. H. Riches in 1935, received 1950. P. 128—1950.

Coll.: John Linnell; given by him to his daughter Mary in 1844[1]; Riches family, Mrs T. H. Riches (d. 1950).

All are unfinished and lack the imprint. Their differences from the final state are discussed in detail in Binyon and Keynes, *Job*, 1935, fascicle 1, p. 53, II, and under the description of each individual plate. This copy is printed on paper with a watermark of an open device surmounted by a 'T', and it is bound in olive-green morocco with gold lettering.

2. Plates marked 'Proof' (b.r.), except for title-page.

Proofs on India paper, watermark 'J Whatman Turkey Mill 1825'.

Purchased 1895 (from Tregaskis, for £21).

Sets of this kind were normally issued in pink or grey boards, with printed slip on front cover. This copy has been rebound at a later date, without the boards and slip.

3. Plates marked 'Proof' (b.r.); no watermark.

Set printed on ordinary paper of smaller size than 2.

Bequeathed by C. B. Marlay in 1912.

Sets of this kind were normally issued in limp brown wrappers with a narrow cloth back. This copy has been rebound at a later date without the wrappers.

4. Four coloured proofs, for plates 11, 15, 18 and 20. India paper; painted in watercolour and strengthened in parts with grey wash by Blake himself; no. 20 is badly stained.

Purchased 1939 (from Messrs Dent), from T. H. Riches Fund.

There is at least one known set of coloured proofs, once in the collection of M. George C. Smith, Jnr. in the U.S.A. See Binyon and Keynes, *Job*, 1935, fascicle 1, p. 54, V.

NOTE

1 See inscription on fly-leaf: 'Mary Linnell / 38 Porchester Terrace / Bayswater— / 1844'.

41 LETTER TO JOHN LINNELL

Addressed to 'Mr Linnell / Cirencester Place / Fitzroy Square'; dated '15 March 1827'.

Holograph MS on a single leaf 4to; watermarks: 21 horizontal lines. Probably a half-sheet of the same paper as cat. no. 42; $8\frac{1}{2} \times 6\frac{9}{16}$ (20·7 × 16·6) written on one side only.

Bequeathed by T. H. Riches in 1935, received 1950. MS.79—1950.

Coll.: John Linnell (d. 1882); the Linnell Trustees; John Linnell sale, Christie's, 15 March 1918 (212), bt. by Messrs Carfax for T. H. Riches (for 30 gns.); Mrs T. H. Riches (d. 1950).

Lit.: Gilchrist, 1863, I, p. 355–6; also 1880 and 1907 editions; Keynes, *Bibliography*, 1921, p. 71, cat. no. 82; *Writings*, 1957, p. 876–7, no. 85; *Letters*, 1968, p. 161, no. 144.

Dear Sir,

This is to thank you for Two Pounds now by me recievd on account I have recievd a Letter from Mr Cumberland in which he says he will take one Copy of Job for himself but cannot as yet find a Customer for one but hopes to do somewhat by perseverance in his Endeavours he tells me that it is too much Finishd or over Labourd for his Bristol Friends as they think. I saw Mr Tatham[1] Senr yesterday he sat with me above an hour & lookd over the Dante he expressd himself very much pleasd with the designs as well as the Engravings I am getting on with the Engravings & hope soon to get Proofs of what I am doing.

<div align="right">I am dear Sir Yours Sincerely
William Blake</div>

15 March 1827

NOTE

1 C. H. Tatham, architect, father of Blake's friend Frederick Tatham.

42 LETTER TO GEORGE CUMBERLAND

Addressed to: 'George Cumberland Esqre / Culver Street / Bristol'; dated '12 April 1827 / N3 Fountain Court Strand'.

Holograph MS on a double leaf 4to; watermarks 'Ruse and Turners / 1810 /' and 21 horizontal lines.

$8\frac{1}{4} \times 6\frac{1}{2}$ (20·9 × 16·5); written on two sides.

Purchased 1935, from the T. H. Riches Fund; (Autogr.) 9—1935.

Coll.: Charles Fairfax Murray (d. 1919); his sale, Sotheby's, 5 February 1920 (21, with plate), bt. by Messrs Maggs Bros.[1]

Lit.: Smith, 1829, p. 494; Ellis and Yeats, 1893, I, p. 162–3; Ellis, 1907, p. 433; Keynes, *Bibliography*, 1921, p. 72, cat. no. 86; *Writings*, 1957, p. 878–9; *Letters*, 1968, p. 162–3, no. 147; Bentley, *Records*, 1969, p. 371.

On the second leaf, recto, are notes by George Cumberland on Blake's death and burial and about his visiting-card plate, a print from which is pasted below (see cat. no. 43).

Addressed: George Cumberland Esq^re / Culver Street / Bristol.

Dear Cumberland,

I have been very near the Gates of Death & have returned very weak & an Old Man feeble & tottering. but not in Spirit & Life not in The Real Man The Imagination which Liveth for Ever. In that I am stronger & stronger as this Foolish Body decays. I thank you for the Pains you have taken with Poor Job. I know too well that a great majority of Englishmen are fond of The Indefinite which they Measure by Newtons Doctrine of the Fluxions of an Atom. A Thing that does not Exist. These are Politicians & think that Republican Art is Inimical to their Atom. For a Line or Lineament is not formed by Chance a Line is a Line in its Minutest Subdivision Strait or Crooked It is Itself & Not Intermeasurable with or by any Thing Else Such is Job but since the French Revolution Englishmen are all Intermeasurable One by Another Certainly a happy state of Agreement to which I for One do not Agree God keep me from the Divinity of Yes & No too The yea Nay Creeping Jesus from supposing Up & Down to be the same Thing as all Experimentalists must suppose.

You are desirous I know to dispose of some of my Works & to make them Pleasin I am obliged to you & to all who do so But having none remaining of all that I had Printed. I cannot Print more Except at a great loss for at the time I printed those things I had a whole House to range in now I am shut up in a Corner therefore am forced to ask a Price for them that I scarce expect to get from a Stranger. I am now Printing a Set of the Songs of Innocence & Experience for a Friend at Ten Guineas which I cannot do under Six Months consistent with my other Work so that I have little hope of doing any more of such things. the Last Work I produced is a Poem Entitled Jerusalem the Emanation of the Giant Albion. but find that to Print it will Cost my Time the amount of Twenty Guineas One I have Finishd It contains 100 Plates but it is not likely that I shall get a Customer for it

As you wish me to send you a list with the Prices of these things they are as follows

	£	s	d
America	6.	6.	0
Europe	6.	6.	0
Visions &c	5.	5.	0
Thel	3.	3.	0
Songs of Inn. & Exp.	10.	10.	0
Urizen	6.	6.	0

The little Card I will do as soon as Possible but when you Consider that I have been reduced to a Skeleton from which I am slowly recovering you will I hope have Patience with me

Flaxman is Gone & we must All soon follow every one to his Own Eternal House Leaving the Delusive Goddess Nature & her Laws to get into Freedom from all Law of the Members into The Mind in which every one is King & Priest in his own House God send it so on Earth as it is in Heaven

I am Dear Sir Yours Affectionately

William Blake

12 April 1827
N 3 Fountain Court Strand

The following is in the hand of George Cumberland:

He died Aug 12. 1827 in the back room of the first floor of N 3 Fountain Court in the Strand, and was buried in Bunhill fields burying ground on the 17 Aug 25 feet from the North Wall N 80.[2]

T. Smith, says his desease was the bile mixing with his blood—in his random way of writing—and considering the malignity of this Smith in his infamous biography of Nollekens it is fortunate that he speaks no ill of him.

My little Message card was the last thing he executed and he dates it thus—W. Blake inv & sc. / A Æ. 70 1827. / . The widow charged me 3.3 for it and £3.3. — for the Job.

NOTES

1 Offered several times in Maggs' catalogues, for example cat. no. 597 (1934), no. 287 plus reprod. (frontispiece) offered for £150 (letter plus card).

2 This information is taken from J. T. Smith's *Life of Nollekens*, 1828.

43 GEORGE CUMBERLAND'S CARD

Inscr. 'W Blake inv & sc: / A Æ 70 1827' (b.r.).

Line engraving; engraved surface $1\frac{1}{4} \times 3\frac{1}{8}$ (3·1 × 8·1); plate mark $1\frac{5}{16} \times 3\frac{3}{16}$ (3·3 × 8·1); printed in black on card measuring $1\frac{3}{4} \times 3\frac{9}{16} \times$ (4·4 × 9).

Purchased from the T. H. Riches Fund in 1935 (with cat. no. 42, Letter to George Cumberland, to which it is attached).

Coll.: See entry for cat. no. 42.

Lit.: Gilchrist, 1863, I, p. 356, II, p. 258; reprod. Keynes, *Bibliography*, 1921, title-page without the name; *Separate Plates*, 1956, p. 58–9, cat. no. XXI, pl. 38; *Letters*, 1968, pl. XIII.

Only state.[1]

NOTE

1 The last plate engraved by Blake shortly before his death. Seven other impressions are known, apart from other impressions on paper in various coloured inks, most of which were probably taken from the plate in recent times.

44 ILLUSTRATIONS TO DANTE'S INFERNO

1827.

Seven unfinished line engravings, designed and engraved by Blake; engraved surface approx. $9\frac{1}{2} \times 13\frac{1}{4}$ (24 × 33·5).

Lit.: Gilchrist, 1863, I, p. 332–5, and 1880 and 1907 editions; Keynes, *Bibliography*, 1921, p. 182–5, cat. no. 56; Albert S. Roe, *Blake's Illustrations to the Divine Comedy*, 1953; Keynes, *Letters*, 1968, p. 156, no. 134, p. 160, nos. 142 and 143, p. 161, no. 146, p. 164, no. 148; Bentley, 1964, p. 88, no. 331.

1. Published by John Linnell, probably in 1838.[1]

Proof impressions printed on India paper, issued as loose leaves with a label.

Given by Mrs T. H. Riches, 1918.

Coll.: John Linnell; the Linnell Trustees; Linnell sale, Christie's, 15 March 1918 (181); bt. by Mrs Riches.

2. Impressions taken from the original copper-plates in 1954,[2] printed on loose sheets.

Given by Sir Geoffrey Keynes, 1957. P.57/65—1957.[3]

3. Plate IV: The Circle of Thieves, only.

A progress proof taken by Blake himself, printed on ordinary paper.

Bequeathed by T. H. Riches in 1935, received 1950. P.58—1950.

Coll.: John Linnell; by descent to Mrs T. H. Riches (d. 1950).

The abdomen of Agnolo Brunelleschi and of the figure to the right are before the addition of further modelling.

NOTES

1 See Bentley, 1964, p. 88, no. 331A.
2 In the possession of Lessing J. Rosenwald.
3 Inscribed to him by Lessing J. Rosenwald.

PORTRAITS OF BLAKE

The collection of portraits of Blake himself is the most extensive in existence, and it contains a remarkable series of studies by John Linnell. The most important is the superb and highly finished miniature of Blake in his last years, but the pencil studies were almost certainly made from life, and give an informal record of Blake in his contented last years as he was seen by his youthful admirers. The drawing by Flaxman is in a book of portraits of other artists, showing him as part of a wide circle of acquaintances, while the posthumous drawings by George Richmond, Blake's most fervent disciple, are indicative of his lasting influence over the younger artists who had known him.

Also included in this section are the life mask of Blake, formerly owned by George Richmond, and Blake's spectacles, which were owned by Samuel Palmer.

45 JOHN FLAXMAN, R.A. (1755–1826): PORTRAIT OF WILLIAM BLAKE *Plate 62*

Full face.

Inscr. in pencil 'Wm Blake' (b.l.), and on verso by Flaxman (?) 'Wm Blake, 1804'.

Pencil; size of drawing $5\frac{3}{4} \times 6\frac{1}{4}$ (14.6×15.9), size of leaf $7 \times 8\frac{1}{4}$ (17.8×21); on fo. 26 of a volume[1] containing 34 pencil portraits.[2]

Given by Charles Fairfax Murray, 1916. 828.

Coll.: John Flaxman, R.A.; Flaxman sale (remainder of his collection), Christie's, 11 April 1862 (450), bt. by Mr Kibble (for 3 gns.); sold at Hodgson's, 25 January 1905 (372), bt. by Quaritch;[3] acquired from them by C. F. Murray, 1910.

Lit.: Keynes, *Bibliography*, 1921, p. 481, no. 7.

Reprod.: Keynes, *Bibliography*, 1921, pl. facing p. 43; Bentley *Records*, 1969, frontispiece.

NOTES

1 Size of volume $7\frac{1}{4} \times 8\frac{9}{16}$ (18.4×21.8).

2 Inscr. in pencil on inner cover of the Volume 'Jan. 1804', in ink 'Mr. Kibble / John Flaxman's sketches / purchased at the sale / at Messrs. Christie Manson and Woods / April 1862'. Many sheets with watermark: 'J WHATMAN 1801' and many drawings dated 1804, including portrait of Blake: inscr. possibly by Flaxman on verso 'Wm Blake 1804'.

The portrait of Canova, however, on fo. 32, has an inscription with date 1815. The volume may have been intended as a gift from Flaxman to his wife, as an album of portraits of close friends of the family and professional acquaintances, in view of the sitters and two vignettes:

fo. 1 putto offering a volume inscribed 'PORTRAITS' to an altar which has linked hands drawn on it, with a lover's knot above the design.

fo. 5 putto with laurel wreath and torch showing the way to a bald-headed putto with spectacles, who carries a book inscribed 'A Gift for my Love'.

The other artists whose portraits are included are: Cromek, Fuseli, Thomas Banks, Thomas Daniell, M. A. Shee, Parker the engraver (Blake's former partner), Benjamin West and Canova.

3 Offered in one of the Quaritch catalogues in 1910 for 5 gns.

46–52 JOHN LINNELL, R.A. (1792–1882), PORTRAITS OF WILLIAM BLAKE

46 Head and shoulders, looking downwards, left hand lightly indicated. PD.57—1950. *Plate 63*

Inscr. 'Portrait of / Wm Blake 1820' (b.l.), signed 'JL fect' (b.r.).

Pencil; $7\frac{15}{16} \times 6\frac{1}{8}$ (20·1 × 15·5).

Bequeathed by T. H. Riches in 1935, with life interest to his wife (d. 1950) (46–52).

Coll.: (For 46, 47, 48, 50, 51 & 52) John Linnell (d. 1882); the Linnell Trustees; Linnell sale, Christie's, 15 March 1918 (169); bt. by Messrs Carfax for T. H. Riches (for 85 gns.).

Exh.: Tate, 1913 (106); Manchester, 1914 (175); Nottingham, 1914 (130); Edinburgh, 1914 (118).

Lit.: Keynes, *Bibliography*, 1921, p. 482, no. 13.

Reprod.: Keynes, *Bibliography*, 1921, pl. 39 facing p. 343; Wilson, 1927, pl. XXIV facing p. 304.

47 Head in profile facing right. PD.55—1950. *Plate 64*

Inscr. 'Mr Blake' (t.r.), signed 'JL' (b.r.), no date, c. 1821–6.

Pencil; $4\frac{7}{8} \times 3\frac{5}{8}$ (12·4 × 9·2).

Exh.: Tate, 1913 (107 i); Manchester, 1914 (173 i); Nottingham, 1914 (129); Edinburgh, 1914 (121); R.A., 1956–7 (701 b); Goldsmiths' Hall, 1959 (88).

Lit.: Keynes, *Bibliography*, 1921, p. 482, no. 14.

Reprod.: Story, 1892, I, p. 243; R. Lister, *William Blake*, 1968, pl. 30.

A study from life, possibly connected with Linnell's miniature portrait (cat. no. 49).

48 Two heads in profile, the lower cut off below the mouth. PD.56—1950. *Plate 65*

Inscr. 'Mr Blake' (t.r.), signed 'JL' (b.l.), no date, c. 1821.

Pencil; $4\frac{7}{8} \times 3\frac{11}{16}$ (12·4 × 9·4).

Exh.: Tate, 1913 (107 ii); Manchester, 1914 (173 ii); Nottingham, 1914 (130); Edinburgh, 1914 (121); R.A., 1956–7 (701 c); Goldsmiths' Hall, 1959 (88).

Lit.: Keynes, *Bibliography*, 1921, p. 483, no. 15.

49 Head and shoulders in profile. PD.61—1950. *Plate 66*

Miniature in watercolour on ivory. $5\frac{1}{4} \times 4\frac{3}{16}$ (13·3 × 11·1). Not signed or dated; 1821.

Coll.: John Linnell (d. 1882); the Linnell Trustees; Linnell sale, Christie's, 15 March 1918 (170), bt. by Messrs Carfax for T. H. Riches (for 70 gns.).

Exh.: Tate, 1913 (111); Manchester, 1914 (170); Nottingham, 1914 (126); Edinburgh, 1914 (124).

Lit.: Keynes, *Bibliography*, 1921, p. 480, no. 4.

Reprod.: Story, 1893, frontispiece; Keynes, *Letters*, 1956, frontispiece; Gilchrist, 1863, I, frontispiece; 1880, I, frontispiece; 1907, I, frontispiece (engraved by T. H. Jeens from a copy by J. Linnell, Snr.).

A watercolour copy of this miniature by John Linnell is in the National Portrait Gallery (no. 2146). It is signed and dated 1861, and inscribed 'Fac Simile of a Portrait on Ivory painted from life by John Linnell 1821'. The engraving by Jeens used as a frontispiece to Gilchrist, 1863, dates the ivory 1827, but this is clearly a misreading.

50 Blake in conversation with John Varley, half-length figures seated by a table. Varley making an animated gesture. PD.59—1950. *Plate 67*

Inscr. 'Cirencester Place' (b.l.),[1] signed 'JL Sept 1821' (b.r.). The figures are marked respectively

'Mr Blake' and 'Mr Varley'; Blake aged 64, John Varley aged 43.

Pencil; $4\frac{7}{16} \times 6\frac{15}{16}$ ($11\cdot3 \times 17\cdot6$).[2]

Exh.: Tate, 1913 (109); Manchester, 1914 (172); Nottingham, 1914 (132); Edinburgh, 1914 (119).

Lit.: Keynes, *Bibliography*, 1921, p. 483, no. 17; Binyon, 1925, pl. 1, Bentley, *Records*, 1969, p. 274.

Reprod.: Story, 1892, I, p. 162; Keynes, *Bibliography*, 1921, pl. 37, facing p. 318; Wilson, 1927, pl. XIX facing p. 260; Butlin, 1969, p. 8, repr. facing p. 10.

On the reverse is a slight sketch of the same composition with differences in detail.

51 Half-length, full face, arms crossed. PD.60—1950.
Plate 68

Signed 'Mr Blake Sept 12 1821. J. L. fect' (b.l.).

Pencil; $3\frac{3}{4} \times 4\frac{7}{8}$ ($9\cdot5 \times 12\cdot4$).

Exh.: Tate, 1913 (108); Manchester, 1914 (172A); Nottingham, 1914 (131); Edinburgh, 1914 (120); R.A., 1956–7 (701d); Goldsmiths' Hall, 1959 (88).

Lit.: Keynes, *Bibliography*, 1921, p. 483, no. 16. Bentley, *Records*, 1969, p. 274.

52 Blake wearing hat, three-quarter view, half-length with hands. PD.58—1950. *Plate 69*

Inscr. 'Wm Blake at Hampstead' (b.l.), signed 'JL fecit'; on verso of mount, in Linnell's hand 'Mr Blake / on the hill before our cottage / at Hampstead[3] c / 1825 I guess'.

Pencil; $7 \times 4\frac{3}{8}$ ($17\cdot7 \times 11\cdot2$).

Exh.: Tate, 1913 (110); Manchester, 1914 (174); Nottingham, 1914 (128); Edinburgh, 1914 (117); R.A., 1956–7 (701a); Goldsmiths' Hall, 1959 (88).

Lit.: Keynes, *Bibliography*, 1921, p. 483–4, no. 18.

Reprod.: Story, 1892, I, p. 230; Keynes, *Bibliography*, 1921, pl. 40 facing p. 344; Wilson, 1927, frontispiece.

NOTES

1 Linnell's home and later his studio, after he moved to Hampstead in 1824.

2 Paper bears watermark LMOTT
20 (1820)

3 In 1824 Linnell rented permanently one end of the Home Farm on the Wylde's estate (see Wilson, 1927, p. 282).

53 MRS CATHERINE BLAKE (1762–1831): PORTRAIT OF THE YOUNG WILLIAM BLAKE *Plate 70*

Not signed or dated, c. 1827–31.[1]

Pencil; $6\frac{1}{8} \times 4\frac{1}{8}$ ($15\cdot5 \times 10\cdot4$).

Bequeathed by Sir Edward Howard Marsh, K.C.V.O., C.B., C.M.G. (d. 1953), through the National Art-Collections Fund, 1953. PD.14—1953.

Coll.: Said to have been given by Mrs Blake to a friend who sold it c. 1886 to Daniels (a printseller in Mortimer Street, London); bt. by Herbert P. Horne (d. 1916); acquired by E. H. Marsh in 1904.

Exh.: Carfax, 1904 (27); Tate, 1913 (104); Manchester, 1914 (169A); Nottingham, 1914 (127); Edinburgh, 1914 (122); B.F.A.C., 1916 (80); B.F.A.C., 1927 (64); Vienna, 1927 (not in cat.); R.A., 1934 (1300); *Comm. Cat.*, 1935 (718); Bucharest, 1935 (23); Paris, 1937 (1); Vienna, 1937 (1).

Lit.: Keynes, *Bibliography*, 1921, p. 480, no. 5.

Reprod.: Ellis and Yeats, 1893, III, frontispiece; Keynes, *Bibliography*, 1921, pl. 10 facing p. 78; Wilson, 1927, pl. II facing p. 12.

This drawing was formerly thought to have been made *c.* 1785, and to show Blake at the age of 28, but Sir Geoffrey Keynes has recently suggested that it is an 'ideal' portrait, probably made after his death. Mrs Blake was said not to have been able to draw when she married Blake in 1782, and it is unlikely that she had reached a high enough level of competence to execute this drawing at the presumed date. A drawing by Blake's executor, Frederick Tatham, of Blake in his youth and old age is partly based on the present drawing,[2] so it may have been made for him by Mrs Blake for that purpose, some time between Blake's death in 1827 and her own in 1831.

NOTES

1 Inscr. on verso in ink 'Blake by his wife', in a nineteenth-century hand, possibly that of Frederick Tatham.

2 Brush and pencil, 1827 (Keynes, *Bibliography*, 1921, p. 484, portrait no. 19). Bound up with a copy of *Jerusalem* in Paul Mellon collection, which also contains a manuscript of Tatham's *Life of Blake* (reprod. Ellis and Yeats, I, 1893; frontispiece).

54 GEORGE RICHMOND, R.A. (1809–96): TWO POSTHUMOUS PEN DRAWINGS OF WILLIAM BLAKE *Plates 71–2*

Not signed or dated, *c.* 1857–9.

Two drawings in pen and ink on fos. 40 and 41 of a sketchbook of 92 leaves;[1] size of leaf $8\frac{1}{2} \times 7$ (21·5 × 17·7).[2]

Given by Mrs J. L. Whytehead in 1943. 2784.

Coll.: The artist's daughter, Mrs F. W. Farrer, *née* Mary Richmond; the artist's granddaughter, Mrs J. L. Whytehead.

Lit.: Walter Buchanan, 'A New Portrait of William Blake', *Country Life*, 17 September 1927, p. 390.

1. Fo. 40 a profile to the left, in a circle and frame.

2. Fo. 41 a profile to the left, with the left hand supporting the jaw; in an oval frame with a design in a panel below.

Inscr. In pen 'William Blake from recollection' (t.r.), and in pencil 'William Blake' (b.r.).

NOTES

1 Notebook used by the artist for sketching. Inscr. 'Mary Richmond / German Translation book. / March 1857' on the first, un-numbered folio. Other sketches in the book refer to portraits that can be dated *c.* 1857–9.
Inscr. in ink 'This book belongs to / Mrs. J. L. Whytehead / Larkfield / Bentley Road / Cambridge' on inner cover (later erased).

2 Size of volume $8\frac{1}{2} \times 7\frac{1}{8}$ (21·5 × 18).

55 J. S. DEVILLE:[1] LIFE MASK OF WILLIAM BLAKE *Plates 73–4*

Life mask in plaster, yellowed in parts. $11\frac{1}{2}$ (29·3) high.

Given by Lady Richmond, 1947. M.7—1947.

Coll.: George Richmond, R.A. (d. 1896); Sir William Blake Richmond, R.A. (d. 1921); Admiral Sir Herbert W. Richmond, K.C.B. (d. 1946); Lady Richmond.

Exh.: Carfax, 1904 (36); N.G.B.A., 1913 (105); Manchester, 1914 (169); B.F.A.C., 1927 (67); on loan to Fitzwilliam Museum since December 1937; Exhibition of English Poetry, National Book League, April–May 1947 (not mentioned in cat.).

Lit.: Herbert P. Horne, *Century Guild Hobby Horse*, 1887, p. 27; H. H. Gilchrist, ed., *Anne Gilchrist: her life and writings*, 1887, p. 258–60; A. M. W. Sterling, ed., *The Richmond Papers*, 1926, p. 26; Wilson, 1927,

pp. 289, 369–70; Keynes, *Bibliography*, 1921, p. 479, no. 1 (described as replica or copy of the Linnell version); Bentley, *Records*, 1969, p. 278, n. 3.

This bust is one of two known life masks of William Blake, the other, from the Linnell collection, being now in the National Portrait Gallery,[2] which also owns a modern bronze cast of it. The Fitzwilliam version is relatively little known, but it has some claim to primacy over the National Portrait Gallery example, which is more highly finished and signed as follows: 'A 66 / PUBd. AUG. 1. 1823 I. DEVILLE / 67 Strand, London'. The present bust was discussed by two writers while in the possession of George Richmond, who had, of course, known Blake in his last years. According to Herbert P. Horne, 'Much of the forced expression of the nostrils and more particularly of the mouth is due to the discomforture which the taking of the cast involved, many of Blake's hairs adhering to the plaster until quite recently'.[3] If this were so, then the present bust was presumably cast directly from the original mould. This is confirmed by a remark by George Richmond quoted by Anne Gilchrist: 'The first mask that the phrenologist took: he wished to have a cast of Blake's head as representative of the imaginative faculty'.[4] The Linnell cast because of its inscription, may have been intended for sale in Deville's shop in the Strand: Deville 'kept a lamp shop at 367 Strand, at the west corner of Burleigh Street, where he exhibited and sold casts and examined heads phrenologically'.[5]

The authority of the life mask as a likeness of Blake is confirmed by H. H. Gilchrist's account of his visit to George Richmond, presumably in 1887: 'Before bidding adieu to Blake in the present volume it will not be out of place if we give the reader the chat that we enjoyed the other day with Mr George Richmond; the only living man who has conversed with William Blake—when a student, closed the poet's eyes and kissed William Blake in death, as he lay upon his bed, in the enchanted work-room at Fountain Court.

'The Academician showed us a cast of Blake's head and face, taken by Deville, when Blake was about fifty years old.

'"The first mask that the phrenologist took: he wished to have a cast of Blake's head as representative of the imaginative faculty."

'Deville's wish was not surprising; (when regarding the mask) we ask if any man ever possessed a fuller temple or a more finely packed brow?—the quivering intensity in the closed eyes and dilated nostrils is wonderful; and when we pass our hand over his stubborn English chin, we understand Hayley's surprise, when calling at the cottage at Felpham, at finding Blake grinding away, graver in hand, during a hot day in August; and the quiet pluck with which he always buckled to etching (for Bookseller Johnson) when Mrs Blake placed the "empty plate" upon the little round oak table.

'Mr Richmond drew our attention to the position of Blake's ear, which is low down, away from the face near the back of the neck, showing an immense height of head above:—"I have noticed this relation of ear finely characterized in three men—Cardinal Newman, William Blake and Henry Hallam." Mr Richmond pointed out an engraving after his portrait of Newman, which instanced the noble characteristic happily. "I told Mr Gladstone that I never understood his character, until the day when I sat in church behind him; then I saw the tremendous bulwark of the statesman's neck".

'"That is not like dear Blake's mouth, such a look of severity was foreign to him—an expression of sweetness and sensibility being habitual: but Blake experienced a

good deal of pain when the cast was taken, as the plaster pulled out a quantity of his hair. Mrs Blake did not like the mask, perhaps the reason being that she was familiar with varying expressions of her husband's fine face, from daily observation: indeed it was difficult to please her with any portrait—she never liked Phillips's portrait; but Blake's friends liked the mask." [6]

NOTES

1 J. S. Deville was an amateur phrenologist, who 'when a young man was employed by Mr Nollekens to make casts from moulds' (J. T. Smith, 1828, p. 371). Despite his French name, Deville was described as a cockney who talked of 'wirtues' and 'wices'. There is an account of a visit to him in Lord John Russell, ed., *Memoirs, Journal and Correspondence of Thomas Moore*, 1854, v, p. 70: 20 May 1826: (Deville's) 'explanations of the principles of his art, and some of the facts he produced, very striking to us all: instances where the organ was considerably increased by the exercise of the faculty connected with that organ, etc.; but his guesses at the characters of the new subjects I brought him (none of whom he knew) egregious failures. For instance said that Lord Lansdowne gave his opinions without deliberation! In Sydney Smith the chief propensity he discovered was a fondness for natural history, and for making collections of the same. Altogether this was the worst exhibition I have seen him make, though very amusing from Sydney Smith's inextinguishable and contagious laughter which I joined in even to tears.'

Deville exhibited busts at the Royal Academy in 1823, 1824 and 1826.

2 Inventory no. 1809. Purchased by the National Portrait Gallery following the Linnell sale in 1918. For a reproduction see Wilson, 1948, pl. VI opp. p. 304.

3 *Op. cit.* 1887, p. 27.

4 See note 6 below.

5 J. T. Smith, *Nollekens*, ed. by W. Whitten, 1920, p. 322.

6 H. H. Gilchrist, *op. cit.* pp. 258–60.

56 WILLIAM BLAKE'S SPECTACLES

Given by Lord Rothschild, 1948.

Coll.: Mrs Blake, who gave them to Sotheby's sale, 2 March 1937, lot 283. Samuel Palmer; his son, A. H. Palmer.

With accompanying letter from A. H. Palmer: 'These spectacles were once the property of William Blake; and were much valued by his friend and disciple Samuel Palmer. A. H. Palmer. March 1908'.

Description: Temple support for side pieces. Right eye: − 2·75 dioptre sphere;[1] left eye: − 2·5 dioptre sphere. Ground on inner surface, plano-convex; diameter 30 mm. There is no correction for astigmatism; this was apparently not possible in the early nineteenth century. On the evidence of the lenses Blake was moderately myopic. Samuel Palmer remarked to Gilchrist on Blake's myopia: 'He was short-sighted as the prominence of his eyes indicated; a prominence in keeping with his faculty for languages, according to the phrenologists again. He wore glasses only occasionally.' [2]

NOTES

1 The museum is indebted to Dr H. L. Backhouse of Cambridge for kindly examining the spectacles.

2 Gilchrist, 1863, p. 314–15.

COMMERCIAL ENGRAVINGS

Blake was enrolled as an engraving student at the Royal Academy in 1779,[1] and in 1780, while still a student there, he had begun to make commercial engravings after the designs of other artists.[2] Before that, from 1772 to 1779, he had been apprenticed to Thomas Basire, a commercial engraver, who employed him principally to make drawings from monuments in Westminster Abbey and elsewhere for Gough's *Sepulchral Monuments in Great Britain*, and it is probable that he engraved many of them himself, although none is signed by him.[3]

Blake continued to make commercial engravings for the rest of his life, and his more successful friends like Thomas Stothard, John Flaxman and George Cumberland frequently used his services as a way of providing him with paid employment. Although Blake regarded reproductive engraving as drudgery, and resented the menial status it conferred on him, he took a great pride in his competence.

I have no objection to Engraving after another Artist. Engraving is the profession I was apprenticed to, & should never have attempted to live by any thing else, If orders had not come in for my Designs & Paintings, which I have the pleasure to tell you are Increasing Every Day. Thus if I am a Painter it is not to be attributed to seeking after. But I am contented whether I live by Painting or Engraving.[1] [Letter to the Rev. Dr Trusler; 23 August 1799.][4]

NOTES

1 Register of entrants to the Royal Academy, *Walpole Society*, XXXVIII, 1962, p. 130.
2 Bentley, *Bibliography*, 1964.
3 For a full discussion of Blake's work as an apprentice see Paul Miner, 'The apprentice of Great Queen Street', *Bulletin of the New York Public Library*, LXVII, no. 10, December 1963, p. 639–42, and Keynes, *Blake Studies*, 1949, p. 41–50.
4 Keynes, *Works*, 1957, p. 794.

57 SEPULCHRAL MONUMENTS IN GREAT BRITAIN...FROM THE NORMAN CONQUEST TO THE SEVENTEENTH CENTURY...

Part 1...by Richard Gough, F.S.A. London, 1786.

83 plates and many smaller engravings in the text. Some of the plates were drawn and engraved by Blake during his apprenticeship to James Basire II (1769–1822), but none is signed by Blake.

Founder's Bequest, 1816.

Coll.: Purchased by Viscount Fitzwilliam in 1807.

Lit.: Keynes, *Bibliography*, 1921, p. 197–8, cat. no. 67; Bentley, 1964, p. 119–20, no. 372.

58 ESSAYS ON PHYSIOGNOMY

By John Caspar Lavater; volume 1, London, 1789.

Numerous plates and vignettes, of which three in Vol. 1 were executed by Blake (one plate and two vignettes), facing pp. 159, 206 and 225.

Given by the Rev. Dr Bayly Wallis (d. 1820), Peterhouse, in September 1818.

Lit.: Keynes, *Bibliography*, 1921, p. 233–4, cat. no. 102; Bentley, 1964, p. 137–8, no. 390.

59 NARRATIVE OF A FIVE YEARS EXPEDITION AGAINST THE REVOLTED NEGROES OF SURINAM

By Captain J. G. Stedman; volume I (II), London, 1796.

Frontispiece to volume I, and 40 plates in each volume, of which 8 in each volume were engraved by Blake. Vol. I: plates facing pp. 80, 110, 132, 166, 174, 200, 227, 326; vol. II: plates facing pp. 10, 56, 74, 104, 280, 296, 348, 394. The majority of the plates are lettered: 'Blake sculpt (Title) / London, Published Dec 2d 1793, by J. Johnson . . . / (no. of plate)'. The other 65 plates were executed by Bartolozzi, Benedetti, Barlow, Condor, Holloway and Smith.

Founder's Bequest, 1816.

Coll.: Purchased by Viscount Fitzwilliam in 1797.

Lit.: Keynes, *Bibliography*, 1921, p. 241–2, cat. no. 111; Bentley, 1964, p. 158–60, no. 408A.

60 LEONORA

A Tale, translated and altered from the German of Gottfried Augustus Bürger; London, 1796.

An illustrated frontispiece and two vignettes engraved by Perry in line and stipple after designs by Blake.

Provenance not known.

Lit.: Keynes, *Bibliography*, 1921, p. 216–17, cat. no. 79; Bentley, 1964, p. 104, no. 356.

61 AN ESSAY ON SCULPTURE

By William Hayley; London, 1800.

Three plates engraved by Blake.

Acquired after 1848.[1]

Lit.: Keynes, *Bibliography*, 1921, p. 247, cat. no. 120; Bentley, 1964, p. 122–3, no. 376.

NOTE

[1] Inscribed on the title-page: 'To / Miss Collins / from the Author' plus a dedication in Italian.

62 THE LIFE AND POSTHUMOUS WRITINGS OF WILLIAM COWPER

By William Hayley; Chichester, 1803 (1804).

5 plates engraved, and one illustration in the text designed and engraved, by William Blake.

Purchased from the T. H. Riches Fund, 1941.[1]

Lit.: Keynes, *Bibliography*, 1921, p. 249–51, cat. no. 124; Bentley, 1964, p. 123–4, no. 377A.

NOTE

[1] From Elkin Mathews of Takeley, Bishops Stortford, for £16.

63 A FATHER'S MEMOIRS OF HIS CHILD

By Benj. Heath Malkin; London, 1806.

Illustrated frontispiece, engraved by Cromek after Paye and Blake, and 3 other plates not by Blake.

Purchased 1909.

Coll.: G. Trower; given by him to J. Gilpin in 1807; Mrs Gilpin; given by her to Miss Oliver;[1] with Tregaskis, purchased from them in 1909 (for 1 gn.).

Lit.: Keynes, *Bibliography*, 1921, p. 217–18, cat. no. 80; Bentley, 1964, p. 138–9, no. 391.

NOTE

1 See inscriptions on half-title page and title-page: 'From G. Trower Esq. / to J. Gilpin', 'From Mr. Trower, to J. Gilpin, / 1807'; fly-leaf: 'J. Gilpin; from Mrs. Gilpin to Miss E. Oliver'.

64 THE LIFE OF GEORGE ROMNEY

By William Hayley; Chichester, 1809.

Illustrated frontispiece, and 11 plates, of which one was engraved by Blake after Romney (facing p. 84). Most of the other plates were engraved by Caroline Watson, and the remainder by Haines, Raimbach, Meadows, and Cooper.

Purchased 1947.[1]

Lit.: Keynes, *Bibliography*, 1921, pp. 254–5, cat. no. 130; Bentley, 1964, p. 124, no. 378.

NOTE

1 From Messrs Maggs Brothers for £3 15s on 28 June 1947. In their cat. no. 368.

APPENDIX

Sir Geoffrey Keynes has very generously promised to bequeath to the Museum a major part of his outstanding Blake collection. A list of the original works by Blake has been included here to make the Museum's catalogue as comprehensive as possible. The entries have, for convenience, been taken from Sir Geoffrey Keynes's catalogue of his collection, *Bibliotheca Bibliographica*, 1964, to which the numbers in brackets refer. The important collection of secondary material which has also been promised is not included here, but further details can be found in *Bibliotheca Bibliographica*, pp. 73–81, nos. 657–727, excepting no. 677.

K: Keynes, see Bibliography at beginning of catalogue.

PAINTINGS IN TEMPERA

467 UGOLINO AND HIS SONS IN PRISON (1827). Tempera on panel, 33 × 44 cm., with incised signature: *W BLAKE fecit*.

Coll.: William Bell Scott, sold at Sotheby's, 21 April 1885, lot 183 (J. Pearson, £10); J. W. White; Mrs Graham Smith; Hon. Anthony Asquith; bought at Hodgson's, 1942.

Exh.: B.F.A.C., 1876 (124); Carfax Gallery, 1906 (25); Arts Council, 1951 (10).

Reprod. Arts Council *Catalogue*, 1951; *Letters of Blake*, ed. Keynes, 1958, 1968.

468 THE CIRCUMCISION (*c.* 1810). Tempera on canvas, 26 × 37 cm. Signed: *W B*.

Coll.: Thomas Butts; Thomas Butts, Jnr., sold at Foster's, 29 June 1853; C. Martin; bought at Appleby's, 1947.

Exh.: Arts Council, 1951 (22).

Reprod.: Arts Council *Catalogue*, 1951.

469 [*CATHERINE BLAKE*] AGNES (*c.* 1800). Tempera on canvas, 14 × 18·5 cm. Inscribed on the back in the hand of William Blake: *Agnes | from the Novel of the Monk | Designed & Painted by Catherine Blake | & Presented by her in Gratitude & Friendship | To Mrs. Butts*.

Coll.: Mrs Butts; Thomas Butts, Jnr.; Captain Butts; W. Graham Robertson, sold at Christie's, 22 July 1949, lot 82.

Exh.: Arts Council, 1951 (32).

PAINTINGS IN WATERCOLOUR

470 HAR AND HEVA ASLEEP WITH MNETHA WATCHING (illustration of *Tiriel*, *c.* 1788). Drawing in sepia, 19·5 × 28 cm.

Coll.: . . .Mrs Graham Smith; Hon. Anthony Asquith; bought at Hodgson's, 1942.

Exh.: British Museum, 1957.

471 TIRIEL CURSING HIS SONS AND DAUGHTERS (illustration of *Tiriel*, *c.* 1788). Drawing in sepia, 18·5 × 27·5 cm.

Coll.: F. Tatham; Joseph Hogarth; E. Bicknell, sold at Christie's, 1 May 1863, lot 385; Mrs Graham Smith; Hon. Anthony Asquith; bought at Hodgson's, 1942.

Exh.: British Museum, 1957.

472 THE BLIGHTED CORN (for wood engraving no. 6 in Thornton's *Pastorals of Virgil*, 1821). Drawing in grey wash, 4·1 × 9·5 cm.

Coll.: John Linnell, sold at Christie's, 15 March 1918 in lot 205; bought from Brick Row Bookshop, New York, c. 1928.

Exh.: British Museum, 1957.

Reprod.: Pencil Drawings, ed. Keynes, 1927, no. 51 (6), Nonesuch Press, 1937; Keynes, *Blake Studies*, 1949, plate 38.

Drawing for woodcut no. 2 in grey wash.

Coll.: John Linnell; Ward Cheney, bought from Lyell, bookseller, 1965.

473 CAIN FLEEING FROM THE BODY OF ABEL (1825). Drawing in sepia, 5·5 × 6 cm., reduced for engraving, on a sheet 9 × 10·5 cm. A miniature version of the tempera painting now in the Tate Gallery.

Coll.: John Linnell; bought from Robinson, Pall Mall, c. 1930.

Exh.: British Museum, 1957.

Reprod.: Keynes, *Blake Studies*, 1949, plate 48.

474 [CATHERINE BLAKE] A FACE IN THE FIRE (1830). On a sheet 9·5 × 12 cm. Inscribed on a similar sheet attached: *A Drawing made by Mrs. Blake taken from something she saw in the Fire during her residence with me: curious as by her. Fred^k Tatham.*

Coll.: F. Tatham; W. Graham Robertson, sold at Christie's, 22 July 1949, in lot 75.

Exh.: British Museum, 1957.

475 [ROBERT BLAKE] A DRUID CEREMONY [?] (c. 1786). Drawing in sepia on a sheet 21 × 32 cm. Inscribed on the back in pencil: *By Robert Blake his brother.*

Coll.: F. Tatham; W. Graham Robertson, sold at Christie's, 22 July 1949, lot 81.

476 [ROBERT BLAKE] A DRUID GROVE (c. 1786). Drawing in watercolours on a sheet 17 × 42·5 cm.

Coll.: H. Buxton Forman; M. Buxton Forman.

Reprod.: Keynes, *Blake Studies*, 1949, plate 5.

MONOTYPE PRINT IN COLOURS

477 RUTH PARTING FROM NAOMI. Monotype mounted on cardboard, 39 × 50 cm.

Coll.: J. W. Pease, bequeathed c. 1905 to Miss S. H. Pease, sold at Christie's, 2 December 1938, lot 58.

Exh.: Whitworth Gallery, Manchester, 1914 (41); Nottingham Art Gallery, 1914 (28); British Museum, 1957.

PENCIL DRAWINGS

[K 1927: Keynes, Geoffrey, editor. *Pencil Drawings*. London: The Nonesuch Press, 1927. K 1956: Keynes, Geoffrey, editor. *Pencil Drawings, Second Series*. London: The Nonesuch Press, 1956.]

478 ADAM AND EVE (c. 1806). On a sheet 6·5 × 4·5 cm., sketch for the watercolour painting of *Satan Watches Adam and Eve* now in the Fogg Art Museum, Harvard University. Inscribed: *Adam & Eve.*

Coll.: Bought from W. T. Spencer, 1920.

Exh.: British Museum, 1957.

Reprod.: K 1956, no. 13.

479 BLAKE'S INSTRUCTOR (also known as LAIS OF CORINTH) (c. 1819). A head on a sheet

27 × 21·5 cm. It is a replica of a drawing now in the Tate Gallery, inscribed: *The Portrait of a Man who instructed Mʳ Blake in Painting &c. in his Dreams.*

Coll.: J. Varley; Albert Varley; A. Aspland, sold at Sotheby's, 27 January 1885, in lot 72; G. Arkwright; W. Graham Robertson, sold at Christie's, 22 July 1949, lot 61.

480 THE BOWMAN. On a sheet 17 × 19·5 cm.

Coll.: W. Graham Robertson, sold at Christie's, 22 July 1949, lot 17.

Exh.: Bournemouth 1949, no. 49; British Museum, 1957.

Reprod.: K 1956, no. 22.

481 FOR CHILDREN THE GATES OF HELL (c. 1793). On a sheet 13·5 × 12 cm., design for the title-page of an unpublished work.

Coll.: F. Tatham; W. Graham Robertson, sold at Christie's, 22 July 1949, in lot 63; bought from Maggs, 1949.

482 HEAD OF JOB (c. 1818). On a sheet 26 × 20 cm.

Coll.: John Linnell, sold at Christie's, 15 March 1918, in lot 163; bought from Parsons, 1918.

Exh.: British Museum, 1957.

Reprod.: K 1927, no. 56.

483 JEHOVAH WITH HIS SONS, SATAN AND ADAM (c. 1818). Drawing in pen and pencil with touches of watercolour, on a sheet 54 × 44 cm. Inscribed in pencil: *Laocoön.*

Coll.: F. Tatham; George Smith; Mrs Graham Smith; Hon. Anthony Asquith; bought from Hodgson, 1942.

Exh.: British Museum, 1957.

Reprod.: K 1956, no. 31.

484 MACBETH AND THE GHOST OF BAN-QUO. On a sheet 36 × 51 cm., with another Shakespearian (?) subject on the reverse (c. 1787).

Coll.: Richard Johnson, sold in 1912; . . .bought at Sotheby's, 1934.

Exh.: British Museum, 1957.

Reprod.: K 1956, no. 3.

485 THE PENANCE OF JANE SHORE (c. 1788). On a sheet 32 × 48 cm. A sketch for the watercolour drawing now in the Tate Gallery.

Coll.: Mrs Alexander Gilchrist; Dr Greville Macdonald; bought from Francis Edwards, c. 1935.

Exh.: British Museum, 1957.

Reprod.: K 1956, no. 1.

486 SATAN (c. 1820). On a sheet 22 × 13 cm. Sketch for the figure at the top of plate 4 of *Illustrations of the Book of Job,* 1925, inscribed *Going to & fro in the Earth,* but without the wings added in the engraving.

Coll.: F. Tatham; W. Graham Robertson, sold at Christie's, 22 July 1949, lot 70.

Exh.: British Museum, 1957.

Reprod.: K 1956, no. 41.

487 A SEATED FIGURE (c. 1820). On a sheet 18·5 × 13 cm.

Coll.: F. Tatham; W. Graham Robertson, sold at Christie's, 22 July 1949, in lot 70.

488 SIR ISAAC NEWTON (1795). On a sheet 20 × 25·5 cm. Drawing for the monotype now in the Tate Gallery, London.

Coll.: F. Tatham; George Smith; Captain Fenwick-Owen, sold at Sotheby's, 4 May 1954, lot 102.

Exh.: B.F.A.C., 1876, no. 235; ditto, 1927, no. 59; British Museum, 1957.

Reprod.: Burlington Fine Arts Club, *Catalogue*, 1927, plate XLIII; K 1956, no. 8.

489 THE THREE TABERNACLES; THE LAMB OF GOD; THE CHURCH YARD; FAITH; MIRTH; HOPE. Five sketches, each on a sheet 15·5 × 10 cm., inscribed with the above titles by Blake.

Coll.: F. Tatham; W. Graham Robertson, sold at Christie's, 22 July 1949, in lot 75.

Reprod.: 'Mirth' in K 1956, no. 19.

490 UNKNOWN SUBJECT (*c.* 1800). On a sheet 25 × 32 cm. The central figure of a nude kneeling man was used in the watercolour painting, *The Stoning of Achan.*

Coll.: . . .Bought from Parsons, 1919.

Exh.: British Museum, 1957.

Reprod.: K 1927, plate 26.

491 URIZEN IN FETTERS (*c.* 1793). On a sheet 34 × 46 cm. Sketch for plate 11 of *The Book of Urizen,* 1794, with another vague figure to the left. On the reverse is a sketch of an unidentified historical scene.

Coll.: Richard Johnson, sold 1912; . . .bought at Sotheby's, 28 May 1934, lot 172.

492 VANITY FAIR (*c.* 1817). On a sheet 22·5 × 18 cm. Probably a sketch for the subject in 'The Pilgrim's Progress' series of watercolour drawings.

Coll.: F. Tatham; W. Graham Robertson, sold at Christie's, 22 July 1949, in lot 70.

493 THE VIRGIN MARY HUSHING THE YOUNG BAPTIST. On tracing paper 27 × 38 cm. Sketch for the tempera painting now in the U.S.A.

Coll.: John Linnell, sold at Christie's, 15 March 1918, in lot 165; Vernon Wethered; bought from Colnaghi, 1946.

Exh.: British Museum, 1957.

Reprod.: K 1956, no. 9

494 VISIONARY HEAD OF CARACTACUS (*c.* 1820). On a sheet 19·5 × 15 cm.

Coll.: John Linnell, sold at Christie's, 15 March 1918, in lot 163; bought from Parsons, 1918.

495 THE WAKING OF LEONORA (1796). On a sheet 15 × 23·5 cm. Sketch for the vignette engraved by Perry for Bürger's *Leonora,* 1796, p. 16.

Coll.: F. Tatham; W. Graham Robertson, sold at Christie's, 22 July 1949, in lot 70.

496 THE WHIRLWIND OF LOVERS (*c.* 1826). On a sheet 23·5 × 28·5 cm. Sketch for the subject of no. 10 of the watercolour designs for Dante's *Inferno* with many differences of detail.

Coll.: F. Tatham; W. Graham Robertson, sold at Christie's, 22 July 1949, in lot 79; bought from Maggs, 1949.

NEEDLEWORK PANEL BY MRS BUTTS

497 TWO HARES IN LONG GRASS (*c.* 1800). Needlework panel, 50 × 58 cm., embroidered in wool and silk by Mrs Thomas Butts.

Coll.: The Butts family, sold at Sotheby's, the property of Anthony Butts, 19 December 1932, lot 119.

Exh.: B.F.A.C., 1927 (68); Birmingham Museum and

Art Gallery, 'British Embroidery', 1959 (187).

Reprod.: The Times, 18 February 1959.

The authorship of the design is a matter of opinion, but its unconventional style with the characteristic colouring can leave little doubt that it is by Blake. Mrs Butts also made similar panels depicting dead game in the conventional style of the period. Her work is regarded as being extremely skilful.

HOLOGRAPH MANUSCRIPTS

498 ALS TO WILLIAM HAYLEY, 11 December 1805. 3 pp. 4to, with address.

Provenance: Sold at Sotheby's, 28 July 1899, lot 262, and at Hodgson's, 22 June 1922, lot 272. Acquired by A. E. Newton. Given by Miss Caroline Newton, December 1956. [K, *Letters,* 1956, p. 154–6.]

499 RECEIPT GIVEN TO JOHN LINNELL, 11 September 1818, signed.

Provenance: Formerly in the possession of A. H. Palmer, son of Samuel Palmer, and inserted by him loose in Blake's copy of Boyd's translation of Dante's *Inferno,* 1785 (722).

500 TWO STANZAS BY R. B. SHERIDAN, beginning 'When tis Night & the midwatch is set', copied in the hand of William Blake on the back of part of the title-page of Hayley's *Ballads,* 1802. Printed in *The Vocal Miscellany,* 1820, and probably elsewhere.

Provenance: Bought by Bertram Dobell with Hayley MSS before 1914. Acquired from P. J. Dobell, 1938.

ILLUMINATED BOOKS (*arranged chronologically*)

[K & W: Keynes, Geoffrey and Wolf, Edwin, II. *Blake's Illuminated Books. A Census.* New York: The Grolier Club of New York, 1953.]

506 ALL RELIGIONS ARE ONE (*c.* 1788)
Title-page only, printed in green and brown within a frame of four ruled lines. On a sheet 29·5 × 23 cm. with watermark: I TAYLOR 1794. [K & W p. 8.]

Coll.: William Muir; Sir Hickman Bacon; bought at Sotheby's, 21 July 1953, in lot 470. One other copy is known, now in the Victoria and Albert Museum.

507 THERE IS NO NATURAL RELIGION (*c.* 1788)
Four plates only: a 3, a 4, a 8, b 10. Printed in green and brown, b 10 within a frame of four ruled lines. On sheets 29·5 × 23 cm. without watermark. [K & W, part of copy L. No. b 10 is a unique print. The other ten plates of the series are in the Pierpont Morgan Library, New York.]

Coll.: The same as 506.

508 SONGS OF INNOCENCE (1789)
Nine plates printed in blue or brown on nine leaves without watermark. Delicately painted with watercolours, with gold sometimes added to the pigments. Foliated by Blake. Consists of the following plates, Blake's numbers being given in brackets: 1 (1), 4 (27), 14 (25), 16 (19), 22 (24), 23 (18), 24 (28), 25–6 (22–3). Size of the original leaves about 20 × 15 cm., though a corner of one leaf is scorched and two others have been trimmed. [K & W, copy R.]

Coll.: Acquired from Blake before 1800 by the first Baron Dimsdale. The series was no doubt originally complete, these nine leaves having been saved from a bonfire in the 1890s. Sold for Major Thomas E. Dimsdale at Sotheby's, 24 November 1952, lot 99.

509 SONGS OF INNOCENCE
Two plates, nos. 29, 30, printed in green on either side of a single leaf, 19 × 14 cm., without watermark. Painted

with watercolours. No foliation. Stitch-holes at the left-hand margin suggest that the leaf was originally part of a complete copy, and the indications are that it was printed about 1794.

Coll.: Removed from an extra-illustrated copy of Gilchrist's *Life of Blake*, 1863.

511 SONGS OF INNOCENCE
Two plates on either side of a single leaf, 24×15 cm., without watermark. Consists of plate 3 in brown and plate 4 in grey. Uncoloured and somewhat soiled.

Coll.: Carries the collector's stamp of William Bell Scott; Mrs Graham Smith; Hon. Anthony Asquith; bought at Hodgson's, 1942.

512 VISIONS OF THE DAUGHTERS OF ALBION (1793)
Plate 3, the design only, having been cut from a pull of the plate printed in two colours, olive-brown and sepia. Size 6·5×11·5 cm., without watermark.

Coll.: Sold at Sotheby's, 26 November 1960, lot 11, having been removed from a sketchbook of Samuel Prout (sold on the same occasion, lot 10).

513 AMERICA, A PROPHECY (1793)
(i) Plate i, frontispiece, printed in blue, uncoloured, on a leaf 26×19 cm., without watermark.

Coll.: Bought at Hodgson's, c. 1924.

(ii) Plate 2, printed in blue, uncoloured, on a leaf 22×17 cm., without watermark.

Coll.: Extracted from an extra-illustrated copy of Bray's *Life of Stothard*, 1851, in 1941.

(iii) Plate 8, printed in red-brown, uncoloured, on a leaf 29×21 cm., without watermark.

Coll.: From the collection of W. E. Moss, sold at Sotheby's, 2 March 1937, lot 170.

514 SONGS OF EXPERIENCE (1794)
Ten plates on ten leaves, 18×12 cm., without watermark. Printed in blue or green and colour-printed, sometimes with watercolour washes added. No foliation. Consists of plates 30, 31, 32, 37, 38, 42, 43, 47, 50, 51.

Coll.: These leaves, uniform in paper, size and style of colouring, were obtained from various sources at various times, but they were probably formerly associated in a copy afterwards broken up. [K & W, copy G.]

516 SONGS OF EXPERIENCE [*printed c.* 1831]
Five plates on five leaves, printed in red-brown. Size 20×16·5 cm., with watermark J WHATMAN 1831. Consists of plates 30, 43, 45, 48, 52. [K & W, copy K.]

Coll.: From the collection of Sydney Morse, sold at Christie's, 19 March 1937, in lot 45.

517 SONGS OF EXPERIENCE [*printed c.* 1831]
Eleven plates on eleven leaves, printed in grey-black. Size 27×19 cm., without watermark. Consists of plates 29, 33, 38, 39, 41, 42, 43, 46, 49, 51, 52. [K & W, copy I].

Coll.: Ten plates were bought from Francis Edwards in 1925; plate 51 was extracted from an extra-illustrated copy of Bray's *Life of Stothard*, 1851, in 1941.

518 SONGS OF INNOCENCE AND OF EXPERIENCE [*printed c.* 1831]
Six plates on six leaves, printed in grey on a tinted ground on thick leaves, 24·5×20 cm., with watermark J WHATMAN 1831. Consists of plates 3, 10, 11, 19, 22, 54. [K & W, copy m.]

Coll.: From the collection of Sydney Morse, sold at Christie's, 19 March 1937, in lot 45.

519 THE BOOK OF URIZEN (1794)

A single plate, 25, printed in pale brown on a leaf 26 × 18·5 cm., without watermark. The design is colour-printed, but is somewhat blurred.

Coll.: Carries collector's stamp of Richard Johnson. Sold at Sotheby's, 28 May 1934.

520 EUROPE, A PROPHECY (1794)

(i) Plate i, frontispiece, printed in blue on a leaf 25·5 × 18·5 cm., without watermark.

Coll.: From the collection of the Earl of Crewe, sold at Sotheby's, 30 March 1903, lot 18. Acquired by E. J. Shaw and sold with his collection 29 July 1925, lot 157.

(ii) Plate ii, title-page, a trial proof printed in grey-black on a leaf 26 × 19·5 cm., without watermark. On the verso is a proof of the frontispiece of *Jerusalem* (see 523).

(iii) Plate 1, the upper part of the plate only with the design, the leaf having been cut to 14·5 × 17 cm. Printed in blue-green and richly painted with watercolours. No watermark.

Coll.: From the collection of George Richmond. Given to his son, John Richmond, 19 March 1890. Bought from Mrs John Richmond in 1927.

(iv, v) Plates 2 and 7 printed in blue on either side of a leaf 38 × 27·5 cm., without watermark.

Coll.: From the collection of W. Graham Robertson, sold at Christie's, 22 July 1949, lot 86.

(vi, vii) Plates 3 and 4, the central parts of the plates printed in blue on either side of leaf a cut to 13 × 16·5 cm., without watermark.

Coll.: Given by John Fleming, New York, 1956.

(viii) Plate 9 printed in blue-green on a leaf 23 × 17 cm., with the margins trimmed close. No watermark. The design is colour-printed and also painted with watercolours.

Coll.: From the collection of Dr. Greville Macdonald. Bought from Francis Edwards in 1928.

522 A SMALL BOOK OF DESIGNS (1796)

Three plates from a copy of this collection of small colour-printed subjects from the illuminated books. [K & W, copy B.]

(i) Plate 1. The lower half of the title-page of *The Book of Urizen* with the date in the imprint altered from 1794 to 1796. Within three framing lines and inscribed below by Blake:

> *Which is the Way*
> *The Right or the Left*

Printed in colours on a leaf 26·5 × 18·5 cm., without watermark.

Coll.: Inscribed on the verso: *This Coloured Print by Wᵐ Blake was given to me by his Widow. Frederick Tatham, Sculptor.* Later in the possession of Lord Killanin and sold at Sotheby's, 28 July 1947, lot 116.

Reprod.: K & W, plate 5.

(ii) Plate 9. The design from *The Book of Urizen*, plate 3, on a leaf cut down to 10 × 15 cm., without watermark. Printed in colours within four framing lines. Inscribed on the verso in an unknown hand: *Oh flames of furious desire.*

Coll.: Said to have been sold by Blake's widow to a dealer named 'E. Danniels'; later in the collection of W. Graham Robertson, sold at Christie's, 22 July 1949, lot 87.

(iii) Plate 17. The design from the upper part of plate 7 of *Visions of the Daughters of Albion*, printed within three

framing lines on a leaf 27 × 18·5 cm., without water-mark. Numbered by Blake 22, and inscribed by him below:

Wait Sisters
Tho' all is Lost

Coll.: From the collection of Dr Greville Macdonald. Bought from Francis Edwards in 1936.

523 JERUSALEM (1804–1818)
(ii) Plate 37, printed in black on a leaf 23·5 × 17 cm., without watermark. The text in the central part of the plate is over-painted with grey and blue watercolour washes. The print is a very carefully and clearly pulled impression of the first state of the plate before *pale death* in the tenth line was altered to *blue death*. [K & W, p. 107.]

Coll.: Carries the collector's stamp of William Bell Scott. Later in the possession of Mrs Graham Smith; Hon. Anthony Asquith. Bought at Hodgson's in 1942.

(iii) Plate 51, printed in blue-green and richly painted with watercolours. Below each figure in the composition is its name in white line (*Vala*, *Hyle*, *Skofeld*) and in the lower left corner is the signature: *W B inv.* These are mostly obliterated by the inking in the five complete copies of the book. [K & W, pp. 108, 112.]

Coll.: From the collection of W. Graham Robertson, sold at Christie's, 22 July 1949, lot 88.

(iv) Plate 100, printed in red-brown on a leaf cut close to 15 × 23 cm. No watermark is visible, but certainly a posthumous impression taken about 1831. Part of the plate-maker's stamp is seen at the upper part of the print.

Coll.: Carries the collector's stamp of William Bell Scott. Later in the possession of Mrs Graham Smith; Hon. Anthony Asquith. Bought at Hodgson's in 1942.

SEPARATE ENGRAVINGS (*arranged chronologically*)
[K.S.P.: Keynes, Geoffrey. *Engravings by William Blake, The Separate Plates. A. Catalogue Raisonnée.* Dublin: Emery Walker (Ireland) Ltd. 1956.]

A. Designed and Engraved by Blake

551 JOSEPH OF ARIMATHEA AMONG THE ROCKS OF ALBION
(ii) Second state printed in black on a leaf 25·5 × 16·5 cm. without watermark. An early impression. Engraved *c.* 1810. [K.S.P. I, 4.]

From the collection of W. E. Moss sold at Sotheby's, 12 March 1937, lot 138.

(iii) Another copy of the second state. Posthumous impression. Printed in black on a leaf 30 × 24 cm. with watermark: J WHATMAN 1828. [K.S.P. I, 5.]

Bought from Mrs John Richmond, 1927.

552 [JOSEPH OF ARIMATHEA] A related print of the same figure, attributed to Beatrizet and likely to have been seen by Blake. Printed in black on a leaf of thin paper 36 × 17 cm. [K.S.P. p. 4.]

Given by E. Kersley.

555 WAR [*or*] THE THREE ACCUSERS (*c.* 1793). Third state. Printed in black on a leaf 23 × 15 cm. without watermark. [K.S.P. VII, A 5.]

From the collection of W. E. Moss sold at Sotheby's, 2 March 1937, lot 185.

558 CHRIST TRAMPLING UPON SATAN (*c.* 1800). Printed in black on a sheet 46 × 29 cm., a recent impression. The engraving was mostly done by

Thomas Butts under Blake's supervision. [K.S.P. XII, 4.]
See also under BUTTS, THOMAS, nos. 775–83.

559 ENOCH (c. 1807). Lithograph, printed in black on a sheet of brown paper 25·5 × 35 cm. without watermark. [K.S.P. XVI, 2.]
From the collection of E. J. Shaw, sold at Sotheby's, 29 July 1925, in lot 157.

560 THE CANTERBURY PILGRIMS (1810)
(i) First state with Blake's colouring. Bought from E. Kersley, April 1969.

(ii) Second state. Printed in black, on a sunk mount. [K.S.P. XVII, 8.]

(iii) Fourth state. Printed in black. [K.S.P. XVII, 14.]
From the collection of George Richmond. Bought at a sale of the effects of Mrs John Richmond, 14 July 1952.

563 THE MAN SWEEPING THE INTER-PRETER'S PARLOUR (c. 1822)
(i) Second state. Printed in black on a sheet 34·5 × 24·5 cm. with watermark: J WHATMAN 1821. [K.S.P. XI, 2.]
Given by Philip Hofer.

(ii) Printed in black on a leaf trimmed to 9·8 × 17·5 cm. [K.S.P. XI, 13.]
Sold at Sotheby's, 9 November 1953, lot 116.

564 MR CUMBERLAND'S CARD (1827)
(i) Printed in greenish grey ink on a card 3·4 × 8·3 cm. [K.S.P. XXI, 5.]

(ii) Printed in black on a card 5·5 × 10·4 cm., pasted as a bookplate in a volume of various etchings, etc. by George Cumberland. [K.S.P. XXI, 6.]

(iii–v) [*Three more impressions*.] Printed in black or brown on different papers; possibly recent impressions. [K.S.P. XXI, not numbered.]

B. Engraved by Blake after others

565 MORNING AMUSEMENT (after Watteau) (1782). Two impressions.
(i) Printed in red-brown on a sheet 29 × 36 cm., last line of imprint trimmed away.

(ii) Printed in colours on a sheet 37·5 × 42 cm. [K.S.P. XXIII, 3 and 5.]

566 THE FALL OF ROSAMUND (after Stothard) (1783). Printed in sanguine on a sheet 44 × 35 cm. [K.S.P. XXV, 1.]

567 ZEPHYRUS AND FLORA (after Stothard) (1784). Four impressions.
(i, ii) Printed in grey on sheets 26 × 26 cm. and 27·5 × 25·5 cm.

(iii) Printed in red on a sheet 25·5 × 26 cm.

(iv) Printed in colours on a sheet trimmed to an oval, 19·5 × 23 cm., removing the inscriptions. [K.S.P. XXVII, 2, 3, 5 and 6.]

568 CALISTO (after Stothard) (1784). Three impressions.
(i) Printed in grey on a sheet 24·5 × 25·5 cm.

(ii) Printed in red on a sheet trimmed to an oval, 18 × 21 cm., removing the inscriptions.

(iii) Printed in colours on a sheet trimmed to an oval, 22·5 × 20 cm., removing the inscriptions. [K.S.P. XXVIII, 2, 4 and 5.]

569 VENUS DISSUADES ADONIS FROM HUNTING. (after Cosway) (1787–1823). Four impressions of two states.
(i) First state. Printed in black on a sheet trimmed to 16·5 × 22 cm., removing the imprint.

(ii–iv) Second state. Three impressions printed in varying colours on sheets of which the largest is 30 × 41 cm. [K.S.P. XXIX, 2–5.]

570 THE INDUSTRIOUS COTTAGER (after Morland) (1788–1803). Impressions of four states.
(i) First state. Printed in brown on a sheet 30 × 33·7 cm.

(ii) Second state. Printed in brown on a sheet trimmed to 27·5 × 30·5 cm.

(iii) Second state. Printed in colours on a sheet 34·5 × 43 cm.

(iv) Third state. Printed in black and coloured by hand, on a sheet 38·5 × 43 cm. [K.S.P. XXX. The first not listed, 5, 6 and 7.]

571 THE IDLE LAUNDRESS (after Morland) (1788–1805). Impressions of three states.
(i) First state. Printed in brown on a sheet 30 × 33·7 cm.

(ii) Second state. Printed in colours on a sheet 26 × 28 cm.

(iii) Third state. Printed in black, coloured by hand, on a sheet 38·5 × 43 cm. [K.S.P. XXXI, 2 and 6; the second state not recorded.]

572 HEAD OF SATAN (after Fuseli) (c. 1790). Two impressions printed in black on sheets 47·5 × 38 cm. and 43 × 32 cm. [K.S.P. XXXIV, 2 and 6.]

573 EDMUND PITTS ESQ. (after Earle) (c. 1790). Printed in black on a sheet 22·5 × 17·5 cm. [K.S.P. XXXVI, 2.]

574 JOHN CASPAR LAVATER (artist unknown) (1800). Three impressions of two states.
(i) First state. Printed in black on a sheet 38·5 × 31·5 cm., somewhat foxed.

(ii, iii) Second state. Two impressions printed in black. [K.S.P. XXXVII, 1, 3 and 4.]

575 THE CHILD OF NATURE (after Borckhardt) (1818). Two proof impressions printed in black on either side of a sheet 44 × 27·5 cm. [K.S.P. XXXIX, 1 and 2.]

576 MRS. Q[UENTIN] (after Huet Villiers) 1820. Printed in colours on a sheet 37 × 26·5 cm. [K.S.P. XLII, 5.]

577 WILSON LOWRY (after Linnell) (1825). Impressions of five states.
(i) First state. Proof printed in black on a sheet 26 × 24 cm.

(ii) Second state. Proof printed in black on a sheet 32·5 × 23·5 cm.

(iii) Third state. Proof printed in black on a sheet 28 × 22 cm.

(iv) Fourth state, the plate finished and lettered *Proof* at the lower right-hand corner. Printed on a sheet 30·5 × 24·5 cm.

(v) Fifth state, without *Proof* lettering. Printed in black on a sheet 36 × 27 cm. [K.S.P. XLIV, 3, 5, 7, 9; (iv) above not recorded.]

579 BLAKE'S CHAUCER. A double leaf. 8vo. [1810].

Unbound. A Prospectus of Blake's engraving of 'The Canterbury Pilgrims'. From the Butts family collection, sold 1932. One other copy is known in the British Museum, Dept. of Prints and Drawings.

WORKS IN LINE ENGRAVING

582 FOR THE SEXES: THE GATES OF PARADISE. London: by W. Blake. 31·5 × 22·5 cm. [c. 1818].
(i) Red niger morocco gilt by Gray. 16 of 21 plates. Lacks title-page, plates 7 and 13 and 'The Keys of the Gates', 2 plates. Several of the plates are cut round and inlaid. [K 53]

From the collection of William Muir, sold at Sotheby's, 21 July 1953, lot 484.

(ii) [Two plates only] Plates 4 and 5 cut round and inlaid in leaves 21·5 × 17 cm. [K 53]

Extracted from an extra-illustrated copy of Bray's Life of Stothard, 1851, in 1941.

583 ILLUSTRATIONS OF THE BOOK OF JOB in twenty-one plates. London: for the Author and J. Linnell. Fo. 1825.

Twenty-one plates, unbound, India paper proofs on large sheets 42 × 33·5 cm., watermark: J WHATMAN TURKEY MILL 1825, untrimmed. Marked Proof on each plate, except the title-page, at the lower right-hand corner. With the paper label. [K 55]

From the stock sold by the Linnell Trustees at Christie's, 22 March 1918, in lot 188.

584 ILLUSTRATIONS OF THE BOOK OF JOB [another issue]

Twenty-one plates in original drab paper boards with paper label; brown cloth spine renewed. Print state on leaves 38·5 × 27·5 cm. with watermark: J WHATMAN 1825, untrimmed, interleaved with thin paper. [K 55]

Reprint made for Lessing J. Rosenwald. 1968.

PRINTED WORKS WITH PLATES DESIGNED
AND ENGRAVED BY BLAKE
(arranged chronologically)

Commins, Thomas

588 AN ELEGY SET TO MUSIC. London: by J. Fentum. 4to. [1786].
Quarter crimson niger morocco by Stoakley. Engraved frontispiece by Blake with five plates of music. [K 68]

Young, Edward

589 THE COMPLAINT, AND THE CONSOLATION; OR, NIGHT THOUGHTS. London: by R. Noble for R. Edwards. Fo. 1797.

Half red niger morocco by Gray, untrimmed. With 43 engraved plates surrounding the text, pp. 11–12 defective. With the leaf of 'Explanation of the engravings'. [K 70]

Hayley, William

590 LITTLE TOM THE SAILOR. Folkestone: for the Widow Spicer. 58 × 19 cm. 1800.
(i) Broadside, untrimmed, on Whatman paper dated [17]97. With headpiece, text, tailpiece and colophon etched by Blake on four plates, printed in sepia ink and touched up with watercolour washes in sepia. [K 71]

(ii) [tailpiece only] A proof of the tailpiece lightly printed in grey ink on a leaf 11·5 × 17 cm. [K 71]

591 DESIGNS TO A SERIES OF BALLADS, written by William Hayley. Chichester: by J. Seagrave for W. Blake. 4to. 1802.

Red straight-grained morocco gilt by Rivière, gilt edges. With frontispiece, 5 plates and 8 vignettes designed and engraved by Blake, comprising the complete set of four ballads, including 'The Dog'. [K 72]

592 DESIGNS TO A SERIES OF BALLADS. Ballads the First and the Third. [only]

Contemporary quarter calf. With frontispiece, 2 plates and 5 vignettes. Bound with 3795 [in Bibliotheca Bibliographica] and 7 other pieces by Peter Pindar, etc. [K 72]

593 DESIGNS TO A SERIES OF BALLADS. Ballad the Second. The Eagle. [only]

Stitched as issued, but lacking the wrappers, untrimmed. With one plate and two vignettes. [K 72]

594 DESIGNS TO A SERIES OF BALLADS [proof of the frontispiece]

Proof of the frontispiece, 'Adam Naming the Beasts', trimmed close and inlaid in a sheet 31·5 × 25 cm.; with two framing lines in red and signed in red: W^m Blake fecit. Proof before the addition of the engraved signature. [K 72]

From the E. J. Shaw collection, sold at Sotheby's, 29 July 1925, lot 157.

595 BALLADS. Chichester: by J. Seagrave for R. Phillips. London. 8vo. 1805.

Original drab paper boards, new cloth spine, untrimmed. With 5 plates designed and engraved by Blake, first state. [K 74] Two other copies: (i) Original brown paper boards and paper label, untrimmed. (ii) Original blue paper boards, blue cloth spine, untrimmed. With 5 plates, second state.

Wollstonecraft, Mary

596 ORIGINAL STORIES FROM REAL LIFE. London: for J. Johnson. 8vo. 1791.

Contemporary calf, red label. With 5 plates designed and engraved by Blake, first state. [K 69]

597 ORIGINAL STORIES FROM REAL LIFE. A New Edition. London: for J. Johnson. 8vo. 1796.

Contemporary sprinkled sheep, gilt. With 5 plates, second state. Inscribed on the fly-leaf: *The Ladies Carnegies*. [K 69]

[Wedgwood, Josiah]

598 [CATALOGUE OF CROCKERY]. [Etruria]. 4to. [c. 1816.]

Red niger morocco by Gray, gilt. With 31 plates, the first 18 drawn and engraved by Blake, the other by J. T. Wedgwood. Made for use at the Wedgwood Works at Etruria, Stoke-on-Trent. [K 76]

Given by Frank Wedgwood at Etruria, 1926.

Thornton, Robert John

599 THE PASTORALS OF VIRGIL adapted for Schools. Illustrated by 230 Engravings. Third Edition. London: F. C. & J. Rivingtons, &c. 2 vols. 8vo. 1821.

Original pink sheep. The illustrations include 17 wood engravings by Blake. Bookplates of John M'Cray and William Cowan. [K 77]

Another copy: Contemporary calf, gilt, rebacked. With signature on fly-leaves: *Lady Caroline Lambe*. The impressions of Blake's wood engravings are unusually fine. [K 77]

600 THE PASTORALS OF VIRGIL [*wood engravings only*]

A set of rough proofs taken from the original wood blocks on smooth paper by the electrotypers who made the reproductions for the Nonesuch edition, 1937. The light inking shows many details of the engravings not seen in heavily inked prints. With ALS from Harry Carter, 22 November 1937.

601 REMEMBER ME! A New Year's Gift or Christmas Present, 1825. London: I. Poole. 12mo. [1825.]

Original printed pink boards, brown endpapers, gilt edges, in pink slip-case with a coloured design on the front. With engraved frontispiece, title-page, and 10 plates, including Blake's 'Hiding of Moses'. [K 78]

Four other copies. (i) Original printed pink boards, brown endpapers, gilt edges, in red-brown slip-case.

(ii) Original printed drab boards, pink endpapers, gilt edges in green slip-case.

(iii) Original printed drab boards, brown endpapers, gilt edges, lacking slip-case.

(iv) Original stiff brown paper wrappers, slate-grey endpapers, gilt edges, in slate-grey slip-case.

PRINTED WORKS WITH PLATES DESIGNED
BY BLAKE, ENGRAVED BY OTHERS
(*arranged chronologically*)

Bürger, G. A.

602 LEONORA. A TALE FROM THE GERMAN OF G. A. BÜRGER. Translated by J. T. Stanley. London: by S. Gosnell for W. Miller. Fo. 1796.

Nineteenth-century blue morocco, untrimmed. With frontispiece and 2 vignettes engraved by Perry after Blake. Bound with 1451 [in *Bibliotheca Bibliographica*]. [K 79]
Another copy: Original grey-blue paper wrappers, untrimmed. Lacking the frontispiece, the vignettes with delicate contemporary colouring.

Malkin, Benjamin Heath

603 A FATHER'S MEMOIRS OF HIS CHILD. London: by T. Bensley for Longmans, &c. 8vo. 1806.

Original brown paper boards, paper label, untrimmed. With frontispiece engraved by Cromek after Blake; 2 other plates and folding map. Bookplate of C. H. Wilkinson. A review inserted from *The British Critic*, September 1806, signed: 'Loves of the Triangles'. [K 80]

Another copy: Contemporary half calf, gilt spine, red label. With signature on fly-leaf: *Thomas H. Cromek* 1860. Bookplate of J. S. Starkey ('Seumas O'Sullivan'). [K 80]

Blair, Robert

604 THE GRAVE, A POEM. Illustrated by Twelve Etchings executed from Original Designs [by Blake]. London: by T. Bensley for R. H. Cromek. 4to. 1808.

Original quarter cloth, grey paper boards, paper label on front cover, untrimmed. With portrait of Blake after Phillips, engraved title-page and 11 plates, all engraved by Schiavonetti. Marked 'Subscriber's Copy' at the bottom of the title-page. [K 81]

605 THE GRAVE, A POEM [*plates only*]

Proofs of 13 plates printed on large sheets, unbound, untrimmed. The plates are before letters or before completion of letters. Plate 9 is on India paper. [K 81]

606 THE GRAVE, A POEM [*plates only, later issue*]

The reissue of the plates extracted from de Mora's *Meditaciones Poeticas*, London and Mexico: R. Ackerman. 4to. 1826. [K 84]

607 THE GRAVE, A POEM [*drawing for the portrait*]

The engraver's drawing of the portrait after Phillips in pen and ink coloured with watercolour washes, on a sheet 33·5 × 24 cm.

608 THE GRAVE, A POEM, now first printed separately from the original plates. With introductory note by A. J. Smith. New York: The Phoenix Press. Fo. 1926.

Thirteen plates loose in portfolio, with announcement form. No. 2 of 110 copies.

609 THE GRAVE, A POEM [*another edition*] New York: A. L. Dick. 4to. 1847.

Original blue cloth, gilt spine and sides, gilt edges. With portrait, title-page and plates engraved by A. L. Dick after Blake and Schiavonetti. Plate 4, 'The Meeting of a Family in Heaven', was omitted, having been regarded as blasphemous.

Varley, John

610 A TREATISE ON ZODIACAL PHYSIO-GNOMY. London: Published by the Author. 8vo. 1828.

Half red morocco by Gray, untrimmed. With 5 plates engraved by J. Linnell, including *Ghost of a Flea*, two versions, and *Reverse of the Coin of Nebuchadnezzar* after Blake. [K 248]

Anonymous

612 THE LADIES' DRAWING ROOM BOOK. London: J. Cassel. 4to. [1852].

Original blue cloth, gilt, gilt edges. With many illustrations by W. J. Linton and others, including *Death and Immortality* after Blake's *Death's Door*, and an unsigned article.

PRINTED WORKS CONTAINING PLATES
ENGRAVED BY BLAKE AFTER OTHERS, AND
PLATES EXTRACTED FROM THEM
(*arranged alphabetically*)

Allen, Charles

613 A NEW AND IMPROVED HISTORY OF ENGLAND. The Second Edition. London: for J. Johnson. 8vo. 1798.

Contemporary calf, gilt spine, presentation label for merit on the front cover. With 4 plates engraved by Blake after Fuseli. [K 115]

614 A NEW AND IMPROVED ROMAN HISTORY. The Second Edition. London: for J. Johnson. 8vo. 1798.

Contemporary half calf, gilt spine, red label. With 4 plates engraved by Blake after Fuseli. [K 116]

Ariosto, L.

615 [ORLANDO FURIOSO, translated by John Hoole. Vol. III. London: for the author. 8vo. 1783.]

One plate only, extracted, engraved by Blake after Stothard [K 96]

Bellamy, J.

616 [PICTURESQUE MAGAZINE AND LITERARY MUSEUM. London: 4to. 1793.]

Plate 10 only, extracted, 'F[rench] Revolution', engraved by Blake after Ryley. [Not in K] The only copy of the book located, in Harvard University Library, has 12 engraved plates by various engravers, including no. 10 by Blake.

Bible

617 [THE PROTESTANT'S FAMILY BIBLE. London: for Harrison and Co. 4to. 1780.]

Four plates only, extracted, engraved by Blake after Raphael and Rubens. [K 88]

Bonnycastle, John

618 AN INTRODUCTION TO MENSURATION, AND PRACTICAL GEOMETRY. London: for J. Johnson. 12mo. 1782.

Original sheep, rebacked; pp. ix, [iii], 285, [3], with half-title and 3 pp. advts. at the end. With a vignette on the title-page engraved by Blake after Stothard and numerous diagrams in the text. [K 90] The engraving as it appears in the book is unsigned; its authorship is established by a proof in the Balmanno collection of Stothard's works in the British Museum Print Room, this being lettered: *Stothard del. Blake sc.* No copy of the book was found until November 1962.

[Boydell, J.]

619 GRAPHIC ILLUSTRATIONS OF SHAKESPEARE; consisting of a Series of Prints; London: by Boydell & Co. Fo. [1803].

Contemporary quarter calf, rebacked. With frontispiece, engraved title-page and 99 plates; no. 93 engraved by Blake after Opie. [K 123]

Brown, John

620 THE ELEMENTS OF MEDICINE. With a Biographical Preface by Thomas Beddoes. London: for J. Johnson. 2 vols. 8vo. 1795.

Contemporary quarter cloth. Portrait in vol. 1 engraved by Blake after Donaldson. [K 109]

Catullus

621 THE POEMS OF CAIUS VALERIUS CATULLUS IN ENGLISH VERSE. London: for J. Johnson. 2 vols. 8vo. 1795.

Original boards, paper labels added, untrimmed. With a frontispiece in each volume (Catullus, Cornelius Nepos) engraved by Blake after Della Rosa. [K 110]

Cumberland, George

622 THOUGHTS ON OUTLINE. London: by W. Wilson for Messrs Robinson and T. Egerton. 4to. 1796.

Original boards, untrimmed. With 24 engraved plates, including 8 by Blake after Cumberland. [K 112]

623 OUTLINES FROM THE ANCIENTS. London: Septimus Prowett. 4to. 1829.

Contemporary half morocco. With 81 plates including 4 by Blake after Cumberland. [K 133]

Darwin, Erasmus

624 THE BOTANIC GARDEN. Pt. i. The Economy of Vegetation. Pt. ii. The Loves of the Plants [*third edition*]. London: for J. Johnson. 2 vols. 4to. 1791.

Original boards, untrimmed. With engraved frontispiece and 8 plates in vol. i, 5 engraved by Blake, one after Fuseli; four engravings of the Portland vase are unsigned; engraved frontispiece and 7 plates in vol. ii. Bookplates of Rd. Drake. [K 103]

625 [THE BOTANIC GARDEN. Third Edition. London: for J. Johnson. 4to. 1795.]

Two plates only extracted, engraved by Blake after Fuseli. [K 108]

626 THE BOTANIC GARDEN. The fourth edition. London: for J. Johnson. 2 vols. 8vo. 1799.

Original marbled paper boards, untrimmed, with engraved frontispiece and 10 plates in each volume, 5 in volume i being engraved by Blake. [K 118]

Euler, Leonard

627 ELEMENTS OF ALGEBRA. London: for J. Johnson. 2 vols. 8vo. 1797.

Contemporary tree calf, red and green labels. Portrait engraved by Blake after Ruchotte. [K 113]

Flaxman, John

628 A LETTER TO THE COMMITTEE for raising a Naval Pillar. London: for T. Cadell, &c. 4to. 1799.

Quarter vellum by Gray. With 3 plates engraved by Blake after Flaxman. [K 119]

Compositions from the Works, Days and Theogony of Hesiod. Engr. by W. Blake. Longman, &c. 1817, 38 plates, oblong fo. Bd. with Flaxman's Aeschylus, 1831. Armorial bookplate. 200 copies printed.

Fuseli, Henry

629 LECTURES ON PAINTING. London: for J. Johnson. 4to. 1801.

Contemporary red straight-grained morocco, black label, gilt edges. With 2 engraved vignettes, one by Blake of Michelangelo after Fuseli. [K 122]

Gay, John

630 [FABLES. London: for J. Stockdale. 2 vols. 8vo. 1793.]

Twelve plates only, extracted, first state, engraved by Blake. [K 106]

631 FABLES. London: for J. Stockdale. 2 vols. 8vo. 1793. [1810]

Original boards, rebacked, untrimmed. The reissue of 1810. With engraved frontispiece, title-pages and 67 plates, of which 12 were engraved by Blake. [K 106]

Haller, Albert de

632 MEMOIRS. Edited by Thomas Henry. Warrington: by W. Eyres for J. Johnson, London. 12mo. 1783.

Half brown calf by Gray, untrimmed. Portrait engraved by Blake. [K 95]

Hartley, David

633 [OBSERVATIONS ON MAN. London: for J. Johnson. 4to. 1791.]

Frontispiece only, extracted, portrait engraved by Blake after Shackleton. [K 105]

Hayley, William

634 AN ESSAY ON SCULPTURE. London: by A. Strahan for T. Cadell and W. Davies. 4to. 1800.

Original boards, rebacked, untrimmed. With 3 plates engraved by Blake. Hayley's copy with corrections in his hand, and a pencil sketch of *The Death of Demosthenes* by Thomas Hayley (engraved Blake) inserted. Blake's engraving of Michelangelo from 629 pasted in. [K 120]

635 [THE LIFE OF GEORGE ROMNEY. London: by W. Mason for T. Payne. 4to. 1809.]

One plate only (*The Shipwreck*), extracted, engraved by Blake after Romney. [K 130]

636 THE LIFE AND POSTHUMOUS WRITINGS OF WILLIAM COWPER. Second edition. Chichester: by J. Seagrave for J. Johnson, London. 2 vols. 4to. 1803.

Contemporary tree calf, gilt spine, black labels. With 3 plates engraved, and 1 in the text designed and engraved, by Blake. [K 124]

THE LIFE AND POSTHUMOUS WRITINGS OF WILLIAM COWPER. Vols. I–III. Chichester: by J. Seagrave for J. Johnson, London. 4to. 1803–4.

Original grey paper boards, untrimmed. Two engr. pl. by Blake in each vol.

637 THE TRIUMPHS OF TEMPER. A POEM. The Twelfth Edition. With Designs by Maria Flaxman. Chichester: by J. Seagrave for T. Cadell and W. Davies. 8vo. 1803.

Original grey boards, large paper, untrimmed. With 6 plates engraved by Blake. Inscribed on the half-title: *From the Author.* [K 125]

Another copy, small paper: Contemporary green straight-grained morocco, gilt edges.

638 THE TRIUMPHS OF TEMPER. A POEM. The Thirteenth Edition. Chichester: by J. Seagrave for T. Cadell and W. Davies, London. 8vo. 1807.

Original brown paper boards, untrimmed, leather label added. [K 125]

Hoare, Prince

639 ACADEMIC CORRESPONDENCE, 1803. London: for Robson, &c. 4to. 1804.

Quarter vellum by Gray. With engraved frontispiece by Blake after Flaxman. [K 126]

640 AN INQUIRY INTO THE PRESENT STATE OF THE ART OF DESIGN IN ENGLAND. London: for R. Phillips. 8vo. 1806.

Original boards, untrimmed. With frontispiece engraved by Blake after Reynolds. [K 129]

Hunter, John

641 AN HISTORICAL JOURNAL OF THE TRANSACTIONS AT PORT JACKSON AND NORFOLK ISLAND. London: for J. Stockdale. 4to. 1793.

Contemporary calf, red label. With engraved portrait, vignette on the title-page and 15 maps; also 1 plate engraved by Blake. [Not in K]

Lavater, John Caspar

642 APHORISMS ON MAN. London: for J. Johnson. 8vo. 1788.
Contemporary calf, gilt spine, red label. With frontispiece engraved by Blake after Fuseli. [K 101]

643 APHORISMS ON MAN. Second Edition. London: by T. Bensley for J. Johnson. 8vo. 1789.
Contemporary half calf. [K 101]

644 APHORISMS ON MAN. Third Edition. London: for J. Johnson. 8vo. 1794.
Contemporary quarter calf. [K 101]

645 [ESSAYS ON PHYSIOGNOMY. London: for J. Murray. 3 vols. 4to. 1789.]
Three plates only, extracted, engraved by Blake. [K 102]

Magazines

646 THE WIT'S MAGAZINE: or, Library of Momus. London: for Harrison and Co. 8vo. 1784. 2 vols.
Quarter calf in one volume. With 15 plates, lacking two others, the first 5 engraved by Blake after Stothard and Collings. [K 98]

647 [THE NOVELIST'S MAGAZINE. Vols. VIII–X. London: for Harrison and Co. 8vo. 1782–3.]
Eight plates only, extracted, engraved by Blake after Stothard. [K 92]

Olivier, J.

648 FENCING FAMILIARIZED. A New Edition. London: for J. Bell. 1780.
Original boards, untrimmed. With engraved frontispiece and 13 plates, one engraved by Blake. [K 87]

Rees, Abraham

649 [THE CYCLOPAEDIA. London: for Longman, &c. 4 vols. 4to. 1820.]
Seven plates only, extracted, engraved by Blake, one from his own drawings. [K 132]

Ritson, Joseph

650 A SELECT COLLECTION OF ENGLISH SONGS. London: for J. Johnson. 3 vols. 8vo. 1783.
Contemporary calf, gilt spines, red and black labels. With engraved frontispiece and 16 vignettes, of which 9 were engraved by Blake. [K 97]

Salzmann, C. G.

651 ELEMENTS OF MORALITY. [*Translated by Mary Wollstonecraft*] London: by J. Crowder for J. Johnson. 3 vols. 8vo. 1791.
Original sheep. With 50 engraved plates, of which at least 16 were engraved by Blake after Chodowiecki, though none are signed. [K 104]

652 ELEMENTS OF MORALITY [*another edition*]. London: for J. Sharpe. 2 vols. 8vo. [n.d.]
Original quarter red sheep. [K 104, p. 237]

653 GYMNASTICS FOR YOUTH. London: for J. Johnson. 8vo. 1800.

Parchment boards, untrimmed. With folding frontispiece and 9 plates, probably engraved by Blake, though unsigned. [K 121]

Scott, John

654 THE POETICAL WORKS. The Second Edition. London: for J. Buckland. 8vo. 1786.

Contemporary tree calf, gilt spine, red label. With engraved frontispiece, title-page, 6 plates and 4 vignettes, of which 2 plates and 2 vignettes were engraved by Blake after Stothard. [K 94]

Shakespeare, William

655 [THE PLAYS. Edited by George Steevens. Vol. VII. London: for J. C. and J. Rivington. 8vo. 1805.]

One plate only extracted (*Queen Katherine's Dream*), engraved by Blake after Fuseli. [K 128]

Stedman, William

656 NARRATIVE OF A FIVE YEARS' EXPEDITION against the Revolted Negroes of Surinam. London: for J. Johnson & J. Edwards. 2 vols. 4to. 1796.

Original marbled paper boards, untrimmed. With engraved frontispiece and 40 plates in each volume, of which 8 in each volume were largely redrawn and engraved by Blake after Stedman. [K 111]

Another copy: On large paper with contemporary colouring.

BOOKS FROM BLAKE'S LIBRARY

Bacon, Sir Francis

720 ESSAYS MORAL, ECONOMICAL, AND POLITICAL. London: by T. Bensley for J. Edwards. 8vo. 1798.

Original boards, cloth spine with gold label added and lettered in ink: BACON'S / ESSAYS, untrimmed. Annotated throughout in pencil by Blake. Signature inside the cover: *Samuel Palmer 1833*. From the library of Mr J. K. Lilly. Bought from him in 1947. *Another copy*: Contemporary calf, rebacked, with 'Etruscan' decoration by Edwards of Halifax on the covers. Bookplate of G. W. Wentworth. With Blake's annotations transcribed from his copy by Geoffrey Keynes.

Barry, James

721 AN ACCOUNT OF A SERIES OF PICTURES IN THE GREAT ROOM OF THE SOCIETY OF ARTS AT THE ADELPHI. London: by W. Adlard for the Author, T. Cadell and J. Walter. 8vo. 1783.

Original grey-blue paper wrappings, the front cover detached, untrimmed. Inscribed on the title-page in pencil: *This was William Blake's Copy*. Attached to the inside of the front cover by wafers is a leaf, 14 × 10·2 cm, with a drawing of an old man, head and shoulders, done in sepia strengthened with pencil. Below this is inscribed in the same hand as before: *This is a portrait of Barry by Blake. A. H. Palmer*. There is a similar inscription, unsigned, on the back of the drawing, which unmistakably represents Barry in old age. The book and drawing were seen by Gilchrist (*Life*, 1880, II, 48). They were afterwards in the collection of H. Buxton Forman (his cipher is inside the back cover) and later of George C. Smith. Bought from Mr Jacob Zeitlin, bookseller of Los Angeles, in 1962. [K 687]

Boyd, Henry

722 A TRANSLATION OF THE INFERNO OF DANTE ALIGHIERI, IN ENGLISH VERSE. Dublin: by P. Byrne. 8vo. 1785.

Early 19th-century purple cloth over original boards, with gold label added and lettered in ink: DANTE, untrimmed. The editor's introduction is annotated in the margins by Blake in pencil and pen. Inscribed inside the cover: *Samuel Palmer's Copy*, and with pencil notes by A. H. Palmer. Loosely inserted is a receipt to John Linnell, 11 September 1818, in the hand of Blake and signed by him. Bought from Bryan Palmer in 1957.

Chatterton, Thomas

723 POEMS BY THOMAS ROWLEY, AND OTHERS. The Third Edition. London: for T. Payne and Son. 8vo. 1788.

Original buff boards, with gold label added and lettered in ink: CHATTERTON, untrimmed. With signature on the title-page: *William Blake*. Inscribed inside the cover: *Samuel Palmer*, and on the fly-leaf: *Sydney C. Cockerell 1908*. Given by Sir Sydney Cockerell, 1958. [K 686]

Swedenborg, Emmanuel

724 THE WISDOM OF ANGELS CONCERNING THE DIVINE PROVIDENCE. London: R. Hindmarsh. 8vo. 1790.

Original grey paper boards, buff paper spine with printed paper label (worn), untrimmed. With signature on half-title: *William Blake*, and annotations by him in pencil in the margins of nine pages. Inside the cover is the monogram: *S P*[almer]. Also on the half-title is a gold label similar to those on the spines of several of Blake's books, but numbered 147.

725 HYMNS FOR THE NATION, IN 1782. In Two Parts. London: by J. Paramore. 12mo. [1782].

Dark blue morocco, gilt panels and spine, by V. A. Brown, Hildenborough, Kent. Two issues bound together, the earlier (pages 1–12, 1–11) following the second (pages 1–24, 25–47). The earlier issue has no title-page, but is inscribed at the top of page 1: *W. Blake 1790* in ink. This has been slightly cropped by the binder. Bookplate of James S. Starkey ('Seumas O'Sullivan'). Bought at Christie's 8 December 1958, in lot 238.

Winkelmann, Abbé

726 REFLECTIONS ON THE PAINTING AND SCULPTURE OF THE GREEKS. Translated by Henry Fuseli. London: for the Translator and A. Millar. 8vo. 1765.

Contemporary calf, joints broken, red label. With inscription on the fly-leaf: *William Blake / Lincoln's Inn*. Inscribed by Blake as an apprentice to Basire in Great Queen Street, Lincoln's Inn Fields. [K 684]

FORMER OWNERS
(EXCLUDING APPENDIX)

NUMERICAL AND SUBJECT CONCORDANCE FOR PAINTINGS AND DRAWINGS
(EXCLUDING APPENDIX)

MUSEUM NUMBER	CATALOGUE NUMBER	SUBJECT
456a	1A	The Story of Joseph: *Joseph's brethren bowing down before him*
456b	1B	The Story of Joseph: *Joseph ordering Simeon to be bound*
456c	1C	The Story of Joseph: *Joseph making himself known to his brethren*
712	27	*Queen Katherine's Dream*
765	23	*Death on a pale horse*
1769	17	*The Lazar House or House of Death*
1771	2	*Queen Katherine's Dream*
2717	35	*A Prophet in the Wilderness*
PD. 27–1949	33	*An Allegory of the Spiritual Condition of Man*
PD. 28–1949	21	*The Judgement of Solomon*
PD. 29–1949	25	*The Angel of the Divine Presence clothing Adam and Eve with coats of skins*
PD. 30–1949	22	*The Soldiers casting lots for Christ's garments*
PD. 31–1949	24	*The Three Marys at the Sepulchre*
PD. 32–1949	26	*The Ascension*
PD. 14–1950	34A	Paradise Regained: *The Baptism of Christ*
PD. 15–1950	34B	Paradise Regained: *Christ tempted by Satan to turn the stones into bread*
PD. 16–1950	34D	Paradise Regained: *Mary's lamentation over Christ*
PD. 17–1950	34E	Paradise Regained: *Satan addressing his potentates*
PD. 18–1950	34F	Paradise Regained: *Christ refusing the banquet*
PD. 19–1950	34G	Paradise Regained: *Satan tempts Christ with the kingdoms of the earth*
PD. 20–1950	34H	Paradise Regained: *Christ's troubled sleep*
PD. 21–1950	34I	Paradise Regained: *Morning chasing away the phantoms*
PD. 22–1950	34J	Paradise Regained: *Christ placed on the pinnacle of the Temple*
PD. 23–1950	34K	Paradise Regained: *Angels ministering to Christ*
PD. 24–1950	34L	Paradise Regained: *Christ returns to His Mother*
PD. 25–1950	34C	Paradise Regained: *Andrew and Simon Peter searching for Christ*

MUSEUM NUMBER	CATALOGUE NUMBER	SUBJECT
PD. 26–1950	39 3r	The Book of Job: *Job and his family*
PD. 27–1950	39 2r	The Book of Job: *Job and his family*
PD. 28–1950	39 4r	The Book of Job: *Satan before the throne of God*
PD. 29–1950	39 5r	The Book of Job: *Job's sons and daughters overwhelmed by Satan*
PD. 30–1950	39 6r	The Book of Job: *The Messengers tell Job of his misfortunes*
PD. 31–1950	39 7r9	The Book of Job: *Satan going forth from the presence of God*
PD. 32–1950	39 8r	The Book of Job: *Satan smiting Job with boils*
PD. 33–1950	39 9r	The Book of Job: *Job's Comforters*
PD. 34–1950	39 10r	The Book of Job: *Job's despair*
PD. 35–1950	39 11r	The Book of Job: *A Spirit passes before Job's face*
PD. 36–1950	39 12r	The Book of Job: *Job rebuked by his friends*
PD. 37–1950	39 13r	The Book of Job: *Job's evil dreams*
PD. 38–1950	39 14r	The Book of Job: *The Wrath of Elihu*
PD. 39–1950	39 15r	The Book of Job: *The Lord answering Job out of the Whirlwind*
PD. 40–1950	39 16r	The Book of Job: *When the morning stars sang together*
PD. 41–1950	39 17r	The Book of Job: *Behemoth and Leviathan*
PD. 42–1950	39 18r	The Book of Job: *The Fall of Satan*
PD. 43–1950	39 19r	The Book of Job: *The Vision of Christ*
PD. 44–1950	39 20r and v	The Book of Job: *Job's sacrifice*
PD. 45–1950	39 23r	The Book of Job: *Every man also gave him a piece of money*
PD. 46–1950	39 21r	The Book of Job: *Every man also gave him a piece of money*
PD. 47–1950	39 24r	The Book of Job: *Job and his daughters*
PD. 48–1950	39 22r	The Book of Job: *Job and his family restored to prosperity*
PD. 48A–1950	39 lv	The Book of Job: *Job and his family*
PD. 49–1950	37	*The Archangel Michael foretelling the Crucifixion*
PD. 50–1950	38	*The Wise and Foolish Virgins*
PD. 13–1953	3	*Har and Heva bathing, Mnetha looking on* (from Tiriel)

PORTRAITS OF BLAKE

Flaxman 828 (45); Richmond 2784 (54); Linnell PD. 55–1950 (47), PD. 56–1950 (48), PD. 57–1950 (46), PD. 58–1950 (52), PD. 59–1950 (50), PD. 60–1950 (51), PD. 61–1950 (49); Mrs Catherine Blake PD. 14–1953 (53).

PLATES

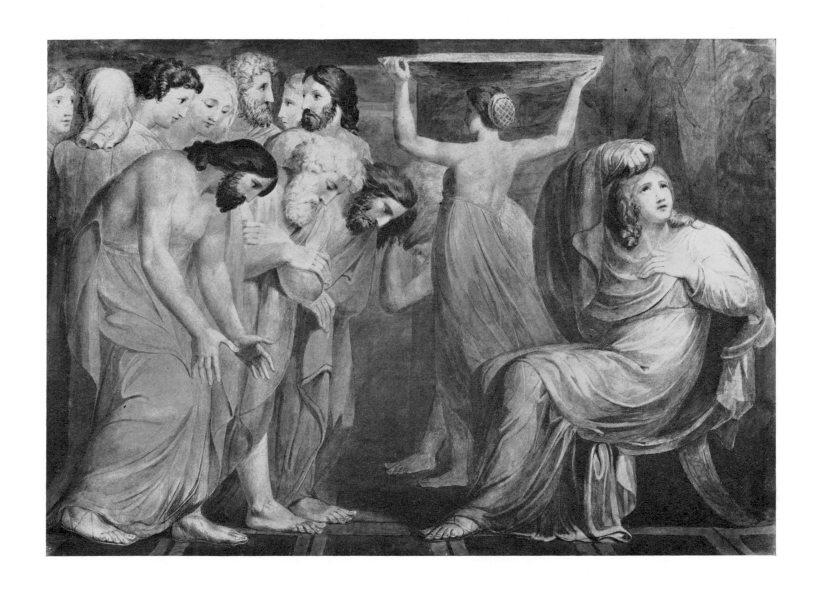

1 The Story of Joseph: *Joseph's brethren bowing down before him* (1 A)

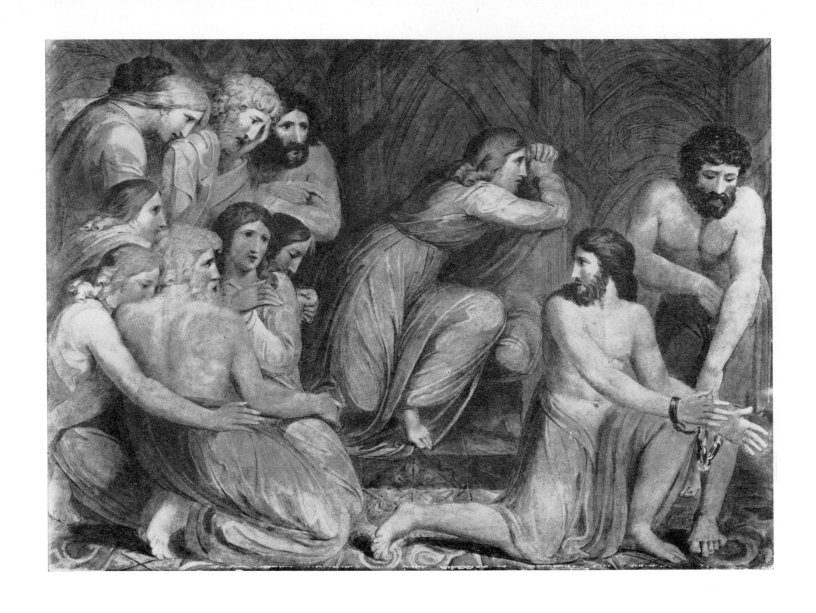

2 The Story of Joseph: *Joseph ordering Simeon to be bound* (I B)

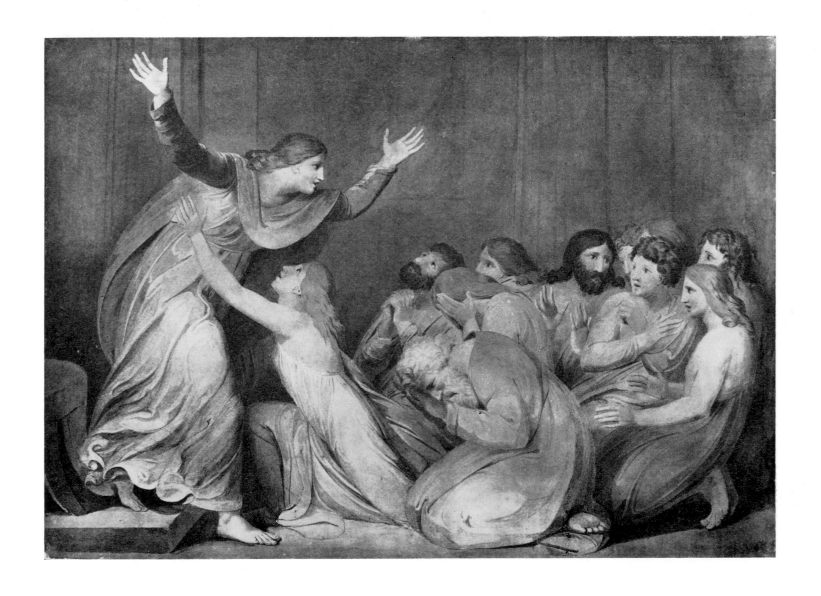

3 The Story of Joseph: *Joseph making himself known to his brethren* (1c)

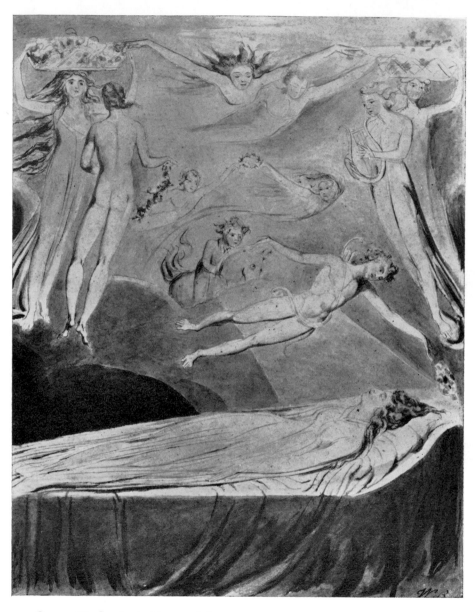

4　Queen Katherine's Dream (2)

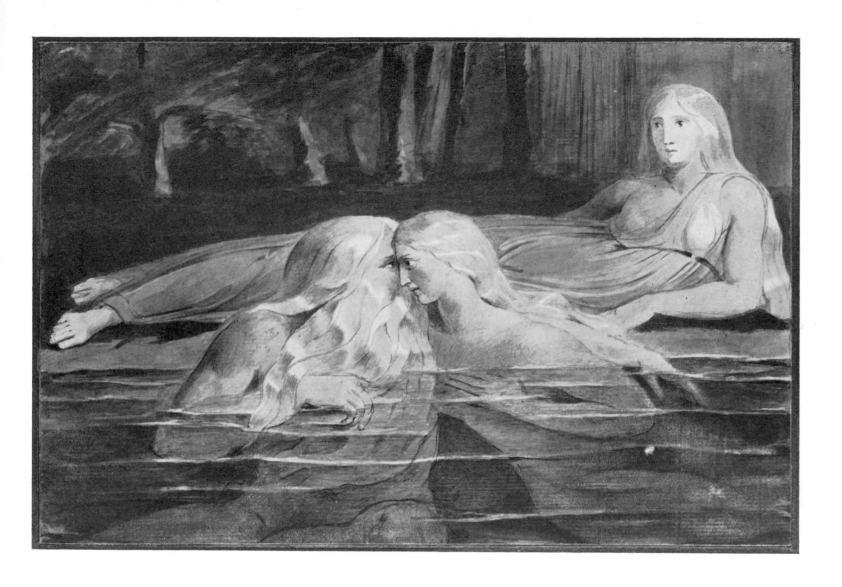

5 Har and Heva bathing: Mnetha looking on (3)

No No let us play for it is yet day
And we cannot ~~go to~~ sleep ~~the rest~~
~~[deleted line]~~
Besides the sky the little birds fly
And the meadows are coverd with Sheep

Well Well go & play till the light fades away
And then go home to bed
The little ones leaped & shouted & laughd
And all the hills echoed
Then ~~[deleted]~~ ~~[deleted]~~ ~~[deleted]~~ Sung Quid

O father father where are you going
O do not walk so fast
O speak father speak to your little boy
Or else I shall be lost

The night it was dark & no father was there
And the child was wet with dew
The mire was deep & the child did weep
And away the vapour flew

Here nobody could say any longer. till Tilly Lally pluckd up a
spirit & he sung.
O I say you Joe
Throw us the ball
I've a good mind to go
And leave you all
I never saw saw such a bowler
To bowl the ball in a ~~[deleted]~~ tansey
And to clean it with my handkercher
Without saying a word

That Bills a foolish fellow
~~[deleted]~~
He has given me a black eye
He does not know how to handle a bat
Any more than a ~~dog or a~~ cat
He has knockd down the wicket
And broke the stumps
And runs without shoes to save his pumps

Here a laugh began and Miss Gittipin sung
Leave O leave to my sorrows
Here I'll sit & fade away
Till I'm nothing but a spirit
And I lose this form of clay

6 An Island in the Moon: fo. 8 *recto* (4)

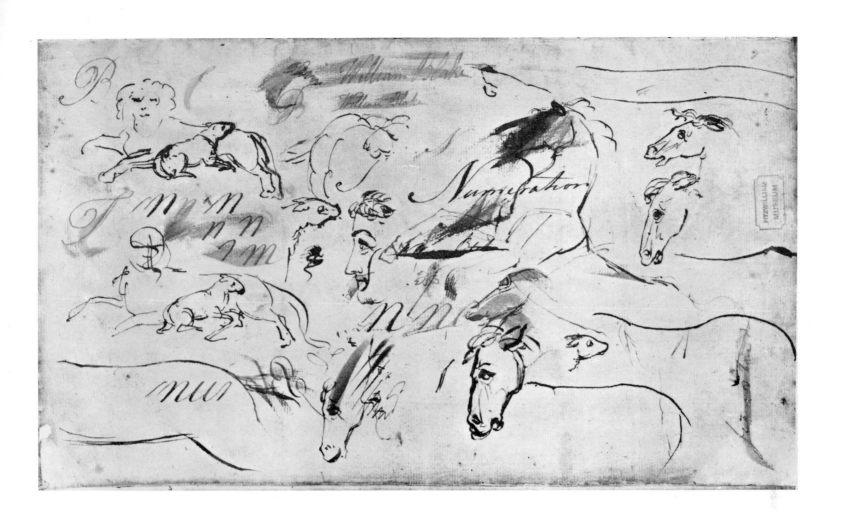

7 An Island in the Moon: fo. 16 *recto* (4)

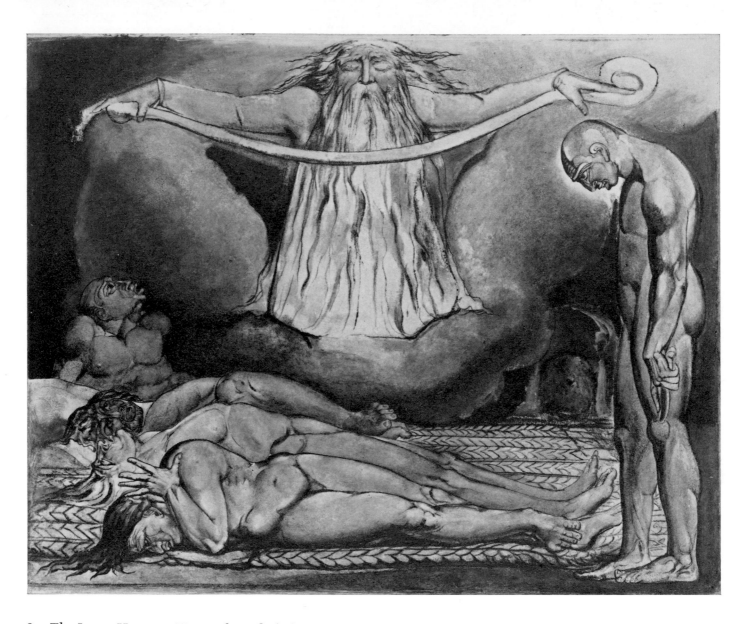

8 The Lazar House or House of Death (17)

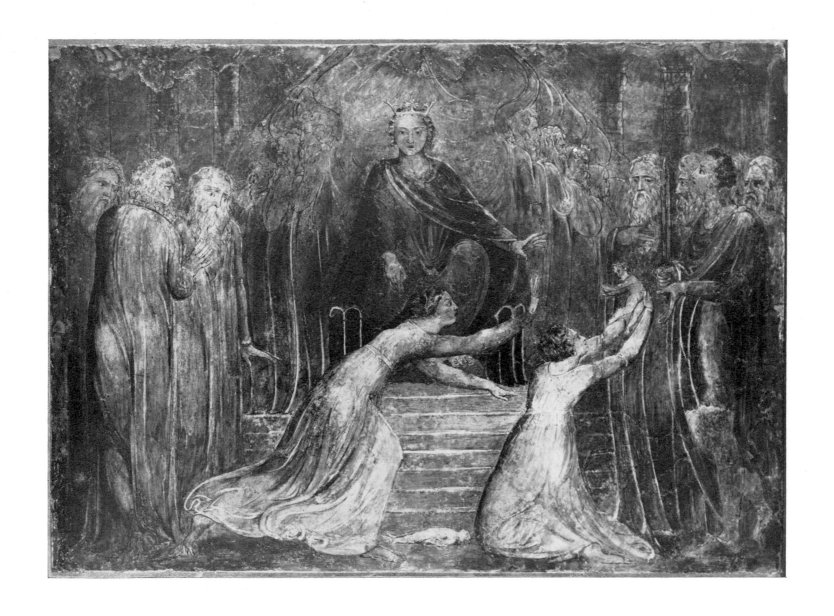

9 The Judgment of Solomon (21)

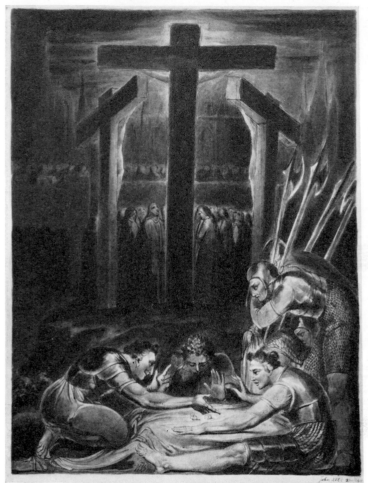 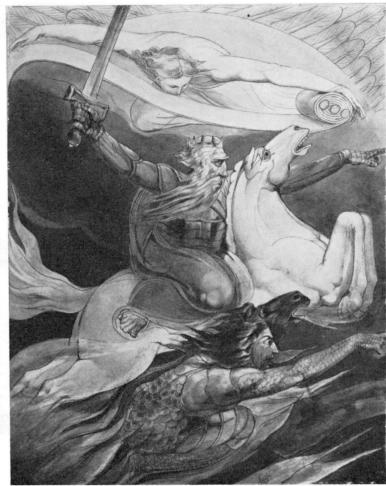

10 The Soldiers casting lots for Christ's garments (22) 11 Death on a pale horse (23)

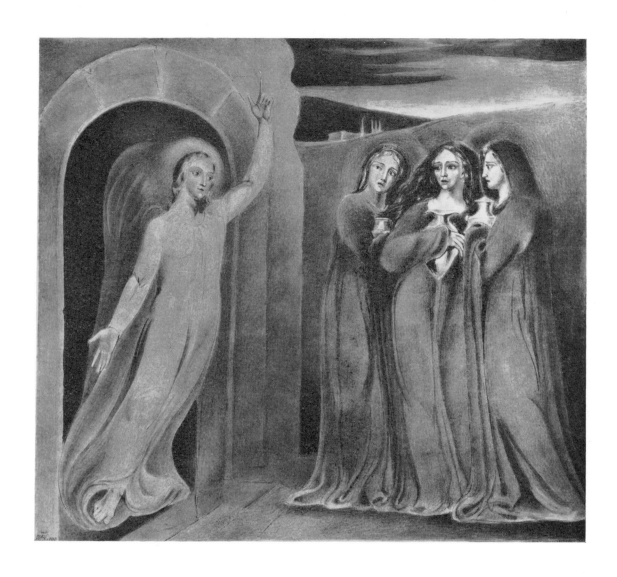

12 The Three Marys at the Sepulchre (24)

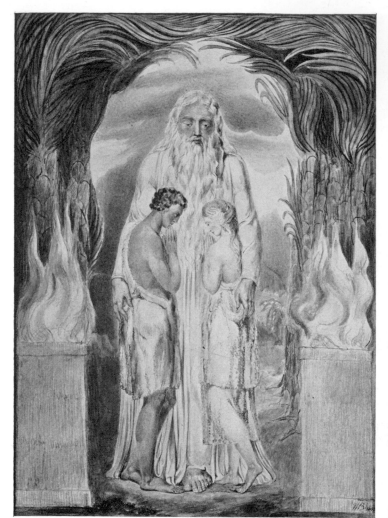

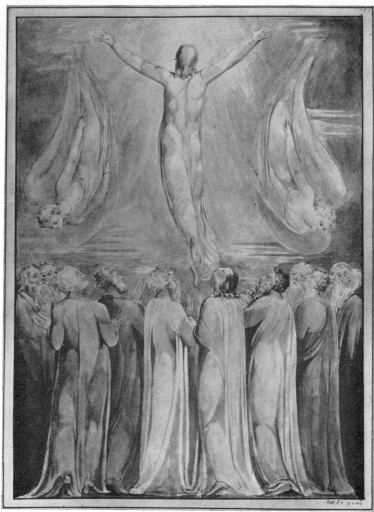

13 The Angel of the Divine Presence clothing
 Adam and Eve with coats of skins (25)

14 The Ascension (26)

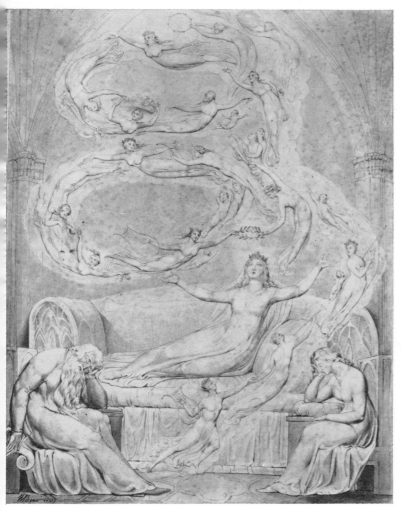

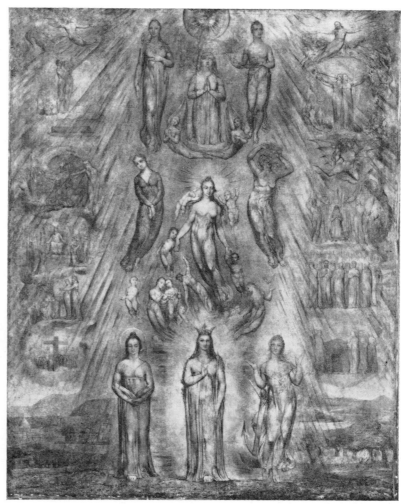

15 Queen Katherine's Dream (27) 16 An Allegory of the Spiritual Condition of Man (33)

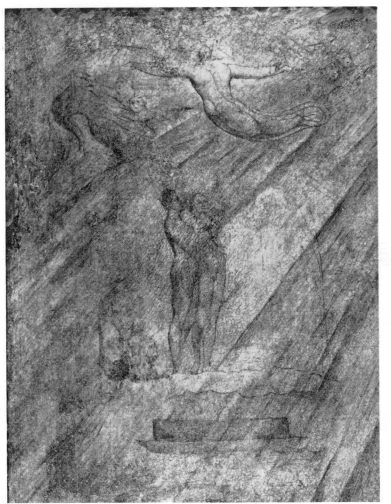

17 An Allegory of the Spiritual Condition of Man:
detail top left (33)

18 An Allegory of the Spiritual Condition of Man:
detail centre left (33)

19 An Allegory of the Spiritual Condition of Man:
detail lower left (33)

20 An Allegory of the Spiritual Condition of Man:
detail lower right (33)

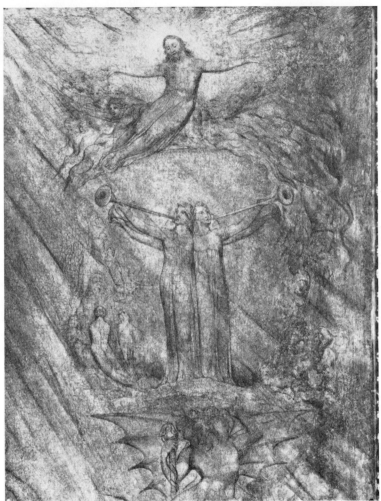

21 An Allegory of the Spiritual Condition of Man:
 detail centre right (33)

22 An Allegory of the Spiritual Condition of Man:
 detail top right (33)

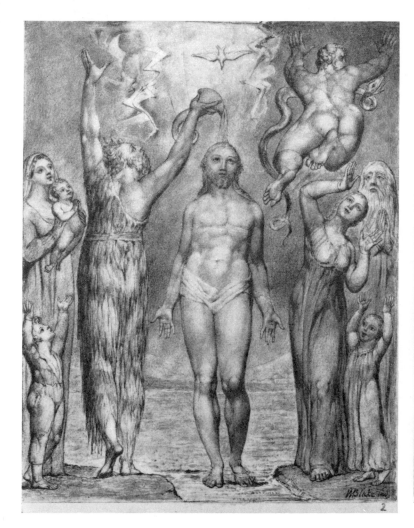

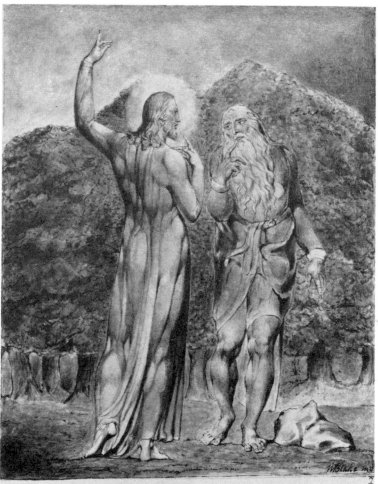

23　Paradise Regained: *The Baptism of Christ* (34 A)

24　Paradise Regained: *Christ tempted by Satan to turn the stones into bread* (34 B)

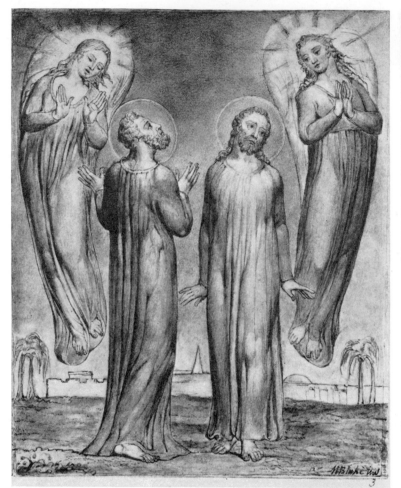

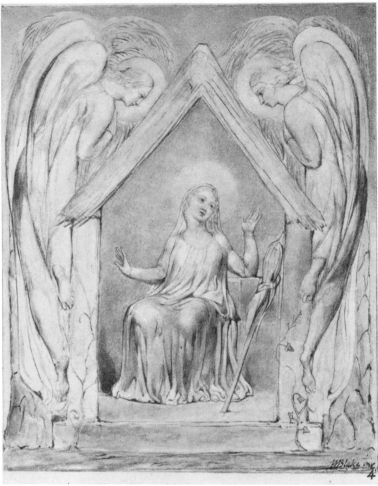

25 Paradise Regained: *Andrew and Simon Peter
searching for Christ* (34 C)

26 Paradise Regained: *Mary's lamentation for Christ* (34 D)

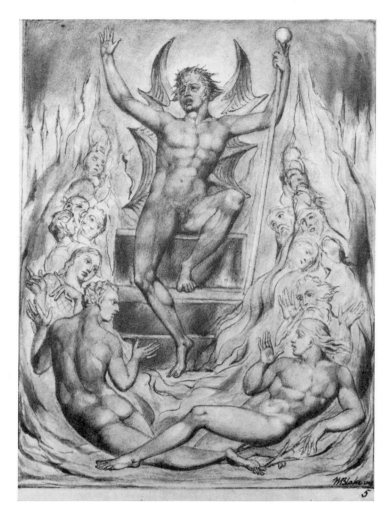

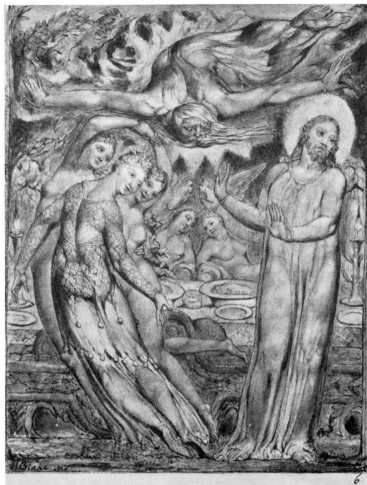

27 Paradise Regained: *Satan addressing
 his potentates* (34 E)

28 Paradise Regained: *Christ refusing the banquet* (34 F)

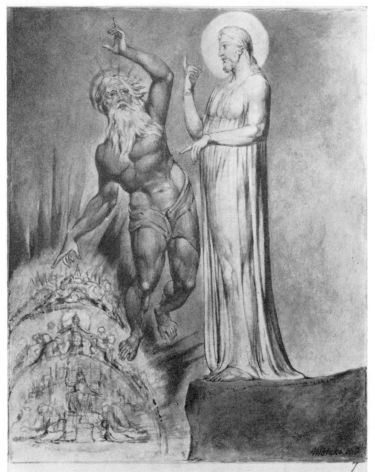

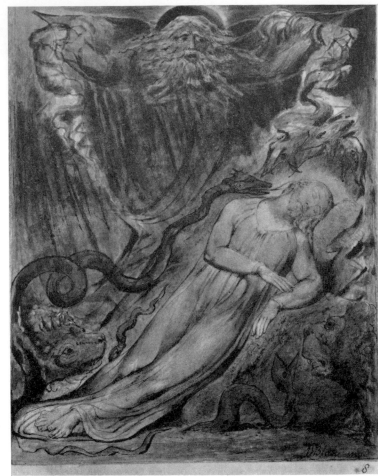

29 Paradise Regained: *Satan tempts Christ*
 with the kingdoms of the earth (34 G)

30 Paradise Regained: *Christ's troubled sleep* (34 H)

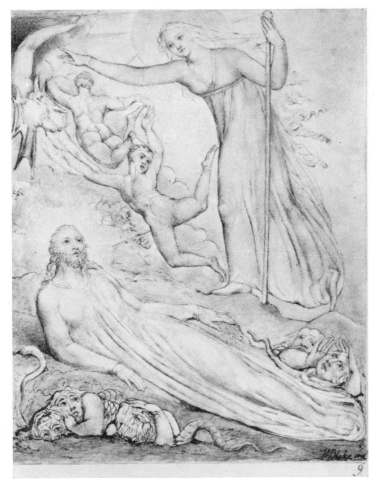

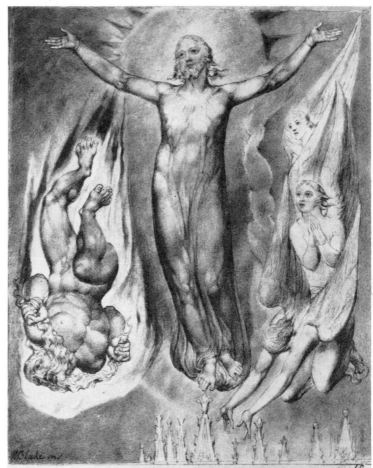

31 Paradise Regained: *Morning chasing
away the phantoms* (34 I)

32 Paradise Regained: *Christ placed on the
pinnacle of the Temple* (34 J)

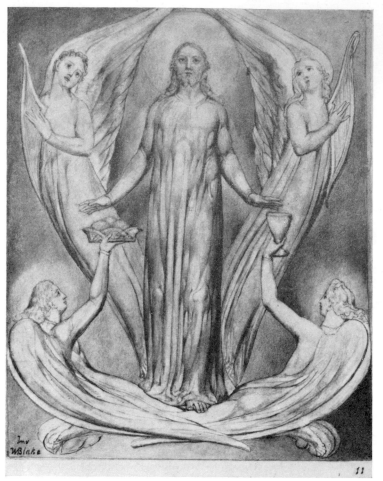

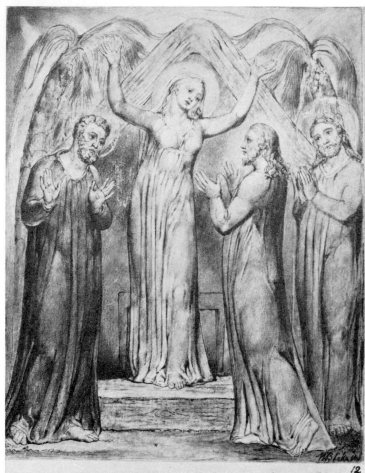

33 Paradise Regained: *Angels ministering to Christ* (34 K) 34 Paradise Regained: *Christ returns to His Mother* (34 L)

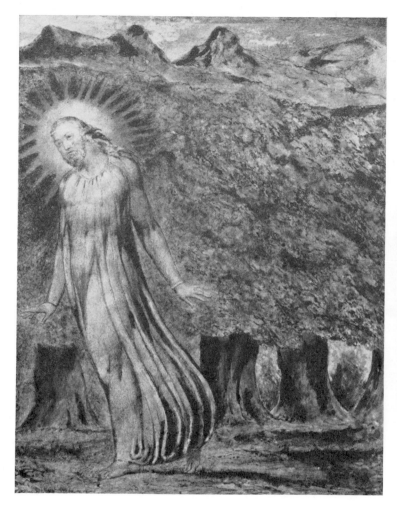

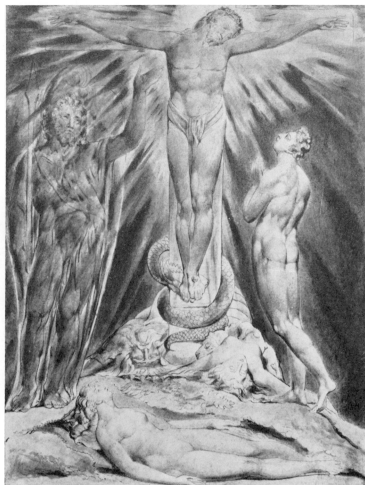

35 A Prophet in the Wilderness (35)

36 The Archangel Michael foretelling the Crucifixion (37)

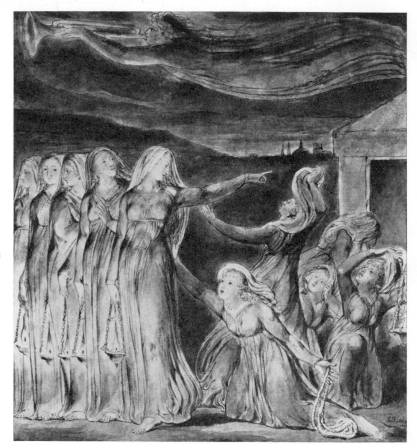

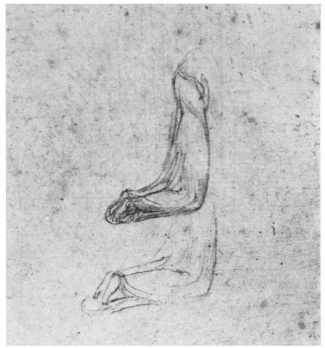

37 The Wise and Foolish Virgins (38)

38 The Book of Job: Study of kneeling daughter
for *Job and his family* (39(1) *verso*)

39 The Book of Job: Studies for
 Job and his family (39(2))

40 The Book of Job: *Job and his family* (39(3))

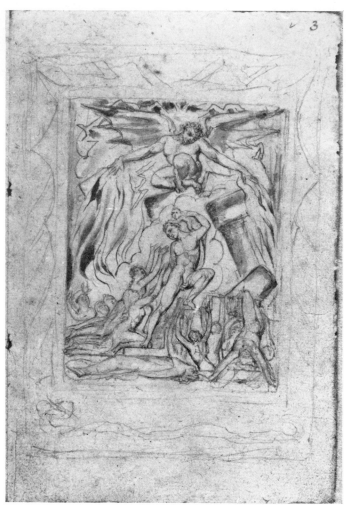

41 The Book of Job: *Satan before the throne of God* (39(4))

42 The Book of Job: *Job's sons and daughters overwhelmed by Satan* (39(5))

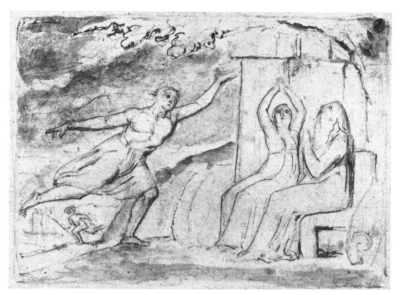

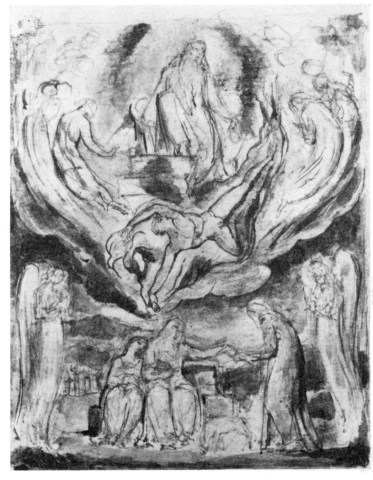

43 The Book of Job: *The Messengers tell Job of his misfortunes* (39(6))

44 The Book of Job: *Satan going forth from the presence of God* (39(7))

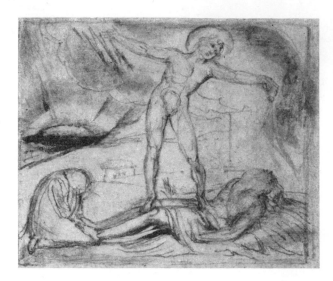

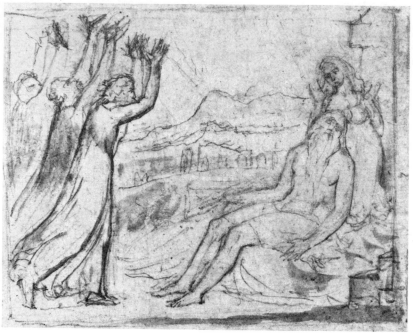

45 The Book of Job: *Satan smiting*
 Job with boils (39(8))

46 The Book of Job: *Job's comforters* (39(9))

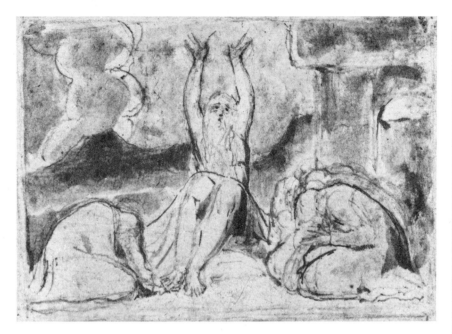

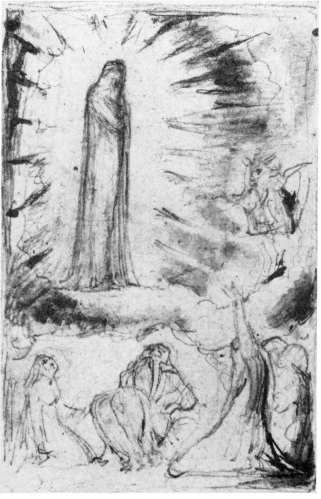

47　The Book of Job: *Job's despair* (39(10))

48　The Book of Job: *A Spirit passes before Job's face* (39(11))

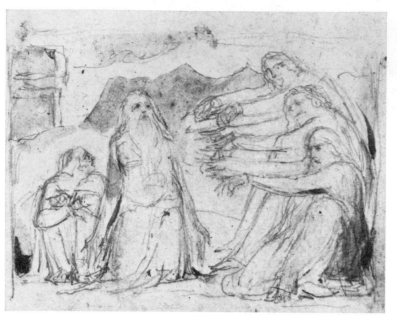 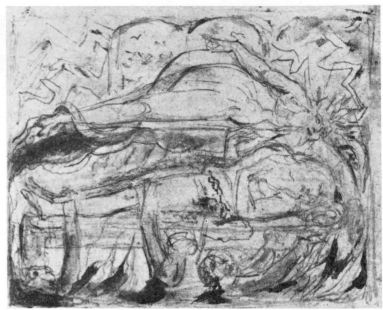

49 The Book of Job: *Job rebuked by his friends* (39(12)) 50 The Book of Job: *Job's evil dreams* (39(13))

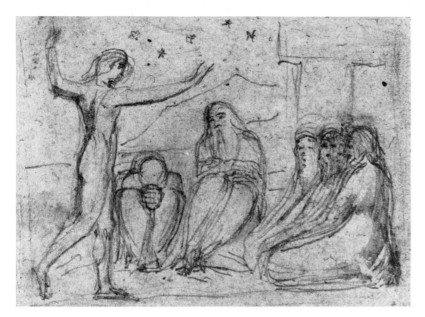 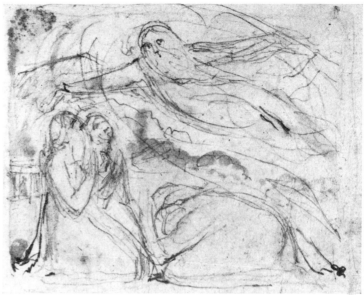

51 The Book of Job: *The Wrath of Elihu* (39(14))

52 The Book of Job: *The Lord answering
Job out of the whirlwind* (39(15))

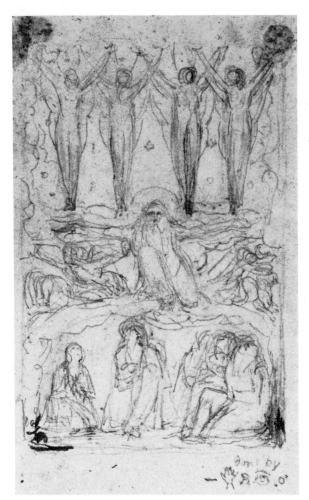

53 The Book of Job: *When the morning stars sang together* (39(16))

54 The Book of Job: *Behemoth and Leviathan* (39(17))

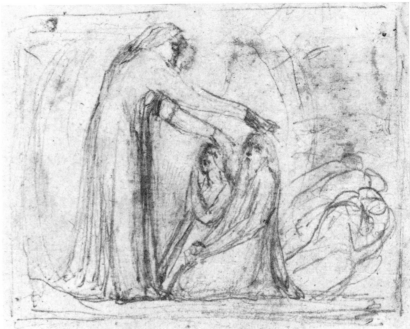

55 The Book of Job: *The Fall of Satan* (39(18)) 56 The Book of Job: *The Vision of Christ* (39(19))

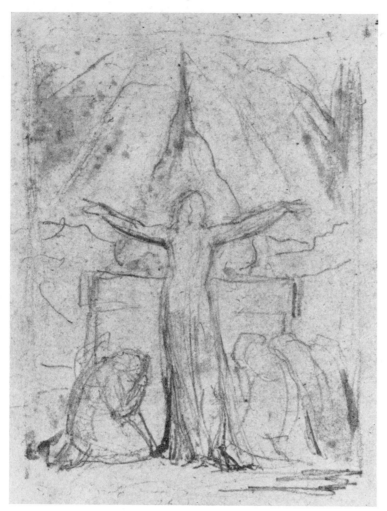

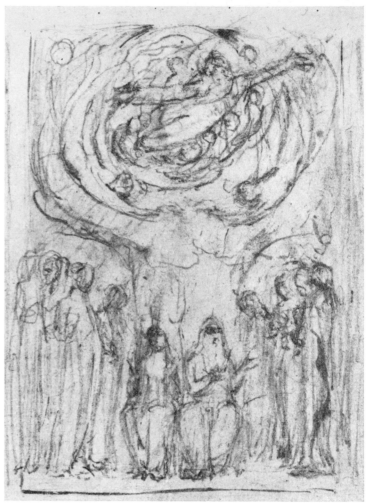

57 The Book of Job: *Job's sacrifice* (39(20) *recto*)

58 The Book of Job: *Every man also gave him a piece of money* (39(21))

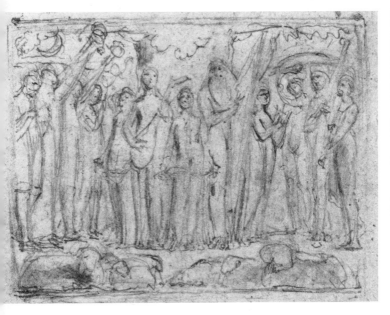 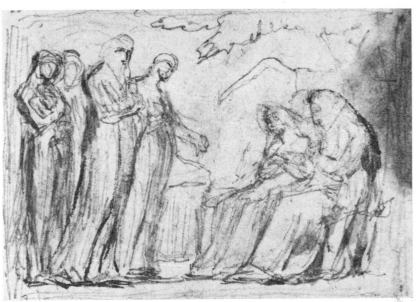

59 The Book of Job: *Job and his family restored to prosperity* (39(22))

60 The Book of Job: *Every man also gave him a piece of money* (39(23))

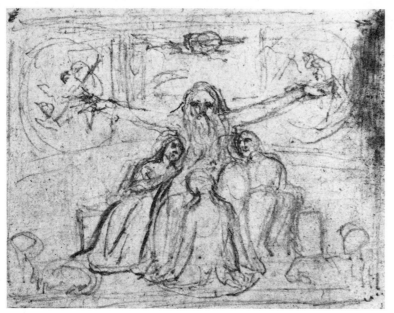

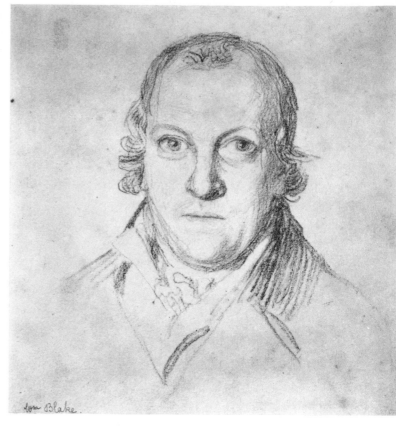

61 The Book of Job: *Job and his daughters* (39(24)) 62 William Blake by John Flaxman (45)

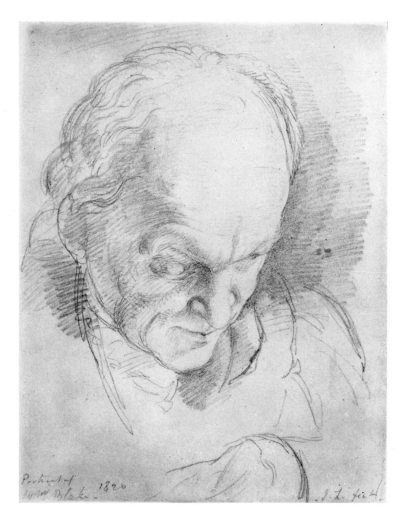

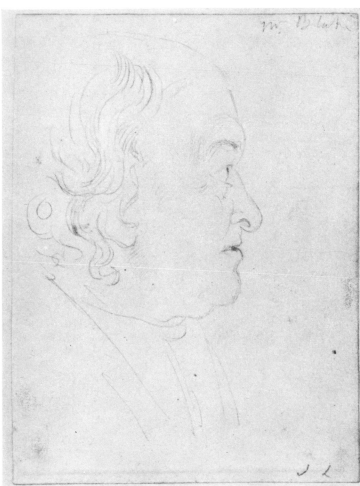

63　William Blake by John Linnell (46)　　　　64　William Blake by John Linnell (47)

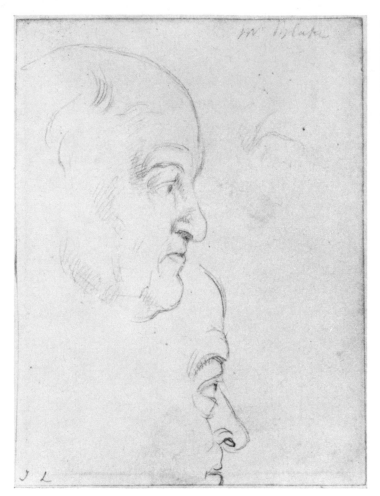 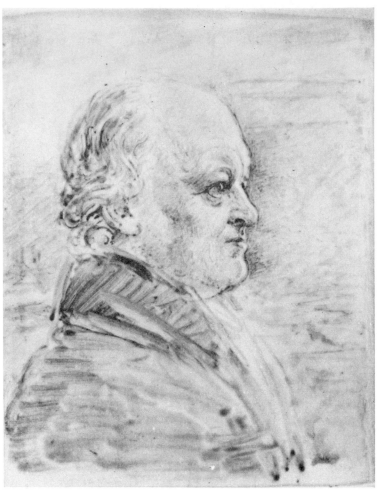

65 William Blake by John Linnell (48) 66 William Blake by John Linnell (49)

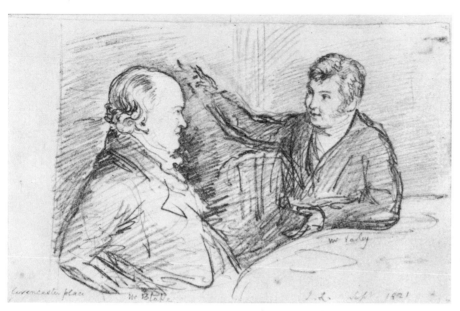

67 William Blake in conversation with
John Varley, by John Linnell (50)

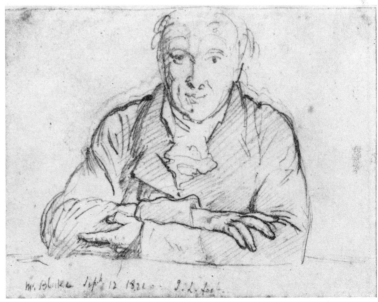

68 William Blake by John Linnell (51)

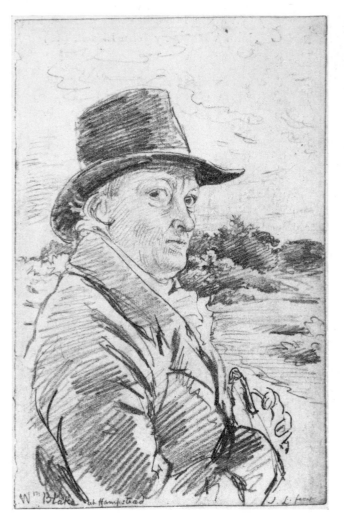

69　William Blake by John Linnell (52)　　　70　William Blake by Mrs Catherine Blake (53)